JOHN BECKWITH

THE ART OF

CONSTANTINOPLE

# THE ART OF CONSTANTINOPLE

## AN INTRODUCTION TO BYZANTINE ART
### 330-1453

BY

## JOHN BECKWITH

PHAIDON · LONDON · NEW YORK

© 1961 Phaidon Press Ltd., 5 Cromwell Place, London, S.W.7
First published 1961
Second edition 1968

Phaidon Publishers Inc., New York
Distributors in the United States: Frederick A. Praeger Inc.
111 Fourth Avenue, New York, N.Y. 10003
Library of Congress Catalog Card Number: 68-18908

SBN 7148 1331 1 (c)
SBN 7148 1332 X (p)

Made in Great Britain
Printed by Robert MacLehose & Co. Ltd., Glasgow

# CONTENTS

ACKNOWLEDGEMENTS
page vii

FOREWORD
page 1

I
INTRODUCTION
page 3

II
FOURTH TO SEVENTH CENTURY
page 7

III
THE ICONOCLAST CONTROVERSY
page 54

IV
NINTH TO TWELFTH CENTURY
page 64

V
THE FRANKISH CONQUEST
page 128

VI
THE PALAEOLOGUE REVIVAL
page 134

NOTES · GLOSSARY · CHRONOLOGICAL TABLE

INDEX

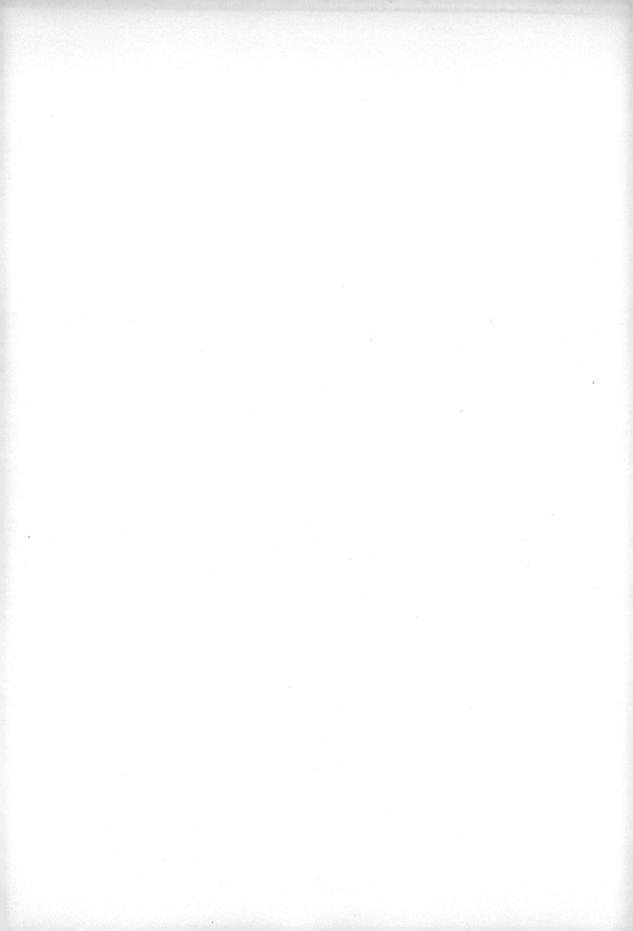

# ACKNOWLEDGEMENTS

AMONG the many friends and colleagues who have helped me in the course of writing this book my thanks go first to the Hon. Sir Steven Runciman for constant encouragement and advice. Professor Francis Wormald and Dr. Otto Pächt, to whom I am also greatly indebted, read the typescript and Dr. Michael and Mrs. Kauffmann undertook the correction of the page proofs. I should like to offer special thanks, in addition, to Professor Hugo Buchthal, Professor Dr. Otto Demus, Professor André Grabar, Dr. J. P. C. Kent, Professor Ernst Kitzinger, Professor Jovanka Maksimović, Dr. Gervase Mathew, o. p., Professor Sirarpie der Nersessian, Professor David Talbot Rice, Mr. Marvin Ross, Professor Dr. W. F. Volbach, and Professor Kurt Weitzmann.

For photographs, in some cases permission to publish, and for help in various ways I am grateful to Dr. Vinzenz Oberhammer, Director, Dr. Hermann Fillitz and Dr. Rudolph Noll, Kunsthistorisches Museum, and Dr. Franz Unterkirche, Österreichische Nationalbibliothek, Vienna; Mademoiselle V. Verhoogen, Conservateur du Département des Antiquités Grecques et Romaines, Musées Royaux d'Art et d'Histoire, Brussels; Mr. A. H. S. Megaw and the Director of the Museum of Antiquities, Nicosia; Dr. Palle Byrkelound, Koniglige Bibliotek, Copenhagen; Mr. T. A. Hume, Public Museum, Liverpool; the Trustees of the British Museum, Mr. Peter Lasko, Department of British and Medieval Antiquities, and Mr. Derek Turner, Department of Manuscripts, British Museum; the Victoria and Albert Museum; the staff of the Warburg Institute, London; Dr. Richard Hunt, Bodleian Library, and Dr. Walter Oakeshott, Rector of Lincoln College, Oxford; Monsieur Robert de Micheaux, Musée Historique des Tissus, Lyon; Monsieur Jean Babelon, Cabinet des Médailles, Monsieur Jean Porcher, Bibliothèque Nationale, Monsieur A. Khatchatrian, Collège de France, Monsieur Francis Salet, Director of the Musée de Cluny, Monsieur Étienne Coche de la Ferté and Monsieur Hubert Landais, Musée du Louvre, Paris; Domvikar Dr. Stephany and Herr Ludwig Falkenstein, Cathedral Treasury, Aachen; Dr. Victor Elbern, Ehemals Staatliche Museen, and Dr. Günter Ristow, Staatliche Museen zu Berlin; Professor Dr. Hermann Schnitzler, Director of the Schnütgen Museum, Köln; Domvikar Dr. Mann, Cathedral Treasury, Limburg an der Lahn; the Director of the Fotoarchiv, Kunsthistorisches Institut, Marburg an der Lahn; Professor Dr. Ludwig Heydenreich and Dr. Florentine Mütherich, Zentralinstitut für Kunstgeschichte, Dr. Theodor Müller, Director, and Dr. Sigrid Müller-Christensen, Bayerisches Nationalmuseum, Dr. Gustav Hofmann, Bayerische Staatsbibliothek, Munich; Dr. W. Fleischhauer, Director of the Würtembergisches Landesmuseum, Professor

Dr. Hans Wentzel, Technische Hochschule, Stuttgart; Dr. Manolis Hadjidakis, Benaki Museum, Professor G. Soteriou, Byzantine Museum, and Professor A. Orlandos, Athens; Dr. Sandor Mihalik, Director of the National Museum of Art, Budapest; Rev. Oliviero Lippi, Chiesa di San Francesco, Cortona; the clergy of the Cathedral at Cosenza; Professor F. Rossi, Soprintendenza alle Gallerie, and the Librarian of the Biblioteca Laurentiana, Florence; Dr. Gianguido Belloni, Museo del Castello Sforzesco, and Dr. Franco Russoli, Soprintendenza alle Gallerie, Milan; the clergy of the Cathedral at Monza; Monsignor Anselmo Albareda, Prefetto della Biblioteca Vaticana, Dr. Hermine Speyer, Pinacoteca Vaticana, the clergy of the Basilica di San Paolo fuori le Mura, Dr. Carlo Bertelli, Istituto Centrale di Restauro, Dr. A. Santangelo, Director of the Museo del Palazzo Venezia, Dr. Helmut Sichthermann, Deutsches Archäologisches Institut, Rome; Ingen. F. Forlati, Procuratoria della Basilica di San Marco, the Librarian of the Biblioteca Marciana, the Directors of the Museo Civico Correr and the Museo Archeologico, Venice; the Director of the Macedonian State Collections, Skoplje; Señor Don Santiago Alcolea, Instituto Amatller de Arte Hispanico, Barcelona; the Director of the Landesmuseum, Zurich; Mr. F. F. de la Grange, British Institute of Archaeology, Ankara; Dr. Rustem Bey Duyuran, Director, and Dr. Nezih Firatli, Arkeoloji Müzesi, Dr. Feridun Bey Diremtekin, Aya Sofya Müzesi, Dr. Luschey, Deutsches Archäologisches Institut, Mr. Ernest Hawkins, and Dr. Erçumend Atabay, Istanbul; Miss Dorothy Miner, Walters Art Gallery, Baltimore; Mr. William Forsyth and Mrs. Vera K. Ostoia, Department of Medieval Art, Metropolitan Museum of Art, Mr. John H. Plummer, Pierpont Morgan Library, New York; Mr. John S. Thacher, Director of the Dumbarton Oaks Collection, and Professor Paul Underwood, Byzantine Institute of America, Washington, D.C.; Dr. Alisa Vladimirnova Bank, Department of Byzantine Art, Hermitage Museum, Leningrad; the Director of the Museum of Fine Art, Moscow; Professor Shalva Amiranashvili, Director of the Museum of Georgian Art, Tiflis.

J.B.

# FOREWORD

THE Greeks were concerned with the creation of the universal type in its most idealized and permanent form. The Platonic doctrine of the idea was the philosophic expression of the whole Greek concept of artistic reality. Greek art was the result of a rational analysis. The personal reference is slight and even on sepulchral monuments the dead are represented as characters in the Theophrastean sense.

The Romans did not aim at the universal or the ideal. Their art became a system of religious and political propaganda emphasizing an historical event or a situation which was transitory. The Emperor was a god; his image and his acts, when represented, were a form of religious art.

The Senate set up the *Ara Pacis* in the Campus Martius at Rome in 13 B.C. to commemorate the return of Augustus from Gaul and Spain and the beginning of the *Pax Romana*. The altar reveals the family of Augustus walking to the temple. The images are faithfully portrayed, cold, tranquil, severe. The Roman insistence on family tradition, piety, gravity, and public service is recorded for all time. Decorative ornament—animal heads, garlands, swags of fruit—is a precise statement of things seen.

The reliefs on the Arch of Titus, completed in A.D. 81, celebrate the Sack of Jerusalem with an imperial triumph and a parade of Jewish trophies. The use of perspective, the effects of light and shade, the abrupt transitions from movement to stillness heighten the illusion of jubilant success. This interest in evoking atmosphere, in eye-deceiving effects of perspective, in landscape and views of cities, may be studied in less official monuments, in wall-paintings at Pompeii, at Herculaneum, and above all in the enchanting Garden Room from the House of Livia now in the Museo Nazionale at Rome.

Trajan's Column, completed in A.D. 114, introduces a detailed military epic, the campaign against the Dacians, carved in marble spirals. Already the style veers away from the classical canons crystallized by the Greeks. The continual appearance of the Emperor which halts the flow of narrative, the disproportion between the figures and the architectural background, the summary treatment of individual forms, herald an art later to be called medieval. Medieval art is foreshadowed further by the Column of Marcus Aurelius, set up between 176 and 193, on which is recorded the triumph over the Sarmatians achieved not by Roman effort but by a miracle. From this time illusion contracts, emotions verge on hysteria or ecstasy, the story is simplified, the technique of expression becomes more summary. In spite of the Hellenistic cult sponsored by Hadrian, art was turning in a new direction.

The decline of the great senatorial families, the collapse of the traditions of a formal Greek education and of the severe moral ideals of the Republic, the growing ascendancy of the army, the rise to power of new ruling classes from all parts of the Empire, all contributed to this new orientation. The new classes did not understand, or chose to ignore, the principles of formal delicacy, the precise statement of nature, the emphasis on technical quality of early imperial times.

In the third century the philosopher Plotinus proposed that art should not merely be an imitation of material Nature; it should be a point of departure for metaphysical experience; it should enable the spectator to come closer to the Divine Mind which had created both the subject and the evocation of the subject. But for the new rulers art was to underline the certainty of power. Thus, the figures of the Tetrarchs now built into the wall of the Church of St. Mark's at Venice and dating probably from about 300, have become stiff, defiant symbols of military strength. The image has become once more the symbol of an idea but not the universal ideal of the Greeks. The development was far from straightforward. Even in the late fourth century pagan patronage caused a 'hellenistic' revival at Rome and these revivals continued under Christian patronage. Christianity, not paganism, was to cosset the dying flames of classical art.

The art of the catacombs before the official recognition of Christianity in 313 is the art of Rome. Private portraits, doves, garlands, the play with illusion merely reflect on the walls of the arcosolia the taste of the Roman citizen. It is a popular art of a kind that had continued beside the grandiloquence of the imperial cult. Christ is first depicted as a Roman god, a Roman philosopher, or as a boy with a lamb round his shoulders. The Virgin appears as a Roman matron. As the needs of the church became more defined, as programmes of instruction demanded illustrations of scenes from the Old and the New Testaments, the patrimony of the Greeks and the Romans was gradually assimilated. But already the new stylistic trends, which had been disintegrating the classical canon, were dominant. The decaying art of late classicism provided the manger for early Christian art and sarcophagi like that of Junius Bassus, dated to the year 359, in the crypt of St. Peter's Basilica at Rome, or the fifth-century mosaics in Santa Maria Maggiore at Rome, in the so-called Mausoleum of Galla Placidia at Ravenna, reveal that the artists were speaking in the contemporary idiom. There was no immediate attempt to form a specifically Christian style. It was impossible, even if the Church had wished to do so, to return to the forms and standards of the *Ara Pacis* or the Arch of Titus. Indeed, for a long time the Church was gravely perplexed over the right to make use of images of any kind. Many centuries were to pass before the East Romans at Constantinople evolved a formula which might represent God without fear of blasphemy and which might satisfy the devotional needs of the faithful without fear of idolatry.

# I

WHEN Constantine the Great dedicated Byzantium, a small Greek town on the Bosphorus, on 11th May 330 as the capital of the Roman Empire, an immediate emphasis was placed on the alliance of imperial might with a religion officially recognized only for some seventeen years. The New Rome was deliberately set up in contrast with the Old, which still clung tenaciously to its pagan rites and customs. The temples of Byzantium rapidly became museums; only the Christian religion was tolerated at Constantinople.

After the conversion of Constantine the predominant position of the Emperor in early Christian political philosophy was established and the cardinal principle that the Emperor was the representative of God on earth, rooted in pagan political philosophy, was accepted and adapted by Christian thinkers. Imperial power was derived from God; the Emperor was the Vicar of God.[1] From the beginning the art of the capital was dedicated to this belief. The portraits of the Emperor received acclamation and *proskynesis*, and were accompanied by candles and incense long before religious images, but this cult was not affected by the recognition of Christianity. Indeed, the position and function which religious images were to acquire in the second half of the sixth century were understood from the beginning to be analogous to those enjoyed for numbers of years by the imperial image.[2] Throughout Byzantine history the preservation of artistic traditions and standards was largely the result of imperial interest and impulses from the court. In time the Patriarchs and some of the monasteries sponsored replicas of the court style, opposed the emperors who wished to abolish images, and set up a rigid programme of religious decoration, but for the most part the rise and fall of aesthetic accomplishment reflects imperial pressure. This state of affairs was in contrast with the West, where both Pope and Emperor, kings, bishops, abbots and merchants, though not always at the same time, exercised patronage which produced a variety of styles.

In spite of the driving power of the will of the Emperor Constantine, for long the importance of the Old Rome was maintained. Not quite a hundred years after the dedication of Constantinople the Empress Galla Placidia was to write to Pulcheria, the sister of the Emperor Theodosius II (408–450), that she regarded Rome as the first city of the Christian world, not only because of its apostolic origin in the See of St. Peter, but because it was the capital of an empire to which it gave its name.[3] If Quintus Aurelius Symmachus, one of the leading Roman pagan patricians, had been asked by his daughter Galla in the year 400 which city of the Empire he thought would become the heir to classical antiquity, it is unlikely that he would

have said Constantinople. For in the late fourth century, under the influence of patricians like Symmachus and Praetextatus, the centre of the pagan revival was still Rome with its new temples dedicated to the old gods and its workshops capable of producing the most beautiful of all late antique ivory diptychs.[4] To Roman patricians such as these, Constantinople must have seemed a new, raw, provincial military and naval base decked out with plunder from other cities—St. Jerome rather tartly observed that it was clothed in the nudity of almost every other city— and the work of any contemporary artist who could be persuaded to make his home there. To Symmachus it would probably have seemed unlikely that Constantinople should rival such cities as Antioch and Alexandria with their great palaces and temples, theatres, libraries, schools of art and traditions, and most of all Rome, where the death of the city was so slow as to be imperceptible and where the past was so imperiously present.[5] And the fact that Constantinople happened to be capital of the Eastern Empire would have weighed little with the Roman patricians of this time since they were accustomed to see Trier, Sirmium, Milan, and later Ravenna as seats of imperial government.

But Rome was sacked by the Goths in 410, pillaged for a fortnight by the Vandals in 455, and suffered yet again from the entry of Ricimer in 472. Finally, when the last Roman emperor, Romulus Augustulus, a boy, abdicated in favour of Odovacar the Ostrogoth in 476, the barbarians were supreme in Western Europe. With their supremacy and the ruin of the Roman patricians, Rome became for a time a provincial city relying from an artistic point of view on the metropolitan impulses from the Near East or on the dry memories of past ornamental design.

With the decline of Rome the importance of Constantinople—structurally embellished and strengthened by the Theodosian house—increased and increased still further with the far-reaching financial reforms of the Emperor Anastasius (491–518) which, in spite of the fact that his reserve of 320,000 pounds of gold was spent in the nine years of Justin's reign (518–527), undoubtedly set the stage, so to speak, for the Emperor Justinian (527–565) and the Empress Theodora (d. 548).[6] In addition, Antioch, the favoured residence of Constantius, the third city in the East Roman Empire after Constantinople and Alexandria, was destroyed by an earthquake in 525. John Malalas, the sixth-century chronicler, relates that not a single dwelling, nor any sort of house, nor a stall of the city remained undestroyed; no church, nor monastery, nor any other holy place was left unruined. Rebuilding began soon afterwards but the Persian king, Khusrau, sacked the mortally wounded city in 540 and no mosaic found at Antioch may be dated after that calamity.[7] The city was captured again by the Persians in 611 and fell finally to the Arabs in 636. Alexandria, whose hey-day under the Ptolemies had been waning slowly into twilight over several centuries, was captured by the Persians in 617, attacked by the Arabs in 641, though it was not fully occupied until the summer of 646. Notwithstanding the

losses that the city had sustained, 'Amr was able to report to the Caliph Omar that he had taken a city containing 'four thousand palaces, four thousand baths, twelve thousand dealers in fresh oil, twelve thousand gardeners, forty thousand Jews who pay tribute, four hundred theatres and places of amusement'. 'Amr was something of a poet and his figures belong to a world of fantasy but there can be no doubt that he had been impressed by the captured city. The Arabs had no intention of destroying Alexandria but they destroyed her as a child might a watch and she was not to function again properly for over a thousand years.[8]

In Syria and Palestine, nevertheless, under the first great Arab dynasty, the Umayyads, the traditions of antique art continued in modified splendour. In 691, the walls of the Dome of the Rock at Jerusalem were decorated with superb mosaic close in style to the mosaic decoration in a room over the south-west ramp in Agia Sophia at Constantinople. About the year 715, the courtyard of the Great Mosque at Damascus was embellished with landscapes and architectural fantasies in mosaic which, though 'orientalized', are almost in the direct line of descent from those in the Church of St. George at Salonika, dating from the late fourth or early fifth century.[9] Mosaic floors of remarkable quality were laid down in the palace of Khirbat al-Mafjar near Jericho for an Umayyad prince in 726.[10] Literary records indicate that some of the artists and the materials for the Umayyad mosaics came from Constantinople.[11] But the evidence in general from the Umayyad palaces and mosques suggests that workshops in Syria, Egypt, and Mesopotamia all contributed to the newly rich Arab princes' demands for craftsmen. On the other hand, it seems clear that the Umayyads were in no doubt as to where to turn when they needed the best artists for their building enterprises. In the late seventh and early eighth centuries Constantinople was universally acknowledged to be the greatest city of the Mediterranean world.

With the fall of the Umayyad house in the middle of the eighth century and with the rise to power of the Abbasids came a new orientation in the world of art in the Near East. The Abbasid dynasty chose for its capital Baghdad, the Syrian and Egyptian towns dwindled in importance, and although late antique traditions of a sort lingered on until the twelfth century in Jacobite manuscripts, a few ceramics, and various sequences of textiles, the formulation of a specific Islamic style based on Persian and Mesopotamian ornamental grammar ran counter to the broad eclecticism of the Umayyad princes.[12]

Thus, the victories of the Goths and Vandals in the West, the calamities produced by an earthquake and by the Persian and Arab invasions, the switch of Islamic power from Syria to Mesopotamia, the creation of an Islamic style relying upon calligraphy and vegetable and geometric arabesque, all combined to isolate Constantinople as the preserver of the traditions of the Greeks and the Romans. Moreover, when the city was besieged by the Arabs in 717, the victory of the

Emperor Leo III, which decimated the Muslim army and destroyed the fleet, should be seen as one of the crucial events of medieval history. From this moment the city was to be more than the eastern bulwark of Christianity; it was to become the heart and conscience of an orthodoxy which was aware of the need for a balance of power in the Middle East. This awareness, increasingly harassed by the advent of the Seljuk Turks and constantly under pressure from the Slav peoples on the northern and western frontiers, was never understood by the West, and when they destroyed it, spurred on by envy and cupidity, it was only a matter of time for Islam in one form or another to overrun the Eastern Empire.

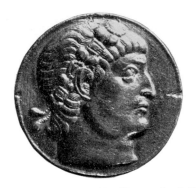 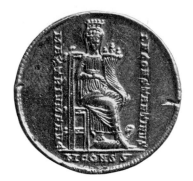

1. *Constantine I.* Reverse: *Constantinople.*
Silver coin struck to commemorate the dedication of the city on 11th May, 330
*Milan, Museo del Castello Sforzesco.*

OF the city founded by the Emperor Constantine little but foundations remains. The temples and the churches, the palaces and arcades, the Basilica where the Senate held its principal meetings and which housed a group of the Muses from Helicon, the statue of Zeus from Dodona, and that of Pallas from Lindus, the statues lining the Mesé, the baths of Zeuxippos,[1] the Hippodrome,[2] the sculptures in the Forum of Constantine like the great figure of Apollo crowned with seven rays on a porphyry column, are no more.[3] Only the bronze horses which now adorn the façade of St. Mark's at Venice, the bronze column of serpents from the Temple of Apollo at Delphi now in the great square before the Mosque of Sultan Ahmet, and some marble jetsam in the Archaeological Museum at Istanbul are a token of the wealth of antique art once to be found in the city and at more than one time providing a source of form from which sprang the streams of perennial hellenism to feed the Byzantine style. Moreover, almost nothing has survived at Constantinople of the art of the time of its foundation: gone are the statue of St. Helena in the Augusteion, the sculptured group of the three sons of Constantine in the Philadelphion, the great equestrian statue of Constantine in the Strategion, and the rich cross of gold and precious stones which that Emperor caused to be erected over the entrance to the palace 'as a protection and a divine charm against the machinations and evil purposes of his enemies'.[4] A fragment of a porphyry sarcophagus, decorated with Erotes and garlands, probably carved in Egypt, is all that remains of what is thought to be the founder's tomb.[5]

The silver coin (Fig. 1) issued to commemorate the dedication of the city and struck with a representation of the Emperor Constantine and the personification of Constantinople[6] enunciated no new principle of style. The new Christian city is personified according to pure Hellenistic tradition, without a trace of Christian symbolism; she holds in her right hand a short branch and in her left hand the cornucopia of prosperity, her feet rest on a prow—the distinctive mark of a sea-port capital.[7] The medallion issued by Constantius II between 333 and 335 (Fig. 2), showing Constantius on one side and on the other Constantine and his three sons, Constantine, Constantius and Constans, might have been issued at any mint throughout the Empire.[8] But a comparison of the multiple *solidi* issued at Nicomedia, near Constantinople, and at Antioch about 355 (Figs. 3 and 4), showing Constantius and the personification of Constantinople,[9] establishes certain differences. The Antiochene version is at once more conventional and of better quality. The personification of the city is wholly in the classical tradition with its subtle

2. *Constantius II.* Reverse: *Constantine and his three sons, Constantine, Constantius and Constans.*
Gold medallion struck at Constantinople, 333–335.
*Vienna, Kunsthistorisches Museum, Münzkabinett.*

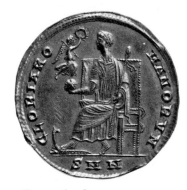

3. *Constantius II.* Reverse: *Constantinople.*
Gold multiple *solidus* struck at Nicomedia, about 355.
*London, British Museum.*

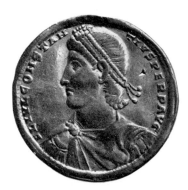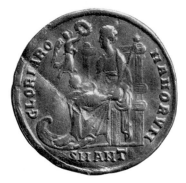

4. *Constantius II.* Reverse: *Constantinople.*
Gold multiple *solidus* struck at Antioch, about 355.
*London, British Museum.*

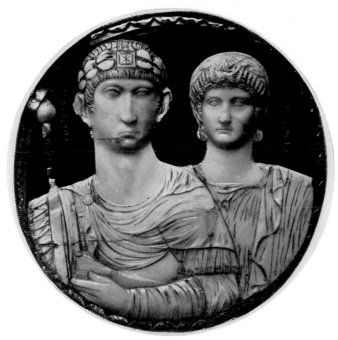

5. *Constantius II and his Empress.* Chalcedony. Constantinople, about 335.
*Paris, Musée du Louvre.*

posture, gently falling drapery, softly waving hair, and its natural appearance seen
in depth. The Nicomedian version presents a harsher, more schematic puppet with
drapery transformed into a series of ridges rising over a flattened relief applied to the
background; the posture of the legs and the running movement of the little Victory
is more exaggerated and generates a certain emotional tension. On the other hand,
in the representation of Constantius, it is clear that both versions demonstrate the
slow destruction of the classical canon of the human form which is one of the chief
characteristics of late antique style. On the Antiochene version, Constantius is
represented by a simplified notation of facial detail, wide staring eyes, prominent
imperial diadem; the full neck and broad profile emerge from the constricted
shoulders sharply different in proportion. That these characteristics were not con-
fined to the coinage may be seen in the famous Rothschild cameo (Fig. 5), almost
universally identified as the Emperor Honorius and the Empress Maria but recently
preferred to be Constantius and his Empress and attributed to Constantinople
about 335.[10] Here, though the portrait is more naturalistic, the relation of the full
neck and large head to the ill-co-ordinated torso, the reduced forearm and hand, the
merest evocation of costume are related to the Nicomedian *solidus*, where these
stylistic tendencies are accentuated. The small hands and shrivelled arms, the
shrunken chest and the ungainly treatment of the shoulder joints contrast with the
broad planes of the head, its dilated eyes, and the helmet surmounted with the

B

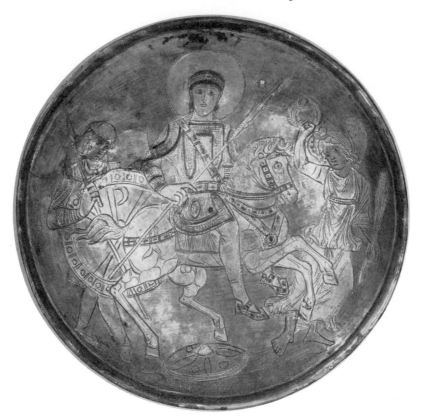

6. *Constantius II*. Silver and silver-gilt dish. Constantinople (?), middle of the fourth century.
*Leningrad, Hermitage.*

imperial diadem. A concept of imperial power is evoked which, like the appearance
of Constantius at Rome in his triumphal entry of 357,[11] painted in the Persian style,
golden-wigged, sparing in gesture and looking neither to right nor left, may have
shocked the conservative Roman patrician. This living imperial icon was a far cry
from the figure of Augustus on the *Ara Pacis*. The transformation of the Emperor
into an abstract, hieratic image may also be observed in the great silver dish from
Kertch (Fig. 6). So sketchy is the style of this imperial image that it has been denied
to a court workshop and assigned to a provenance in the Black Sea area[12] but one
must beware of visualizing the art of the capital as necessarily homogeneous. Artists
from all parts of the Empire were attracted to the new centre of patronage. Several
styles were present, as will be shown in connection with some of the later sculpture
and silver, and it is possible that the Constantius dishes from Kertch[13] as well as the
great silver amphora from Concesti (Figs. 7-9) with its riot of Amazons and warriors,
Nereids and monsters, its reduced but classicizing forms, its more emotional pene-
tration into the subject, may reflect discrete elements in the metropolitan output.[14]

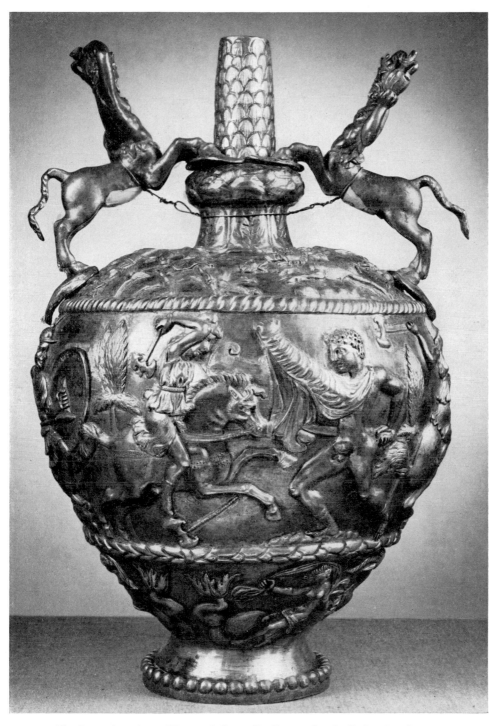

7. *The Concesti amphora*. Silver and silver-gilt. Constantinople (?), late fourth century. *Leningrad, Hermitage.*

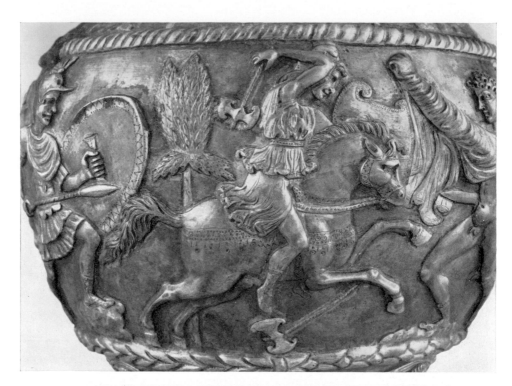

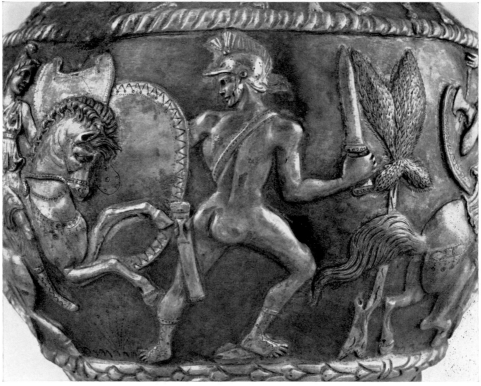

8–9. Details from *The Concesti amphora*. Cf. Fig. 7.

10. *Julian the Apostate*. Reverse: *A bull*. Bronze coin struck at Constantinople, 361–363. *London, British Museum*.

11. *Valentinian I*. Reverse: *The Emperor in a quadriga*. Gold coin struck at Constantinople, 364–375. *London, British Museum*.

Frequently in late antique art there is a contrast between the quality of rendering the human form and that of rendering animal forms. This contrast is present on the Concesti amphora but it may also be studied on a curious bronze coin issued at Constantinople (Fig. 10) by the Emperor Julian the Apostate (361–363). The retrograde tendencies of the Emperor are well known, and although the mysterious presence of the bull, a symbol which no one understood in the context, and an ill-considered speech at Antioch provoked laughter, the Emperor Julian made little change to his own effigy.[15] The bull is represented with a grasp of modelling and form and suggests an atmosphere of style quite different from the imperial image. Two almost opposed styles, therefore, could exist on the same artefact. The portrait of Valentinian I (364–375) on a gold *aureus* (Fig. 11) issued at Constantinople[16] continues the models established by the Constantinian house—his image differs little from that on the multiple *solidi* of Constantius but the horses on the reverse are portrayed with great liveliness and verisimilitude.

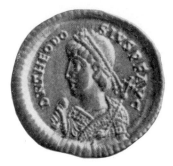 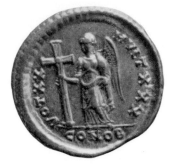

12. *Theodosius II*. Reverse: *A Victory holding a jewelled cross*. Gold consular *solidus* struck at Constantinople, about 420. *London, British Museum*.

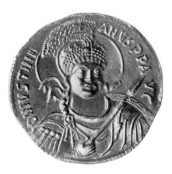 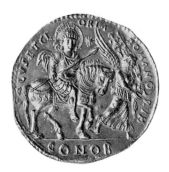

13. *Justinian I*. Reverse: *Justinian I preceded by a Victory*. Electrotype of a multiple gold *solidus* struck at Constantinople, about 534. *London, British Museum*.

After Arcadius (395–408) the style of the coinage declines in general terms.[17] A consular *solidus* of Theodosius II, about 420, while important iconographically because of the introduction on the reverse of the standing figure of a Victory holding a jewelled cross (Fig. 12), reveals stylistically a marked falling off in the quality of the imperial image.[18] Standards varied from mint to mint, as before, and the coins issued from the capital were not necessarily the best. In the reign of Leo I (457–474), for example, the mint at Salonika was superior to that of Constantinople. By Justinian's reign (527–565), in spite of the splendour of the multiple *solidus* (Fig. 13) issued in 534 to commemorate the triumph of Belisarius after his defeat of the Vandals in Africa,[19] the coins in general tend to be bad in design and indifferently struck, and the parallelism of the mints breaks down. Neither coins issued at Rome nor those issued at Ravenna bear any relationship to the Constantinopolitan coin; the Ostrogoths used different models. Moreover, as will be seen, the style of the Byzantine coinage tends from this time to go its own separate way from that of other objects and, though helpful archaeologically, is of little use as a pointer to general stylistic change.

The reign of Theodosius I (379–395) established a marked revival of the arts in both halves of the Empire. A clearer concept of monumental style in the Eastern capital may be gained. Although frequently in ruinous condition and numerically slight in comparison with monuments in the West, a sequence of sculptures ranging from the late fourth to the sixth century has survived. While the date of some is still open to discussion, at least there are grounds for assessment.

One of the key works to the art of the late fourth century, the carved base (Fig. 14) supporting an obelisk of Thutmosis III (about 1504–1490 B.C.), brought from Karnak to Constantinople and set up with some difficulty in the Hippodrome, may be dated to about 390.[20] On all four sides of the base are scenes representing the imperial court at the games. On the lower part of the base, on the north-east and south-west sides, are scenes depicting the erection of the obelisk and a chariot race; on the south-east side a Latin inscription states that the obelisk was erected in thirty days by the Emperor Theodosius with the assistance of Proclus (who was at the time *praefectus urbi*); on the north-west side, a Greek inscription refers to the same operation but states that it took thirty-two days. The presence in the imperial box of three Augusti wearing the imperial diadem and a young prince wearing the chlamys on the north-west and south-west sides would seem to portray the Emperor

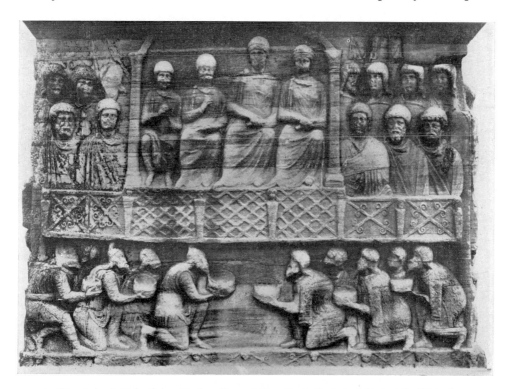

14. *Theodosius I, Valentinian II, Arcadius and Honorius in the imperial box at the Hippodrome.*
Marble base of an obelisk, about 390. *Istanbul, At-Meidan.*

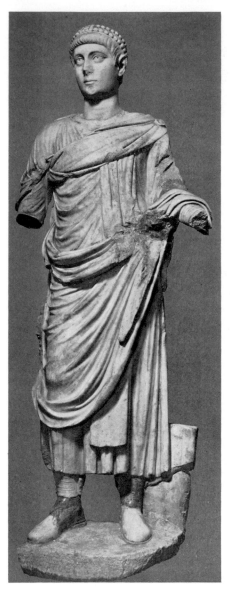

15. *Valentinian II*. Aphrodisian marble.
Aphrodisias, 387–390.
*Istanbul, Archaeological Museum.*

Theodosius I, his nephew Valentinian II, and his sons Arcadius and Honorius. On the north-east and south-east sides the same three Augusti preside, accompanied by two young princes, one of whom wears the toga (Honorius had been made Consul in 386) but the identity of the other remains uncertain. Proclus, owing to the intrigues of Rufinus, was overthrown and beheaded in the autumn of 392, and although his memory was rehabilitated by Arcadius in 396, it seems likely that the carvings date before his execution.

The style should be compared with the statue of Valentinian II from Aphrodisias (Fig. 15), now in the Archaeological Museum at Istanbul, which presents the same smooth, soft summary of the imperial ideal, the stiff bearing and the slightly conceptualized dress so typical of the Theodosian period.[21] The statue is carved from the blueish marble of Aphrodisias and is presumably local work, but the authenticity of the portrait suggests a Constantinopolitan model. The inscription referring to Valentinian was so close to the position of the statue when it was found that there seems no reason to doubt that it is the portrait of Valentinian dressed as a Consul and dating from between 387 and 390. The general characteristics of the head should be compared with that of Arcadius (Fig. 17), found not far from the Column of Theodosius I, just outside the west wall of the Forum Tauri at Constantinople.[22] The Column was erected about 392 and destroyed by an earthquake in 480. The head of Arcadius, in Pentelic marble, may be dated between 395 and 400. Comparison should also be made with the great silver dish at Madrid (Fig. 16) with a representation of Theodosius, Valentinian II and Arcadius, made to celebrate the *Decennalia* in 388.[23] It is by no means certain that the dish was made at Constantinople; it would appear to have closer affinities with Western rather than with

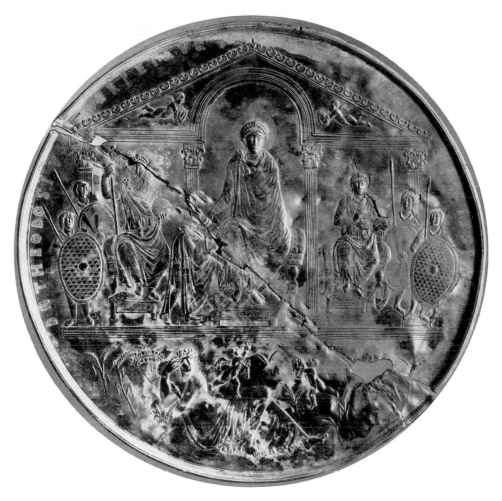

16. *Theodosius I, Valentinian II and Arcadius.* Silver dish. Constantinople (?), 388.
*Madrid, Academia de la Historia.*

Eastern silver. But a comparison of the Augusti seated in the imperial box on the
base of the obelisk with the Emperor and his sons on the silver dish shows a number
of close parallels: reluctance to think in terms of depth, insistent frontality, figures
looming out of a 'wall' of space, rhythmic treatment of the drapery sliding over the
forms in soft folds, and the mild, almost exaggeratedly youthful contours of the
imperial face. The appearance of youth caught in suspense in the imperial portraits
is echoed in some of the bodyguard depicted on the silver dish and on the base of the
obelisk. They stand with spears, their long hair falling to a loose curl on the curve
of a shoulder, their faces cast almost in the same mould. The senators and patricians
drawn up in stiff ranks on either side of the imperial box are shown with some degree

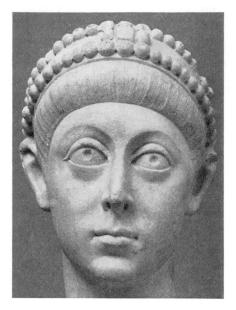

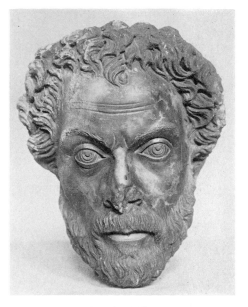

17. *Arcadius*. Pentelic marble. Constantinople,
395–400. Found near the Forum Tauri.
*Istanbul, Archaeological Museum.*

18. *Head*. Aphrodisian marble.
Aphrodisias, late fourth century.
*Brussels, Musées du Cinquantenaire.*

of contrast, heavily bearded, moustached and furrowed. A head from Aphrodisias
now in Brussels (Fig. 18) repeats the type, haggard with lines reaching down from
the bridge of the nose to the corners of the mouth and the brow wrinkled with
tripled crease.[24] The same characteristics also occur in a *chlamydatus* (Fig. 20), also
from Aphrodisias,[25] where the troubled face of the late fourth century turns towards
the spectator above the heavy folds of office. A second *chlamydatus* from Aphrodisias

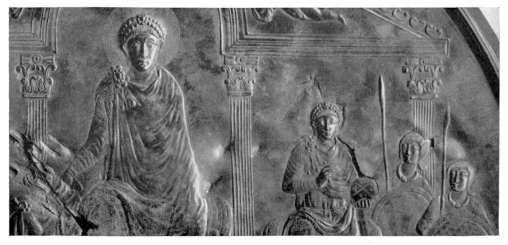

19. Detail from Fig. 16.

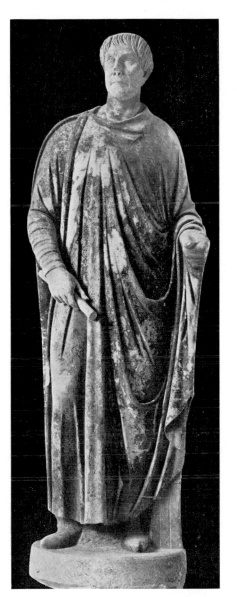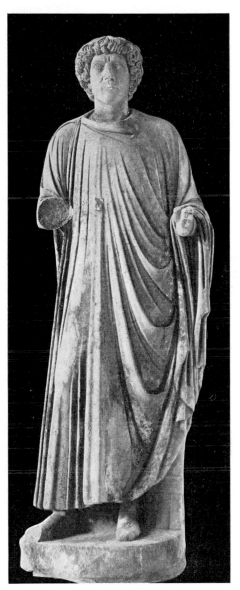

20–21. *Two Chlamydati*. Aphrodisian marble. Aphrodisias, late fourth century.
*Istanbul, Archaeological Museum.*

(Fig. 21) provides another version; the tense, strained, brutally determined features accentuate the calm idealization of the young Valentinian II or of Arcadius.[26] All these official sculptures are conceived in terms of cylindrical mass, the drapery rarely breaks away from the figure, and it is as though the fluttering draperies and deeply cut folds of Antiquity were being ironed out over the surface of the column

from which the imperial or official mask gazes out like an icon and almost as disembodied.

At the same time, when the imperial or the official image is not represented, a freer style is possible. On the south-east side of the base of the obelisk (Fig. 22) the row of dancers contrasts in its fluid movement with the united front of the patricians below the imperial box. In the silver dish of Theodosius (Fig. 16), the personification of the Earth and the attendant figures are depicted with a freedom of line and posture which stresses the tense epiphany of the imperial house above.

It is not without irony that possibly the earliest Christian sculpture to have survived in Constantinople is the most classical in spirit. A child's sarcophagus (Fig. 23) found in a fourth-century cemetery near Fenari Isa Djami (the coins uncovered in the course of excavations range in date from Constantine to Arcadius), although superior in quality to any of the sculptures so far discussed, cannot be far removed in date from them.[27] The faces and draperies of the apostles at either end of the Sarigüzel sarcophagus (Fig. 24) are close in style to the base of the obelisk

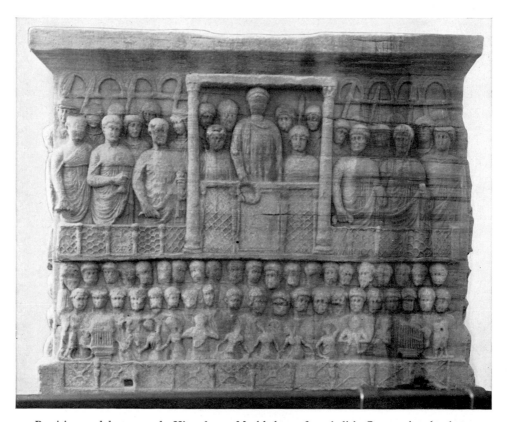

22. *Patricians and dancers at the Hippodrome.* Marble base of an obelisk. Constantinople, about 390. *Istanbul, At-Meidan.*

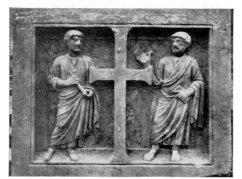

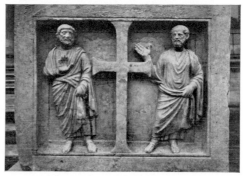

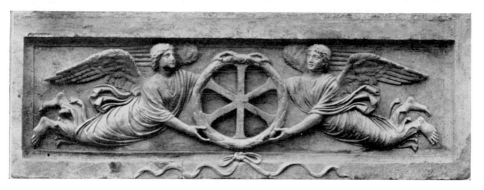

23–26. *The Sarigüzel Sarcophagus.* Marble.
Found near Fenari Isa Djami. Constantinople, second half of the fourth century.
*Istanbul, Archaeological Museum.*

and the statue of Valentinian II, though the movement of the Apostles is less stiff
and their features less smoothed out. The angels bearing the monogram of Christ in
a garland, on the other hand, are superbly conceived and interpreted. The fore-
shortening of the forms is such that they appear to be flying out of the corners of the
sarcophagus and away from the centre of the marble plane. The turn of the wings,
the set of the heads, the fluttering draperies, the undulations of knotted ribbons
coursing along the bottom edge, the merging of planes and the recession of forms

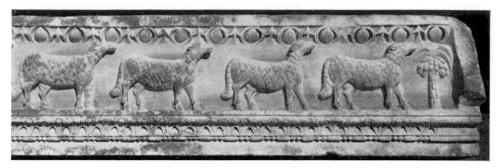

27. *Part of a frieze of lambs* on the architrave over the entrance to the outer hall of the pre-Justinianic Church of Agia Sophia. After 404. *Istanbul, Archaeological Museum.*

establish a masterpiece of late antique art. The style of these angels would seem to be infinitely finer in quality than anything that has survived in the West, including the superb so-called sarcophagus of Stilicho in the Basilica of St. Ambrose at Milan,[28] and they suggest that artists in the new capital were beginning to surpass those of Rome and Milan.

A frieze of lambs on the architrave over the entrance to the outer hall of Agia Sophia (Fig. 27), built by Theodosius II after the fire of 404, rivals similar work at Rome and Ravenna.[29] Considering the ruined state of the base of the obelisk, it is particularly fortunate that other fragments in the Archaeological Museum at Istanbul echo the quality of the Sarigüzel sarcophagus. A fragment of a relief with a representation of the Delivery of the Law (Fig. 30), and another with Christ between two Apostles (Fig. 28), reinforce, by the subtlety of their draperies, the moulding of the forms, the gentle change of posture, the evidence of the sarcophagus.[30] Reliefs such

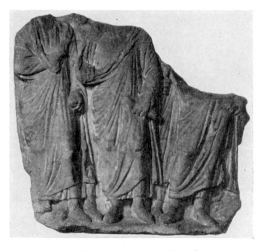

28. *Christ between two Apostles.*
Marble relief. Constantinople, late fourth or early fifth century.
*Istanbul, Archaeological Museum.*

as these must have served as models for the artists of the Macedonian emperors; the apostles on the Sarigüzel sarcophagus are, so to speak, blue-prints for the ivory carvers of Constantine VII Porphyrogenitus. They show that, in spite of the danger of being overwhelmed by artists coming from the eastern provinces with approaches of a more 'oriental' nature to the hellenistic heritage, that heritage was maintained over the flood of influences from Asia Minor, Syria and Palestine. The foundations of imperial art, so deeply rooted in Rome, were never submerged.

Throughout the fifth century the forms appear to harden and stiffen. A comparison of a Victory from the Gate of Ayvan Saray (Fig. 29) with the angels on the Sarigüzel sarcophagus shows a change of direction.[31] For all the fluttering draperies and classical detail of dress, the clumsy movement and the flattened form—typical of advanced late antique simplification—suggest a date towards the end of the reign of Theodosius II, about the middle of the fifth century,

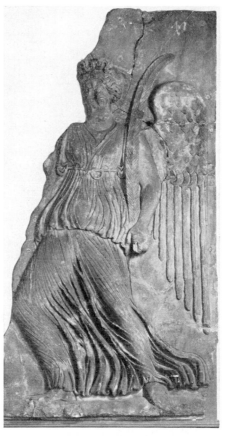

29. *A Victory*. Marble relief. From the Gate of Ayvan Saray. Middle of the fifth century. *Istanbul, Archaeological Museum.*

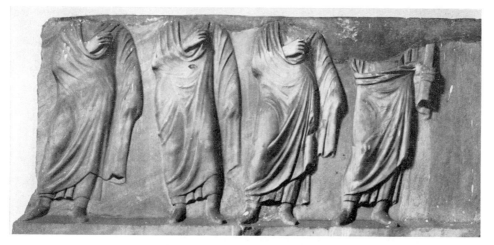

30. *The Delivery of the Law*. Marble relief. Constantinople, late fourth or early fifth century. *Istanbul, Archaeological Museum.*

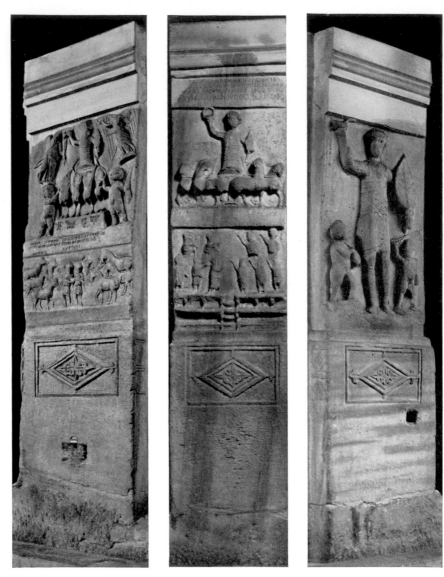

31–33. *Marble base of the bronze statue of Porphyrius,* once in the Hippodrome.
Late fifth or early sixth century. *Istanbul, Archaeological Museum.*

but before the yet stiffer and ungainly gesture of the Victory on the ravaged
base of the Column of Marcian.[32] The base of the bronze statue of Porphyrius (Figs.
31-33), the adored charioteer of the late fifth and early sixth century, once in the
Hippodrome and now in the Archaeological Museum at Istanbul, presents, for all
its weathered condition, a stiffness and stylization of form far removed from the
Theodosian revival.[33] The great personal beauty of this Alexandrian charioteer is
reduced to the official formula of a consular diptych.

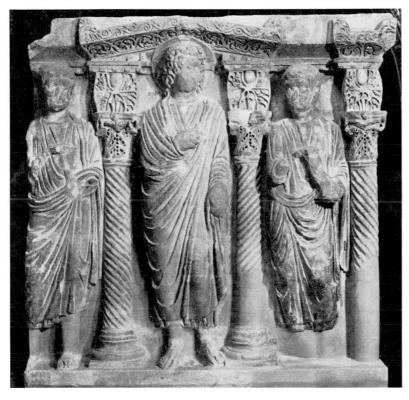

34. *Christ between two Apostles*. Marble relief. From the Monastery of the Theotokos
Peribleptos, Psamatia. Late fourth or early fifth century.
*Berlin, Staatliche Museen.*

It has already been suggested that the student, when considering the works of art
executed in or near the capital, should be prepared to meet a number of different
styles: the official monument, with its impulse from imperial patronage, and the
works of artists who appear to be outside the main stream, in someways *retardataire*,
or just incompetent. The well-known relief carved with the figure of Christ standing
between two Apostles (Fig. 34) from the Monastery of the Theotokos Peribleptos
in Psamatia, a district of the city, is in so ruinous a condition as to preclude pre-
cise stylistic analysis but it would seem to fall into the *retardataire* category.[34]
The columns and pediment which frame the figure of Christ seem to hark back to
the Asiatic sarcophagi typified by the Sidamara and Lydian examples dating from the
third century.[35] The soft ovals of the faces, on the other hand, the drapery of the
Apostles, particularly the one on the left, are related to the style of the base of
the obelisk and to the statue of Valentinian II. The approach to the ornament of the
architecture and the treatment of the folds are more sketchy, brittle, and drier than
any of the Theodosian carvings, as though a provincial artist were using as models
two types of monument—an earlier Sidamara example and Theodosian sculpture.

C

35. *An Evangelist*. Marble relief. Found at
Fatih. Late fourth or early fifth century.
*Istanbul, Archaeological Museum.*

The bust of an Apostle (Fig. 35) in the Archaeological Museum at Istanbul fits into a 'provincial' category with its coarse, emotional approach, rough and sketchy facture, and total lack of the severe elegance of the imperial style.[36] A relief, probably from a sarcophagus, with figures of saints or apostles in the same Museum (Fig. 36) is also a candidate for this secondary sequence: the figures flattened into

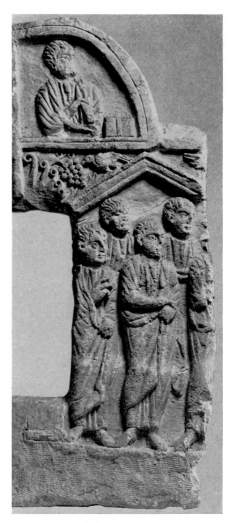

36. *Saints or Apostles.*
Marble relief, probably sixth century.
*Istanbul, Archaeological Museum.*

little more than two planes, the perfunctory treatment of drapery and of facial types which suggest parallels with the Stuma and Riha patens,[37] and the primitive carving of the bird pecking at a bunch of grapes in the spandrel—almost Coptic in its provincialism. Indeed, a relief with a representation of Christ enthroned and on his left an Apostle standing with a large cross (Fig. 37) from the Monastery of St. John of Studius, frequently assigned to the fifth century, would seem on general principles of stylistic development to be outside this secondary sequence of the fifth or sixth century, and although there is nothing comparable to be found in the capital, one is tempted to see it as a carving dating well into the seventh century. The figures of Christ and the Apostle have become mere cut-out figures applied to a ground, the drapery has become a series of parallel lines bearing little relation to the form they cover, the face of Christ is a diagram, the outsize acanthus leaves on the

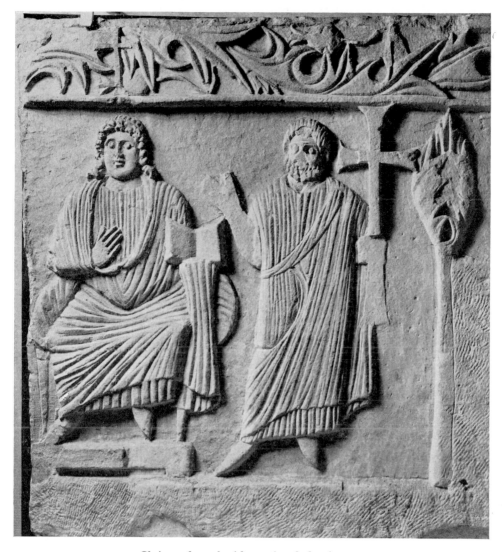

37. *Christ enthroned with an Apostle bearing a cross.*
Marble relief, seventh century. From the Monastery of St. John of Studius.
*Istanbul, Archaeological Museum.*

border above are dry, schematic, and treated in terms of geometric pattern rather than naturalistic representation. Such characteristics are difficult to reconcile with a fifth- or sixth-century ambiance.[38]

But the difficulty of dating even major works of art after the reign of Theodosius I is well illustrated by the colossal bronze statue of an emperor at Barletta (Fig. 38) which was brought from Constantinople after the sack in 1204, and which should be visualized without the ungainly restorations of arms and legs added in the fifteenth

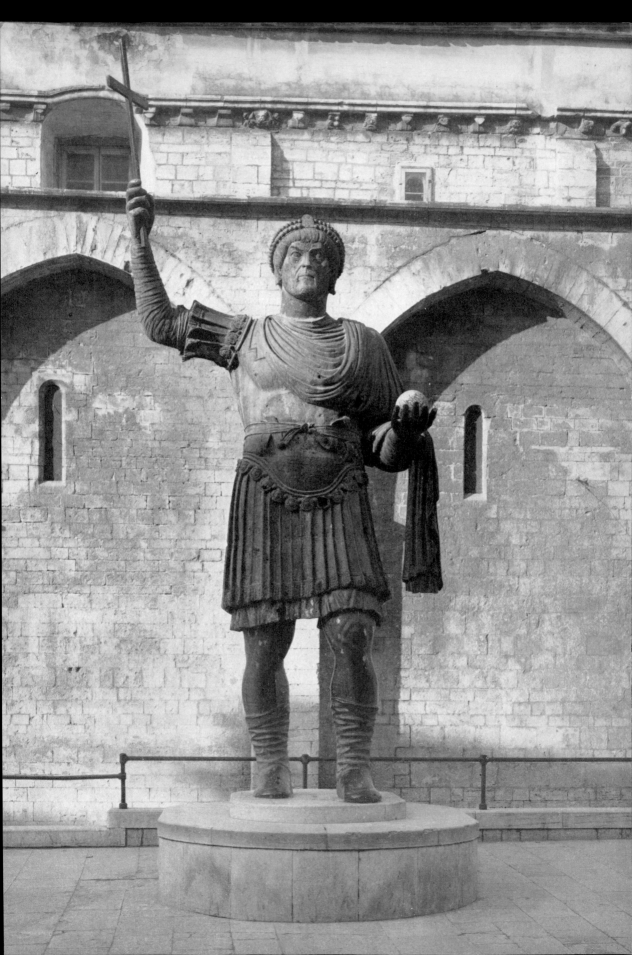

century. The statue has been identified as Valentinian I (364–375) and as Marcian (450–457) but so stylized a portrait fits ill into a period before the imperial portraits of the Theodosian house, nor does it have any close affinity with monuments which would appear to date about the middle of the fifth century. It is not surprising, therefore, that the Emperors Leo I (457–474), Anastasius I (491–518), Heraclius (610–641) and even an emperor 'in the Carolingian period' have been suggested.[39] The diadem, the hair-style, the staring eyes, the lines of the face from above the nostrils reaching down to the corners of the mouth have their origin in official portraiture of the Theodosian period, but the whole effect is more pinched and strained. The lines caused by the knitted brows, the parallel lines framing the long upper lip and the lower part of the mouth, the short beard emphasizing the heavy jowl, are all more exaggerated and stylized than any work of the Theodosian period, and yet hardly apply to Leo, Anastasius, and Heraclius in the latter part of his reign, since sizeable beards were affected by all three. The Emperor is shown as a triumphant general. Stylistically, a date in the second half of the sixth century or in the early seventh century seems more acceptable, and it is possible that the identification as Heraclius in the first two decades of his reign, when even before his great victory over the Persians in 627 he could already claim to be a triumphant general, is the correct one. Local tradition at Barletta has long held the colossus to be Heraclius, and its position outside the Church of the Holy Sepulchre, which contains a relic of the True Cross, is not without significance.[40]

Again, the mosaics of the Great Palace, when published in the First Preliminary Report, were assigned to the early part of the reign of Theodosius II (408–450) but

39. Detail from the mosaic of the Great Palace. 565–578. *Istanbul.*

38. *Heraclius.* Bronze. Constantinople, 610–629. *Barletta.*

40. Detail from the mosaic of the Great Palace. 565–578. *Istanbul.*

this did not meet with general acceptance.[41] A date in the reign of Marcian (450–457) was proposed later, but the archaeological evidence of the Second Report would seem to indicate that the mosaic floor was laid down after the constructions of Marcian. Since the well-documented reign of Justinian gives no evidence of the undertaking of such considerable work, a date in the reign of Justin II (565–578) must be taken into account.[42] The floor is of the utmost importance (Figs. 39 and 40); nothing comparable has yet been discovered in the city and it confirms the extraordinary continuity of the classical heritage into the advanced sixth century—a link in the chain of continuous Hellenistic impulses which makes the word 'renaissance' so inappropriate when reviewing the artistic history of the capital. Like the Sarigüzel sarcophagus the mosaics of the Great Palace, although they must have been covered over by the tenth century, 'explain' the characteristics of style under the Macedonian emperors. At a time when the subject matter of art would seem to be confined to the hieratic portrait of the Emperor and his officials or to the evocation of numinous being in the religious image, it is vital to our understanding of the period to be aware that in the palaces of the Emperor, and no doubt of the patricians as well, were mosaic decorations which included genre scenes of country life, the chase, the Hippodrome, and mythological fantasies in a style which, with its roundness of form, naturalistic representation, variety of posture, and vitality of expression, runs counter to the apparently prevailing styles.

That there was a kind of *renovatio* during the reign of Justinian there can be no

doubt; as though the victories of the barbarians in the West, and to a certain extent Justinian's counter-victories, had aroused a need for the reaffirmation of classical standards in the East. The reign of Justinian was one of the greatest periods of building in the history of medieval art. His patronage built the twin churches of St. Sergius and St. Bacchus, St. Peter and St. Paul (527–536), began in 536 the Church of the Holy Apostles (which was to be the burial place of the Byzantine emperors until the early eleventh century), rebuilt the Church of St. Irene after it had been burnt down in the Nika riots of 532, and with the miracle of the dome of the Great Church dedicated to Holy Wisdom (532–537) created one of the most sublime architectural achievements in the history of man.[43] His interest was not confined to churches or to his palace. One of the remarkable features of Constantinople are the number of underground cisterns, the two most striking being the Yerebatansaray (or the Basilica) and Binbirdirek (the Thousand and One Columns, the cistern of the Forty Martyrs). These were enlarged by Justinian, the latter in 528, and he built an aqueduct to supplement those of Hadrian and Valens and to bring water from the Forest of Belgrade.[44]

This is not the place to discuss the technical brilliance of Justinian's architects, Anthemius of Tralles and Isidore of Miletus, but it should be observed that under the close supervision of the Emperor a scheme of church decoration was evolved which differed widely from that current in the West. In the first place it was aniconic. There is no evidence to suggest that there were religious images in mosaic on the walls of Justinian's churches at Constantinople.[45] Decoration consisted of the contrasting effects of different marbles, porphyry and other stones used in a manner which was both detailed and broad-scale; mosaic effects consisted of large expanses of gold tesserae with areas of small geometric and floral ornament; carved decoration was largely confined to the capitals, of which the shapes were themselves an innovation, and to the intervening spaces between the arches which sprang from the capitals. This carved ornament was treated as a fretwork of stylized vegetable scrolls and devices based largely on the acanthus, which linked together the groups of columns and capitals, producing a superficial rather than an organic pattern of intricate light and shade running across and counter to the vertical thrust of the columns and the curve of the arches. Extensive use of the imperial monogram, occasional 'trees of life', and the superb inscription coursing round the walls of the Church of St. Sergius and St. Bacchus propose an atmosphere of religious decoration which was proto-Islamic. It would seem to stress the fact that there were already in the sixth century strong iconoclastic tendencies in the religion of the Eastern Empire.[46]

This incipient iconoclasm was not to conflict with the representation of the imperial or official image nor was it necessarily consistent in other works of art. One of the finest carvings of this period of *renovatio*, the leaf of an imperial diptych

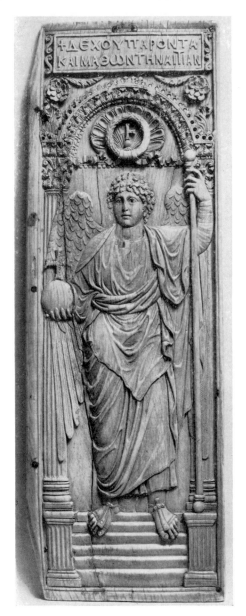

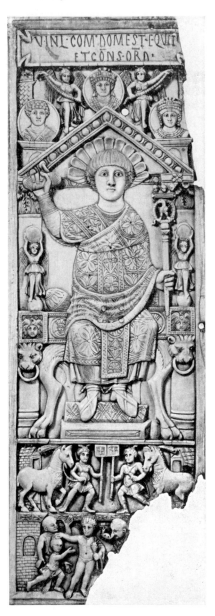

41. *St. Michael*. Leaf of an ivory diptych.
Constantinople, 519–527.
*London, British Museum.*

42. *Leaf of the Consular diptych of Flavius
Anastasius*. Constantinople, 517.
*London, Victoria and Albert Museum.*

with the figure of the Archangel Michael and a Greek inscription (Fig. 41) suggests with its grasp of the human form, the subtleties of drapery folds, and its detailed architectural frame, a new metropolitan impulse so different from the summary idealization of officialdom seen in not a few of the consular diptychs.[47] It has been

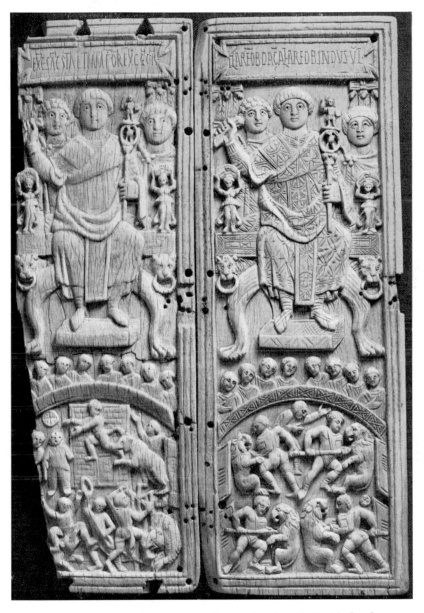

43. *Consular diptych of Areobindus.* Ivory. Constantinople, 506. *Zurich, Landesmuseum.*

proposed that the Archangel Michael was carved in the reign of Justin I (518–527) —a preamble to that of his nephew Justinian—to commemorate the reunion signed with Rome at Constantinople in the presence of the papal delegates in 519.[48] It may well be that the new artistic force was generated in the reign of Anastasius (491–518). On the other hand, among the general run of Anastasian diptychs the style suggests the end of the late antique period rather than the advent of something new.

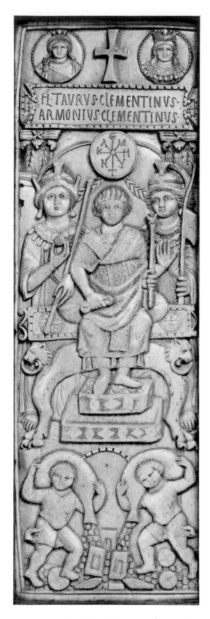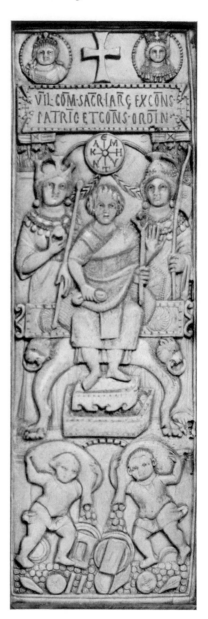

44. *Consular diptych of Clementinus*. Ivory. Constantinople, 513.
*Liverpool, Public Museum.*

The class of consular diptych typified by those of Areobindus (506), Clementinus (513) and Flavius Anastasius (517), issued at Constantinople (Figs. 42, 43 and 44), maintains the massive authority of the late antique tradition.[49] The central figure of the consul is depersonalized into a hieratic symbol of power surrounded by precisely seen and carefully modelled attendant figures; it sets the seal on a formula. A

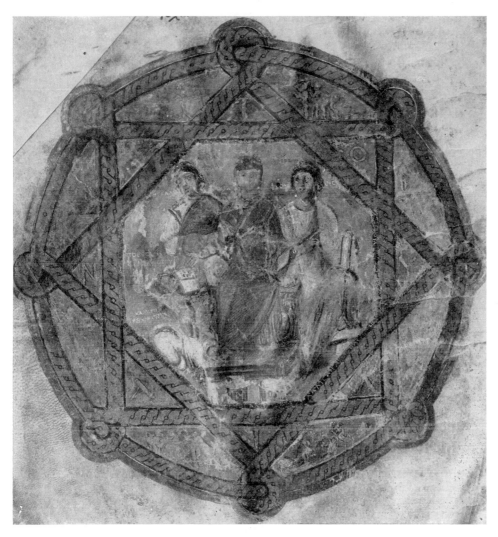

45. *Princess Juliana Anicia between Magnanimity and Prudence attended by Gratitude of the Arts and
Love of the Foundress of a Church at Honoratae, a suburb of Constantinople.*
From a copy of Dioscurides' *Materia Medica* executed at Constantinople about 512.
*Vienna, Österreichische Nationalbibliothek, Ms. Med. gr. 1, fol. 6v.*

similar approach may be seen on the base of the statue of the charioteer Porphyrius
(Fig. 32). The portrait of the Princess Juliana Anicia—she was the granddaughter
of the Emperor Valentinian III and the wife of Areobindus—in the copy of
Dioscurides' *Materia Medica*, executed at Constantinople in 512 (Fig. 45), is a
direct descendant of the Theodosian imperial style.[50] The ivory leaf with the
Archangel Michael, on the other hand, bears all the marks of a fresh work of art
conceived in a classicizing manner. Something of this may be said of one of the
finest of the consular diptychs, believed to have been issued by Magnus in 518

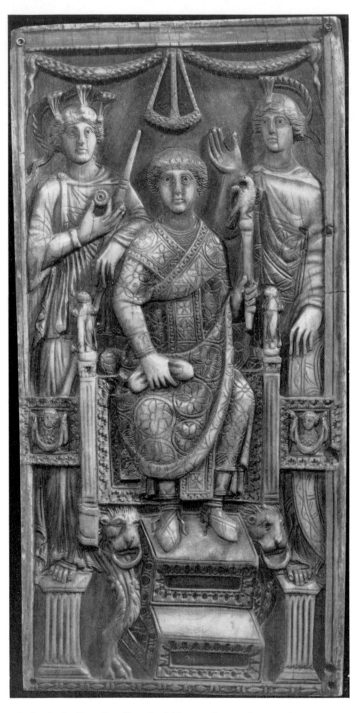

46. *Leaf of a Consular diptych of Magnus.* Ivory. Constantinople, 518.
*Paris, Cabinet des Médailles.*

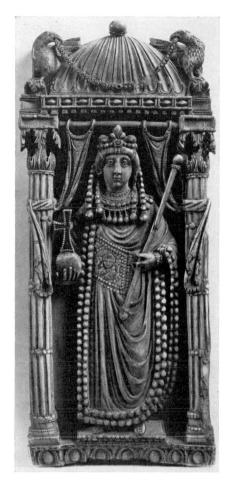 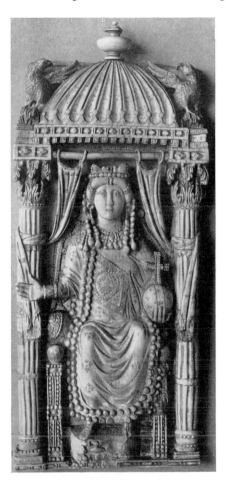

47-48. *The Empress Ariadne.* Panels of two imperial diptychs. Ivory. Constantinople, early sixth century. *Florence, Museo Nazionale,* and *Vienna, Kunsthistorisches Museum.*

(Fig. 46). Magnus was probably the great-nephew of the Emperor Anastasius; he appears to have been the son of Probus, consul in 502, and the grandson of Secundinus and the Emperor's sister Magna.[51] Like Juliana Anicia, he was closely connected with the court and his diptych represents Anastasian court art. The treatment of the drapery, particularly the fall of the drapery over the feet of the personifications of Rome and Constantinople, foreshadows the carving of the Archangel Michael, while the face of the Consul and his dress reflect the serene elegance of late antique metropolitan style. But the epitome of the old-fashioned metropolitan art is represented by the imperial image of the Empress Ariadne (d. 515) where the Augusta is revealed as a cult image (Fig. 47), loaded with jewels and regalia so out of proportion as to dwarf her humanity; she stands or sits (Fig. 48) beneath an ornate baldacchino, an epiphany of late antique imperial power.[52]

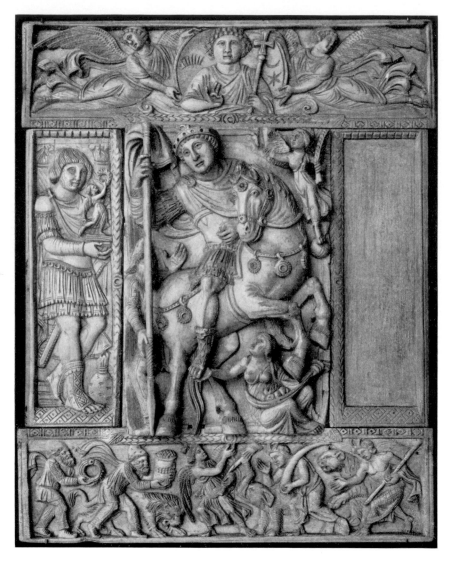

49. *Justinian.* Leaf of an imperial diptych. Ivory. Constantinople, 527.
*Paris, Musée du Louvre.*

Imperial power may, however, be represented with less stylization. The Barberini diptych in the Louvre (Fig. 49) would seem to be the outcome of new artistic impulses. The identity of the Emperor has been debated; ingenious arguments have been produced in favour of the Emperor Zeno (474–491), the first husband of the Empress Ariadne, but a number of scholars have preferred an identification with Justinian.[53] The style suggests a new departure, and at the same time a deliberate return to classical models. The smaller panels cannot be far removed in date from the fragments of an imperial diptych at Milan[54] dating from the reign of Anastasius

50. *Consular diptych of Justinian*. Ivory. Constantinople, 521. *Milan, Museo del Castello Sforzesco.*

and from Maximian's chair at Ravenna[55] (about the middle of the sixth century) but the extreme subtlety of the central panel counts. The heavily modelled figure of the Emperor, the curve of the prancing horse and the treatment of the animal's legs, the intricate posture of the allegorical figure in the bottom right-hand corner, the little victory in the top right, establish a technical mastery combined with precise perception of form. The detail and intricacy of the carving are in direct

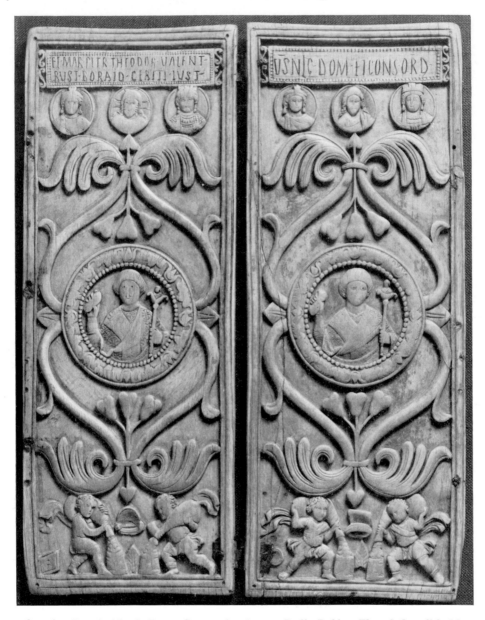

51. *Consular diptych of Justin.* Ivory. Constantinople, 540. *Berlin-Dahlem, Ehemals Staatliche Museen.*

contrast with late antique style, which tends to devaluate and simplify the form.

It is not without interest to note that even the consular diptych of Justinian (Fig. 50), issued at Constantinople in 521, stands apart from the main sequence of Anastasian diptychs: an austerely elegant, delicate, highly sophisticated work, not only in the carving of the four devices composed of lion's masks set in the rosettes but in the subtle hollowing of the central medallion and in the tilting of the *tabula*

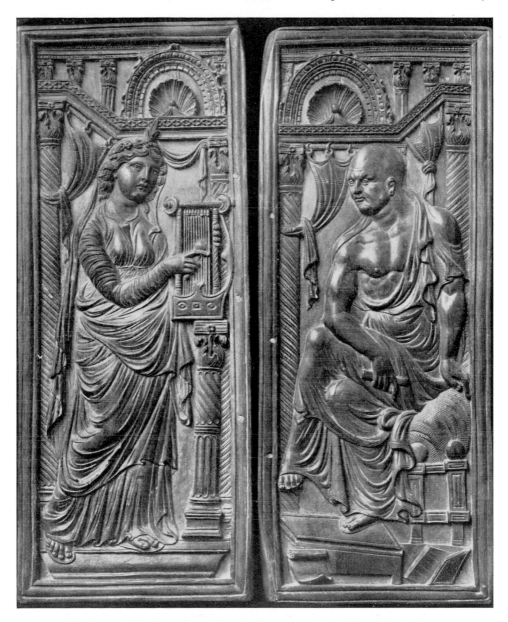

52. *The Poet and the Muse.* Ivory diptych. Constantinople, middle of the sixth century.
*Monza, Cathedral Treasury.*

*ansata.*[56] At the same time, the old-fashioned type of consular diptych continued in Justinian's reign and although the last ivory diptych to be issued, that of Justin in 540 (Fig. 51), reveals the bust of Christ between those of the Emperor and Empress —an innovation in the design of consular diptychs—stylistically it is as *retardataire* as any of the secondary sort issued under Anastasius.[57]

D

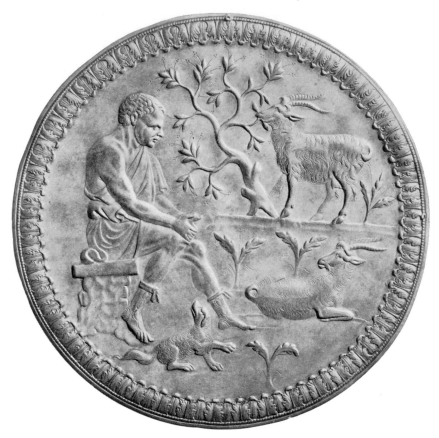

53. *A Goatherd*. Silver dish. Constantinople, 527–565. *Leningrad, Hermitage.*

The atmosphere of *renovatio* in the school of ivory carvers is, perhaps, exemplified by a diptych in the Cathedral Treasury at Monza, usually known as that of the Poet and Muse (Fig. 52), wherein before a complicated architectural structure seen in depth both figures are carved with a feeling of monumentality of form, intricacy of posture and drapery folds, and sensitive perception of layers of flesh and muscle.[58] But the classical *renovatio* is best documented by an astonishing sequence of works in silver.

So classical in spirit are the silver dishes of this time that for long they were assigned without question to the second and third centuries A.D. The dish with a representation of a goatherd (Fig. 53), found at Klimova in South Russia, is a surprising apparition after such a carving as the imperial leaves of Ariadne, but it bears on the back the control stamps of the Emperor Justinian. It has been shown conclusively that the stamps were punched on the silver before it was chased— frequently the chasing cuts into the stamps, of which some have been identified as those of the *Comes Largitionum Sacrarum*, the head of the Treasury, who seldom

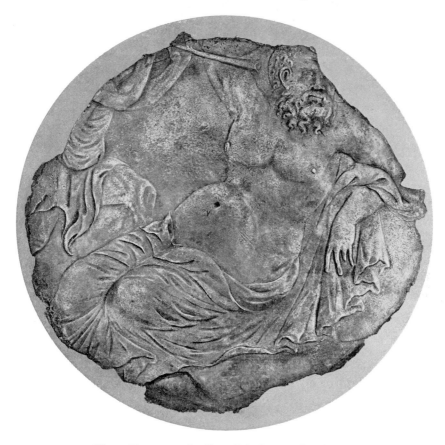

54. *Silenus.* Fragment of a silver dish. Constantinople, 527–565.
*Washington, D.C., The Dumbarton Oaks Collection.*

held office for more than one year.[59] There is, however, one element of uncertainty; it was possible for stamped undecorated silver to be exported and decorated later, and specimens are known, but it seems reasonable to suppose because of their style and in certain cases because of the iconography that the majority of the stamped dishes were decorated in the capital. The classical heritage could hardly be more gracefully maintained than by the pastoral scene on the dish from Klimova and yet it is possible to trace certain weaknesses. The figure of the goatherd is less masterfully controlled than that of the poet on the Monza diptych. The treatment of the left leg shows less grasp of the canon of form; the foot is weakly modelled and appears to be applied to the ground rather than resting upon it, and both feet and hands are out of proportion with the rest of the body. The drooping shoulder, the handling of the goat in the lower right-hand field and the twist of the dog have elements of pastiche. On the other hand, the silver fragment in the Dumbarton Oaks Collection with a representation of Silenus (Fig. 54) shows considerably more

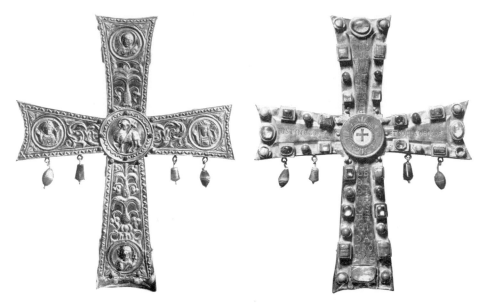

55.  *The Cross of Justin II.*  Silver-gilt. Constantinople, 565–578.
*Vatican, Treasury of St. Peter's.*

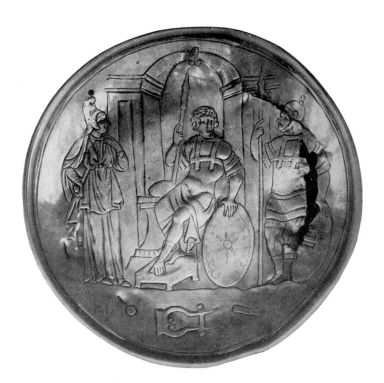

56.  *Aphrodite in the Tent of Anchises.* Silver dish. Constantinople, 527–565.
*Leningrad, Hermitage.*

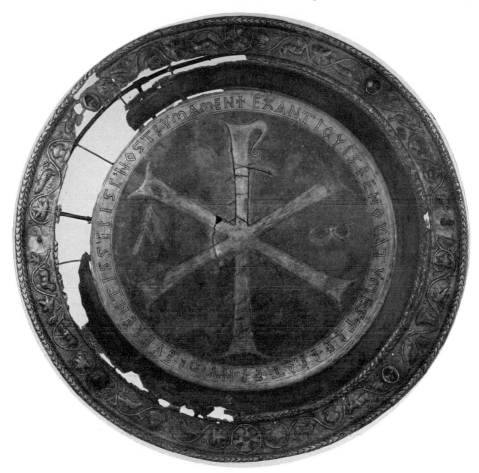

57. *Dish of Paternus, Bishop of Tomi* (about 517–520). Silver and silver-gilt.
Constantinople, about 518 but with later additions probably executed at Tomi.
*Leningrad, Hermitage.*

mastery. The modelling of the chest and stomach, the treatment of the hair and drapery leave little to be desired in the assimilation and representation of form, and only the weakness of the left hand betrays the concern with something that has gone before.[60]

Securely dated carvings in ivory end with the consular diptych of Justin in the year 540 but the silver ranges from the reign of Anastasius to that of Heraclius (610–641). Anastasian silver such as the ladle from Perm and Paternus' dish (Fig. 57), both in Leningrad, tend to confirm the stylistic evidence offered by the Anastasian diptychs.[61] Both media show that the late antique style ends here, but it is also confirmed that there were still various currents of style at Constantinople from the time of Justinian, discernible in the earlier monumental sculpture. Thus the goatherd dish, which seems the result of a classical *renovatio*, contrasts with a

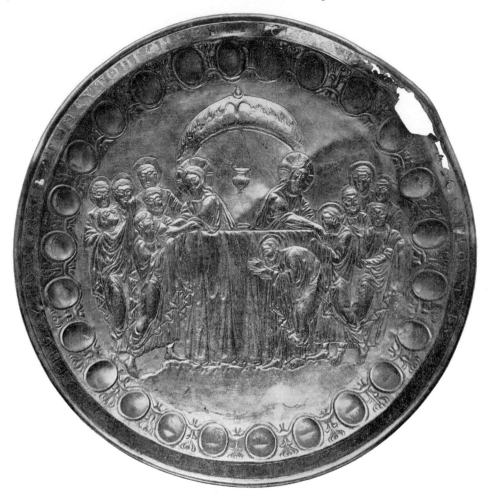

58. *The Stuma Paten*. Silver and silver-gilt. Constantinople, 565–578.
*Istanbul, Archaeological Museum.*

dish decorated with a scene showing Aphrodite in the tent of Anchises (Fig. 56) in
which a much freer, and more simplified Hellenistic style may be observed.[62] After
the reign of Justinian, the small silver-gilt cross presented by Justin II (565–578) to
Rome (Fig. 55), the Stuma and Riha patens (Figs. 58 and 59), each with control
stamps of the same Emperor Justin, give evidence of a third style, or series of styles,
present at Constantinople.[63] The hunched stiff figures on the cross, the emphasis on
pattern and line, the stylized faces and draperies which no longer convincingly
mould the form suggest that, when it came to representing a religious subject, a
convention of artistic approach was required which was different from the steady
flow of Hellenistic reproduction. The Stuma and Riha patens differ from each other
in style; they have frequently been assigned to a Syrian workshop and it has been

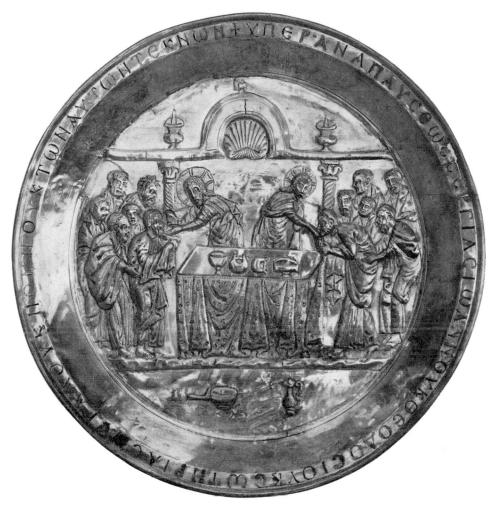

59. *The Riha Paten*. Silver and silver-gilt. Constantinople, 565–578.
*Washington, D.C., The Dumbarton Oaks Collection.*

pointed out that the inscriptions reflect very closely one of the prayers in the Dismissal in the Liturgy of the Syrian Jacobites.[64] It is possible that the silver stamped at Constantinople was exported and decorated in the provinces. However, the principles of this religious style—and it was to be current throughout the Empire from Salonika to Mt. Sinai—were an avoidance of any sense of weight and volume or any suggestion of a third dimension. In the attempt to evoke a religious image and at the same time to counter possible accusations of idolatry, it was felt that contemplation was helped by a vision of a numinous being which was at the other end of the scale from material notation. Absolute Reality was substituted for the human image, and the forms used to represent God, the Virgin, and the Saints were

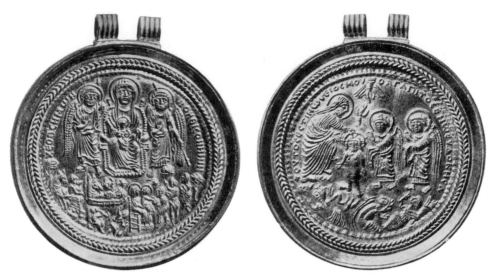

60. *The Epiphany*. Reverse: *The Baptism of Christ*. Gold medallion. Constantinople, late sixth century. *Washington, D.C., The Dumbarton Oaks Collection.*

thought of as a statement of intellectual perception rather than an historical record in pictorial or sculptural form.[65]

These principles may be observed on a gold medallion with representations of the Epiphany and the Baptism of Christ (Fig. 60), found in Cyprus with among other things a belt made up from gold coins of Theodosius II, Justin I, Justinian, Maurice Tiberius (582–602) and four gold consular medallions of Maurice Tiberius (Fig. 61); there was also a fragment of a clasp with a coin of Justin II and Tiberius II (578). At this time gold coins seem to have been struck only at Constantinople,

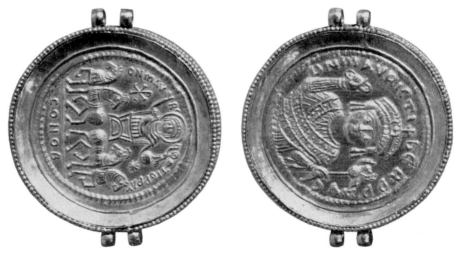

61. *Gold consular medallion of the Emperor Maurice Tiberius.* Constantinople, 582–602. Found in Cyprus. *New York, The Metropolitan Museum of Art.*

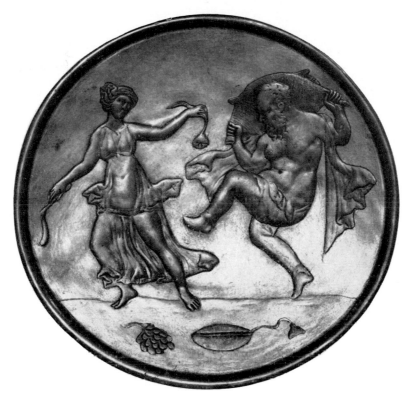

62. *Silenus and a dancing Maenad.* Silver and silver-gilt. Constantinople, 610–629.
*Leningrad, Hermitage.*

Ravenna, and possibly Carthage. After a treaty made with the Persians in 562, the East Romans had a monopoly of gold coinage, and there seems no reason to doubt that all the medallions found in Cyprus were struck at Constantinople.[66] The medallion with the Epiphany and the Baptism presumably dates from the late sixth century and it is interesting to compare the treatment of the drapery in close parallel lines and the emptying out of corporeal form with the fragment of a relief with Christ and an Apostle from the Monastery of St. John of Studius (Fig. 37), although the latter would seem to be even further gone into abstraction.

The formulation of this new 'religious' style did not interrupt the others. Standards of secular silver were maintained until well into the seventh century. The silver dish with a dancing Maenad and a satyr or Silenus with a wineskin (Fig. 62), bearing the control stamps of the early part of the reign of Heraclius— 610–629—is perhaps less brilliant in execution than the Dumbarton Oaks Silenus (Fig. 54), but the freedom of handling, the grasp of form and movement, and the delicacy of touch reveal the care with which these standards were maintained. There was, nevertheless, a considerable variation in quality. The coarseness of the casserole

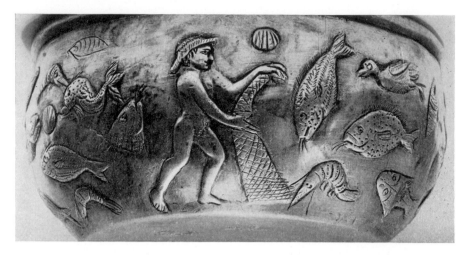

63. *Fishing scenes.* Silver casserole. Constantinople, 610–629. *Leningrad, Hermitage.*

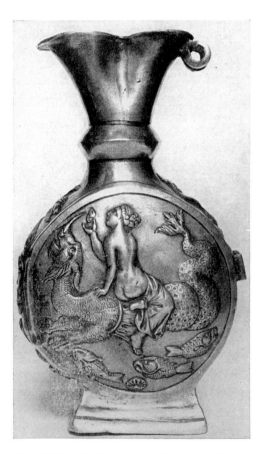

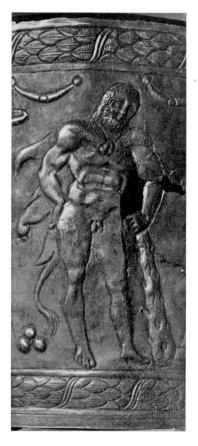

64. *A Nereid with a monster.* Silver vase. Constantinople, 610–629. *Leningrad, Hermitage.*

65. *Herakles.* Detail from a silver bucket. Constantinople, 610–629. *Vienna, Kunsthistorisches Museum.*

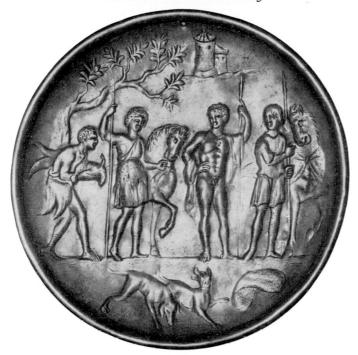

66. *Atalanta and Meleager*. Silver dish. Constantinople, 610–629.
*Leningrad, Hermitage.*

with fishing scenes (Fig. 63), and the clumsiness of the vase with a Nereid on a monster (Fig. 64), contrast with the lighter touch visible on a silver bucket decorated with a series of gods and goddesses (Fig. 65)—Aphrodite, Ares, Herakles and others —and the serene grace of a silver dish showing Atalanta and Meleager setting out on a hunting expedition (Fig. 66). In all these, the forms are beginning to lose weight, the heaviness of modelling still possible in the time of Justinian; they stand less certainly within their setting but they retain the firmness of outline and an understanding of the structure of the human body which was rapidly being forgotten in the West and was to be deliberately ignored by artists under the rule of Islam.[67]

They contrast, too, with the superb quality of the silver dishes found in Cyprus with scenes from the life of David. Apart from the existence of such quality dated to the reign of Heraclius, the series is important because the subjects depicted precede those of any of the surviving illuminated Psalters and the style not only illustrates a stage in the absorption of classical elements in the Christian tradition but proposes a contrast with the incipient 'religious' style. The cross of Justin II, the Stuma and Riha patens, presented, about 570, a stylistic approach which seemed to cut across the main Constantinopolitan trends. There is no reason to believe that the Stuma and Riha patens are 'court art', although the Cross of Justin II presumably is a product of the court workshops. But the Cyprus dishes, whether they depict scenes

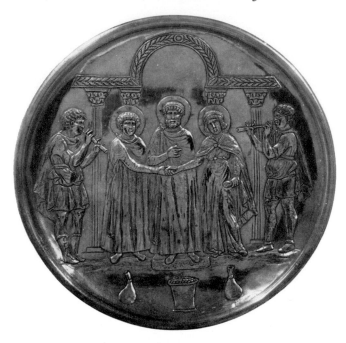

67. *The Marriage of David*. Silver dish. Constantinople, 610–629.
*Nicosia, Museum of Antiquities*.

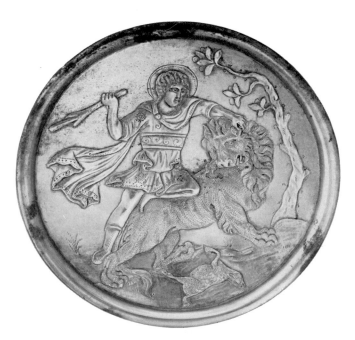

68. *David slaying the Lion*. Silver dish. Constantinople, 610–629
*New York, The Metropolitan Museum of Art*.

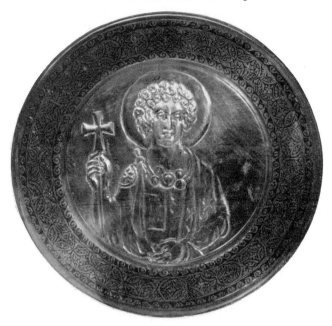

69. *St. Sergius or St. Bacchus.* Silver bowl. Constantinople, 641–651.
*London, British Museum.*

from the life of David or a representation of a Saint (Fig. 69), are essentially 'court art' and should be seen as products of a deliberate attempt to emulate the standards and ideals of the early days of the Empire. The scene showing the Marriage of David (Fig. 67) presents, before an architectural screen reminiscent of that on the great silver dish of Theodosius at Madrid (Fig. 16), a group of figures which contrast with the mythological dishes by their heavily modelled forms, by the deeply chased and crumpled drapery which at the same time falls into soft folds, and by the precise but smooth details of physiognomy. On the dish showing David slaying the Lion (Fig. 68) the treatment of the mane, the posture of David, presumably taken over at some remove from that of Mithras, the presentation of the scene within the entire circumference of the dish—not divided into zones like the Missorium of Theodosius—would seem to return to models in the full antique tradition. It is important to note, therefore, that the models for the Heraclian renewal were only in part Theodosian. While the mythological dishes represent one aspect of a living Hellenistic tradition and the Cross of Justin II represents an aspect of a 'new' style, the artistic impulses of the court style under renewed imperial pressure sprang not only from Theodosian art but coursed over the art of Augustus and the Antonines.[68]

WHEN assessing the approach of Constantinople towards religious art before the outbreak of the Iconoclast Controversy, the student is handicapped by an almost total lack of visual evidence. We have seen in the monumental sculptures a development from Theodosian classicism, typified by the Sariguzel sarcophagus, to advanced stylization of form in the panel with a representation of Christ and an Apostle from the Monastery of St. John of Studius. It would seem that by the time of Justin II a deliberate attempt was being made to create a separate style suitable for the presentation of the religious image. In the Cross of Justin II and the Stuma and Riha patens the image is no longer seen in the late antique convention—there is a movement away from the simplified naturalism of the late fourth and fifth centuries in a direction of the disembodied icon. This movement had already been given impetus by the stylization of the imperial image into something approaching a secular icon. The emphasis on the close link between the Empire and Christianity, made from the beginning by Constantine the Great, is given increased force by the representation of the Emperor as subordinate to Christ. On the Barberini diptych (Fig. 49) the bust of Christ appears above the figure of the triumphant Emperor; on the consular diptych of Justin (Fig. 51) Christ appears for the first time between the busts of the Emperor and the Empress. When Justin II substituted the personification of Constantinople on his coins for the Cross and Victory the people complained, and a convenient vision came to Tiberius II (578–582) to the effect that the Cross should be reinstated. Tiberius II was the first emperor to renounce the representation of his own enthroned image on his coins, and it was he, probably, who first set an image of Christ enthroned in the apse of the Chrysotriclinos above the imperial throne. In the first reign of Justinian II (685–695) the image of Christ appeared for the first time on the Byzantine coin (Fig. 70). Christ was proclaimed

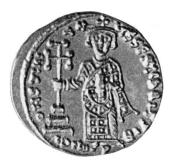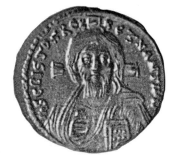

70. *Justinian II.* Obverse: *Christ, King of Kings.*
Gold coin struck at Constantinople, 685–695. *London, British Museum.*

*Rex Regnantium*; the Emperor, standing, was designated *Servus Christi*. Thus the Emperor made it known to the world that he was subject to the King of Kings.[1]

At the same time, even after the first two centuries of the Christian era there had always been the seeds of opposition to images. When the Empress Constantia, step-sister of Constantine I and wife of the Emperor Licinius, asked Eusebius of Caesarea for an image of Christ, she was sharply snubbed. From the fourth century onwards there had always been a minority among the intellectuals and the upper classes who disapproved of the cult of icons and the superstitious practices so often attached to them. Moreover, in the Byzantine Empire near the eastern frontiers strong iconoclastic tendencies had been fairly constant. There is no period between the fourth and the eighth centuries in which there is not some evidence of opposition to images within the Church. The East Romans constantly maintained that Divinity, because it is outside the compass of the human senses, should not be the subject of artistic expression. The decoration of Agia Sophia was from the beginning aniconic, although after the collapse of the dome in 558 and the subsequent rebuilding of the chancel area, the altar screen was decorated with silver reliefs bearing the figures of Christ, the Virgin, angels, prophets and saints. While the reigns of Justin II and Tiberius II are thought to have produced a reaction to the lack of pictorial ornament in Constantinopolitan churches, there is no real evidence for any comprehensive iconographic scheme. It is probable that *ex-voto* panels were present on the walls of churches as in the Church of St. Demetrius at Salonika—a city with strong local traditions of mosaic decoration. At least part of the mosaic decoration of the Church of the Dormition at Nicea was pre-iconoclast but how much survived the hands of the Iconoclasts has long been a matter of controversy, and there is certainly not enough to establish a plausible theory of the extent to which the churches were decorated in the capital and with what subjects.[2]

It seems clear that the late sixth and seventh centuries were the period when the isolated panel and the portable icon became necessary to popular devotion. The official use of images as protectors of armies and cities was, of course, an ancient pagan practice, and the belief in and the exploitation of the magic properties of particular images was common enough in the Hellenistic and Roman world, but with Christianity the belief in images of miraculous origin was added to the popular beliefs so deeply rooted in the pagan past. An image claimed to have been produced by touching the face of Christ with a linen cloth, images 'not made by human hands', were not only closely linked with the cult of relics such as the True Cross but were a useful answer to charges of idolatry and the worship of images made by man. In addition, there was a widespread belief that divine forces were present in the religious image, a relic of paganism which became so hallowed that it was possible to imply that the image was more than a reminder of God or the Virgin or the Saints, it was an extension of their personalities. As long as these images were

confined to the church or to official places of honour, this highly complex tissue of theological speculation and popular superstition could be vested with some kind of orthodox sanction, but once they were admitted to the private house the use and abuse of icons was beyond control. There can be no doubt that the abuses were a principal factor underlying the fury of persecution, and the portable icons were quickly restored or brought out of their hiding place, when the fury abated. The backbone of the defence of the icons lay in the monasteries, whose wealth partly depended on the attraction of pilgrims, and among certain elements of the people, particularly the women. The first attempt on the part of some men connected with the court to destroy in 726 an especially popular icon, that of Christ above the Chalke Gate—the main entrance to the imperial palace—led to a murderous on-slaught of enraged women headed by one who was afterwards martyred in the Hippodrome and later canonized as St. Theodosia.[3]

On a higher level the resistance to icons was based on a renewed adherence to the Old Testament law on the worship of images and on theological arguments about the divine nature of Christ and the consequent impossibility of representing his likeness. On the coins of Justinian II there had been two entirely different types of Christ, one full-bearded and long-haired, the other slightly bearded and with short curly hair. From the imperial point of view the outbreak of iconoclasm was a reassertion of imperial power and its authority over the Church. The Cross and the accompanying inscription which replaced the icon of Christ over the Chalke Gate affirmed imperial policy. 'The Emperor cannot endure,' the inscription read, 'that Christ should be represented as a mute and lifeless image graven on earthly materials. But Leo and his young son Constantine have at their gates engraved the thrice-blessed representation of the Cross, the glory of believing monarchs.' The first iconoclast edict was issued by Leo III in 730 but the movement reached its highest point under his successor, Constantine V (741–775). He required the army to take an oath that they would not worship images, hold communion with the monks, or even greet them. It was an oath easy to exact since the army, for the most part levied from the eastern provinces, was a stronghold of iconoclasm; the navy, on the other hand, manned by sailors drawn from the Greek coasts, was largely iconodule. The edicts were accompanied by a savage persecution of the monasteries; iconodule clergy were forced to leave the country, lost their property, and were frequently martyred; many went to Rome. The movement collapsed under the influence of the Empress Irene the Athenian but there was a new outbreak in 815, and orthodoxy was not restored until the Council of 843 inaugurated by the Empress Theodora. The influence of the women of the imperial house is an important factor in the controversy; even before the death of the last iconoclast emperor, Theophilus, Theodora and her daughters prayed before icons in their apartments in the palace.[4]

It is not clear how far the iconoclast edicts were enforced throughout the

71. *An Iconoclast Cross in mosaic* in a room over the south-west ramp in the Church of Agia Sophia; middle of the eighth century. *Istanbul.*

Empire, but at least at Constantinople under the eyes of the Isaurian emperors the destruction of images was systematic. In 768 Nicetas, the patriarch under Constantine V, is said to have destroyed 'the images of gold mosaic and wax encaustic' in all the churches of Constantinople, and Theophanes Continuatus states that 'throughout every church the figures of saints were destroyed, and the forms of beasts and birds were painted in their places'.[5] Although one monastery, St. John of Studius, defied the Emperor with impunity after the reinstatement of the monks in 786, it is a matter of interest that no mosaic, except for a representation of a large cross in the Church of St. Irene and some crosses let into mosaic in a room over the south-west ramp in Agia Sophia (Fig. 71), no silver nor ivory carving with figure subjects may be assigned to the capital in the eighth and early ninth centuries.[6] And

E

72. *A Charioteer*. Silk compound twill. Constantinople, late eighth century.
*Paris, Musée de Cluny*.

yet there was no objection to representations of imperial triumphs. We know that Pope Gregory II reproached the Emperor Leo III for having stripped the churches of their decoration and for replacing it with pictures of vain and foolish fables and with musicians playing the harp, the sistrum and the flute; we know that Constantine V destroyed the images of the oecumenical councils represented on the walls and ceiling of the Milion and substituted a picture of his favourite charioteer; we know that considerable building enterprises, some based on Abbasid models at Baghdad, and redecoration of parts of the Great Palace were undertaken by the Emperor Theophilus (829–842).[7] Nothing has survived. To arrive at an estimate of the probable type of decoration in iconoclast churches and palaces, one must turn to Umayyad monuments in Syria and Palestine—the mosaics in the Dome of the Rock at Jerusalem and in the Great Mosque at Damascus, the paintings and stuccoes of Kasr al-'Amra, Kasr al-Hair, Khirbat al-Mafjar, and to the sculpture of Mshatta.[8]

It is possible that one or two textiles preserved in the West, all with secular subjects, may be assigned to Constantinople in the iconoclast period. The Charioteer silk (Fig. 72), shared between Aachen and the Musée de Cluny in Paris, often dated to the sixth century, was more probably made in the late eighth century. There is a tradition that the silk came from the tomb of Charlemagne (d. 814), and if this is correct, there seems no reason to suppose that the Western Emperor should be

73. *Emperors hunting.*
Silk compound twill. Constantinople, middle of the eighth century.
*Lyon, Musée Historique des Tissus.*

buried with a silk nearly two hundred years old at the time of his death.[9] A *quadriga* silk with the figure of an emperor, in the Victoria and Albert Museum, would also seem to date from about this time or into the ninth century.[10] The great imperial silk from Mozac (Fig. 73), now at Lyon, is traditionally supposed to have enfolded a relic presented by Pepin the Short; the silk was a gift to Pepin from the Emperor Constantine V in the middle of the eighth century.[11] Byzantine silks which may be attributed with any certainty to the capital all show a combination of Persian and 'Hellenistic' motives. The horses, for example, represented in the Mozac silk are in the full classical tradition but the fluttering ribbons attached to the tail are adapted

74. *Helios.* From a copy of Ptolemy's astronomical writings. Constantinople, 813–820.
*Vatican, cod. gr. 1291, fol. 9r.*

from Sasanid royal caparison.[12] Similarly, the Aachen-Cluny *quadriga* silk combines an early Byzantine figure subject with ibexes copied from Persian models.

Only one manuscript has survived from the iconoclast period, the Vatican Ptolemy (Ms. gr. 1291), which may be dated between 813 and 820 (Fig. 74). This scientific treatise is an obvious copy from a late antique model, and although an important survival, by its nature offers little evidence of the state of the arts in Constantinople apart from showing that in a particular sphere the classical heritage was maintained.[13]

Once again, as in the early days of the new capital, the coins are the principal survival. Their interest is predominantly iconographic. The coins of the emperors immediately preceding the Isaurian dynasty, those of Philippicus Bardanes (711–713), Anastasius II Artemius (713–716), and Theodosius III (716–717), had already shown a substitution of a cross on steps for the two types of Christ introduced by

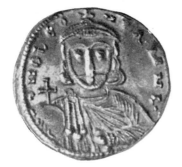

75. *Leo III*. Reverse: *Constantine V*. Gold coin struck at Constantinople, 720–741.
*London, British Museum.*

Justinian II. The iconoclast emperors raised no objection to the representation of
the Cross. This type of coin, therefore, was maintained throughout the iconoclast
period but Leo III also issued variants which substituted for the cross busts of his
son Constantine V (Fig. 75) and his grandson Leo IV, 'the Khazar'. The coins of the
iconodule Artavasdes, son-in-law of Leo III and rival of Constantine V, issued
probably between 742 and 744, made no attempt to return to a religious image other
than the cross combined on the reverse with an inscription referring to the usurper
and his son Nicephorus. This last formula was continued by Leo IV (775–780) and
by Constantine VI (780–797), who also returned to portraits of himself and of his
mother the Empress Irene. Moreover, he introduced a double portrait of himself
and the Empress Irene with three ancestors on the reverse. The Empress deposed
and blinded her son in 797 and during her term of autocracy (797–802) she intro-
duced a coin with her image on both sides. Although she reversed the policy of the
iconoclast emperors, and the Seventh Oecumenical Council at Nicea had pro-
claimed in 787 that religious images in stone and other materials were lawful, the
Empress made no attempt to introduce the bust of Christ on her coins. Theophilus
(829–842), last of the iconoclast emperors, was to issue another variant which added
the images of his wife and daughters to that of his own. Thus it may be seen that the
coins of the iconoclast period reflect more the dynastic and autocratic policy of the
emperors and their rivals than the expression of religious controversy. Stylistically
the coins of Leo III and Constantine V tend to be of higher quality than those
issued towards the end of the iconoclast period.[14]

Although orthodoxy was finally restored in 843 by the Empress Theodora, widow
of Theophilus, iconoclasm remained a live issue at least until 870. Apparently, since
the commemorative epigram was composed by the Patriarch Methodius (843–847),
and symbolically, one of the first images to be reinstated was that of Christ over the
Chalke Gate. But an extensive programme of religious decoration was not imple-
mented until the sixties. In the Great Palace the Chrysotriclinos was decorated
between 856 and 867, after the banishment of Theodora, since she is not mentioned

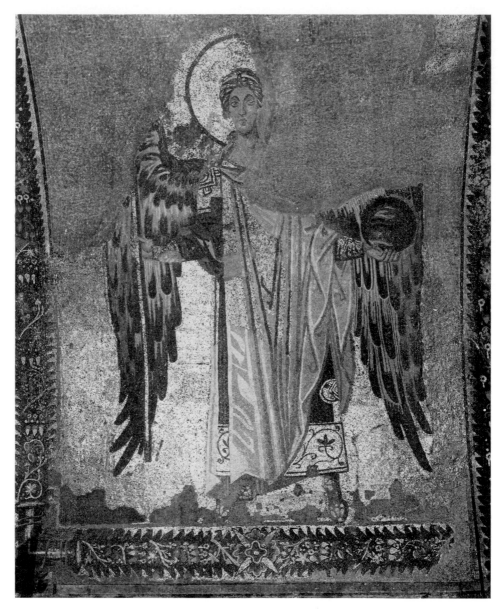

76. *The Archangel Gabriel.* Fragments of a mosaic on the south side of the apse in Agia Sophia.
Probably late ninth century. *Istanbul.*

in the commemorative epigrams, and another hall also before 867. New work in the
Church of the Theotokos of the Pharos was completed by 864. Mosaics in Agia
Sophia were not begun until 867 and were probably not completed until the end of
the century; small fragments of the Archangel Michael on the north side of the apse
(Fig. 76), the major part of the archangel Gabriel on the south side, the beginning

and end of a commemorative inscription referring to the Emperors Michael III and Basil I, and a rich floral border are probably all that survives of these post-iconoclast undertakings. The mosaic representation of the Virgin and Child enthroned in the apse of Agia Sophia, almost unanimously assigned to the ninth century, should be regarded as largely a fourteenth-century restoration (Fig. 196). It is recorded that the Patriarch John Xiphilinus (1064–1075) restored 'all the pictures of the saints' that were in the church but in 1346 a serious earthquake caused the fall of the great eastern arch and one-third of the dome. It is not yet known whether the damage extended to the conch of the apse. It is possible that the face of the Virgin is of a date approaching that of the Archangel Gabriel but a comparison of the drapery of the Virgin and that of the Child, of the treatment of the hands, with work done at St. Saviour in Chora suggests that after the calamity of 1346 extensive restoration had to be done. The Church of St. Sergius and St. Bacchus was redecorated at the instigation of the Patriarch Ignatius between 867 and 877. The Church of the Holy Apostles may have received a new set of mosaics in connection with the consolidation of the building undertaken by the Emperor Basil I (867–886), and it is with his reign and those of his successors that the great glories of medieval Byzantine art unfold.[15]

THE new religious art still received its chief impulse from the imperial court. The Empresses Irene and Theodora, not the Patriarch, had summoned the Councils of the Church which reversed the iconoclast decrees; the Emperors Michael III and Basil I sponsored the new building plans and schemes of decoration; a sermon of Leo VI on the Annunciation delivered early in his reign is reflected in the mosaic above the imperial doorway of Agia Sophia (Fig. 77). There is a new emphasis on the orthodoxy and the piety of the Emperor. Above the entrance of the greatest church in the Empire, that of Holy Wisdom, Leo VI makes *proskynesis* before Christ enthroned and receives the blessing of wisdom from Christ Who is Holy Wisdom. Justinian II admitted that he was the Servant of Christ but his figure remained standing; the Emperor Leo the Wise is prostrate before the King of Kings. Where before the Christian element in the imperial iconography had been limited to the cross, the sacred monogram, and the *labarum*, from this time onwards the figures of Christ, the Virgin and the Saints are present. The imperial *mystique* was not diminished by this humility before God. The Emperor was the intermediary between God and the Empire, and his position demanded always a sense of that which was fitting and that which was just, beyond the scope of ordinary men. The imperial secretaries, the palace eunuchs, the army, the fleet, the remarkable civil service, and not least the Church, all ministered to this imperial concept. Even an emperor who was not born in the Purple Chamber, once raised on the shield, realized that he was dedicated to an almost supernatural life with duties and responsibilities heavier for the sense of purpose that governed them. A soldier of humble origins like Basil I, an admiral like Romanus Lecapenus, generals like Nicephorus Phocas and John Tzimisces, even Michael IV, the minion of an aged and eccentric empress, were conscious of their supreme destiny. Through all the vicissitudes of the medieval Empire the proud words of the Empress Theodora at the time of the Nika riots in 532 must have sounded in more than one imperial ear: purple makes a fine shroud.

Side by side with the new orientation of the imperial image the development of medieval religious art at Constantinople was to become inseparable from a set programme and rigid iconographic and aesthetic rules supervised by the ecclesiastical authorities and enforced by imperial patronage. The Council of 787 had decreed that strict control should be exercised over the subject and form of religious art. Unsuitable iconographic and artistic traditions were severely censored; by a process of selective restriction and standardization the main iconographic themes were given their final shape. It would be a mistake, however, to regard medieval

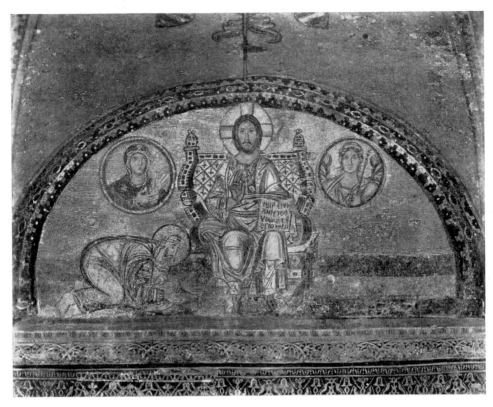

77. *Leo VI making proskynesis before Christ.* Mosaic in the lunette over the imperial doorway in Agia Sophia. Late ninth century. *Istanbul.*

Byzantine art as a mere repetition of traditional schemes. The tendencies, already noticeable before the Iconoclast Controversy, towards a religious art which avoided the appearance of weight, volume, or the third dimension, which excised the inessential and accidental, which evoked an image of the Absolute, merely became fact. Art was to reflect the Intelligible Being; it was not to record the vagaries of humanity.[1] As a result, the production of works of art under the Macedonian dynasty from the late ninth century onwards bears all the marks of a *renovatio* on the one hand, and at the same time presents aspects of a new style which, though based on the apprehension of late antique and early Byzantine art, is the expression of an entirely new will to form.

The *renovatio* may be seen in two ways: a return to the works of art immediately preceding the Controversy, and a deliberate and enthusiastic cult for the works of antiquity on every level. The first trend appears in the mosaic over the imperial doorway of Agia Sophia (Fig. 77). The heavily bearded, long-haired head of Christ harks back to the representation on the coins of Justinian II; the busts of the Virgin and the Archangel Gabriel, broad-featured, looming out of the medallions, would

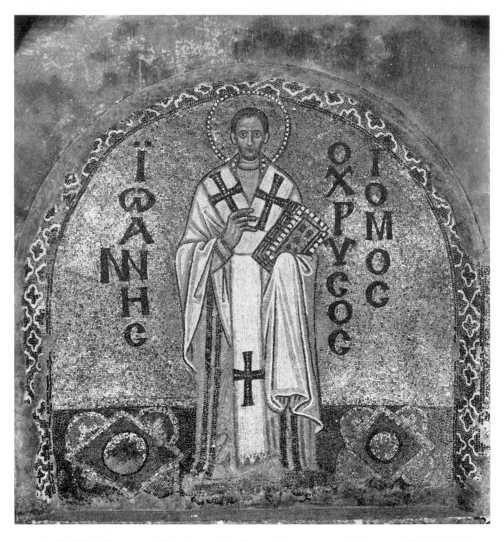

78. *St. John Chrysostom.* Mosaic panel in the north tympanum of the nave of Agia Sophia. First half of the tenth century. *Istanbul.*

seem to be based on a pre-iconoclast icon. This broad, heavy style may also be seen in the representations of the Church Fathers in the north tympanum of the nave of Agia Sophia (Fig. 78) dating from the first half of the tenth century and the remains of mosaic decoration in a large vaulted chamber immediately above the south-west vestibule.[2] In this chamber is revealed the first evidence of a detailed iconographic programme which included probably the Deesis, the Apostles, St. Stephen the first Christian martyr, St. Constantine the first Christian emperor, and the four iconodule Patriarchs, Germanus (715–729), Nicephorus (806–815), Tarasius (784–806) and Methodius (843–847). The same principles of style may be observed in the

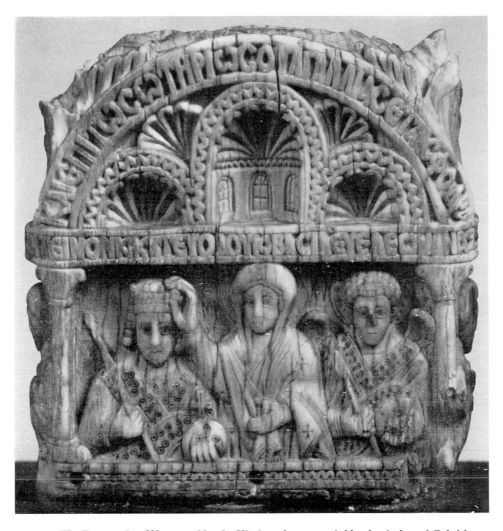

79. *The Emperor Leo VI crowned by the Virgin and accompanied by the Archangel Gabriel.*
Fragment of an ivory sceptre. Constantinople, 886–912.
*Berlin-Dahlem, Ehemals Staatliche Museen.*

fragment of an ivory sceptre with an inscription referring to the Emperor Leo (Fig. 79) where the hunched, thick-set, intensely gazing figures look back to the pre-iconoclast icon rather than forward to the essentially middle-Byzantine style of the *ex-voto* relief bearing the Epiphany of Constantine VII Porphyrogenitus (Fig. 80), issued about 945, when the Emperor was at last Autocrator.[3]

On the other hand, one of the earliest manuscripts executed for a Macedonian emperor, the Homilies of St. Gregory Nazianzen (Paris, Bibl. Nat. gr. 510) written in the imperial scriptorium between 880 and 886 for Basil I, presents elements of the new style.[4] In the miniature depicting the Vision of Ezechiel in the Valley of

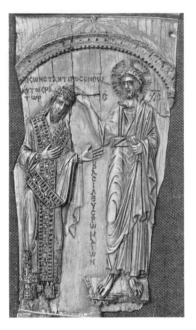

80. *The Epiphany of the Emperor Constantine VII Porphyrogenitus.* Ivory relief. Constantinople, about 945. *Moscow, Museum of Fine Art.*

Dry Bones (Fig. 83), the drapery is pressed against the body to emphasize its full plastic value but it is not modelled in the soft, clinging and sometimes fluttering folds visible in classical art or that of the reign of Heraclius. The folds of the garments are now and then indicated by sharp, angular lines, as though crumpled, in places where the fall of the drapery would not call for them. Direct observation from nature, which would entail the personal vision of the artist, is no longer considered necessary; folds and forms have become conceptualized.

The second trend of the *renovatio* is best illustrated by the works executed for Constantine VII (913–959). The usurpation of his father-in-law Romanus Lecapenus from 919 to 944 gave Constantine time to indulge his passion for learning and the arts. He was responsible for the great enterprise of the encyclopaedias of classical learning, and is supposed to have written one of these, the *Hippiatrica,* himself. His book on the court ceremonies reveals his antiquarian interests and his reverence for the harmonious order of the palatine rites. From historical sources we know that his interest was not confined to literature. 'The art of painting the man practised as accurately as anyone I know of before him or after,' wrote the author of the continuation of Theophanes, also supervised by Constantine. 'He corrected many people who busied themselves with it and he appeared as the best teacher. . . . But who could enumerate how many artisans the Porphyrogenitus corrected? He corrected the stonemasons, the carpenters, the goldsmiths, the silversmiths and the blacksmiths, and all in all the emperor appeared as the best.' Both Sigibertus Gemblacensis and Liutprand of Cremona bear witness to the Emperor's skill as a painter.[5]

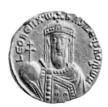
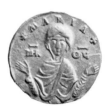
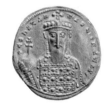
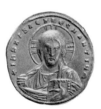

81. *Leo VI.* Obverse: *Virgin Orans.*
82. *Constantine VII.* Obverse: *Christ, King of Kings.* Gold coin struck at Constantinople in 945. *London, British Museum.*

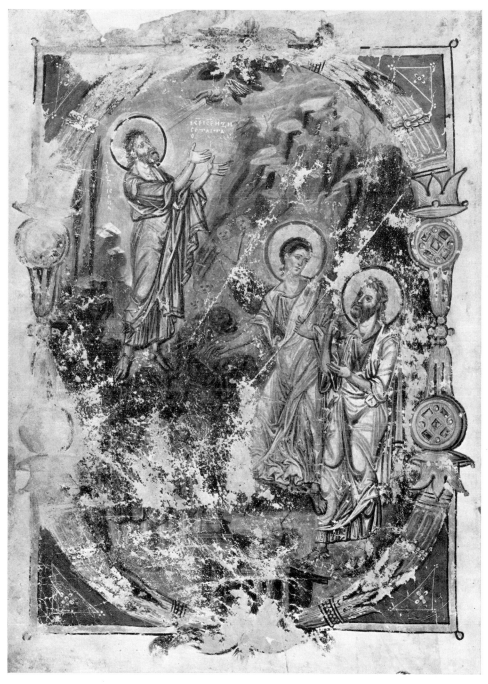

83. *The Vision of Ezechiel in the Valley of Dry Bones.*
From a copy of the Homilies of St. Gregory Nazianzen executed for Basil I between 880 and 886.
*Paris, Bibl. Nat. gr. 510, fol. 438v.*

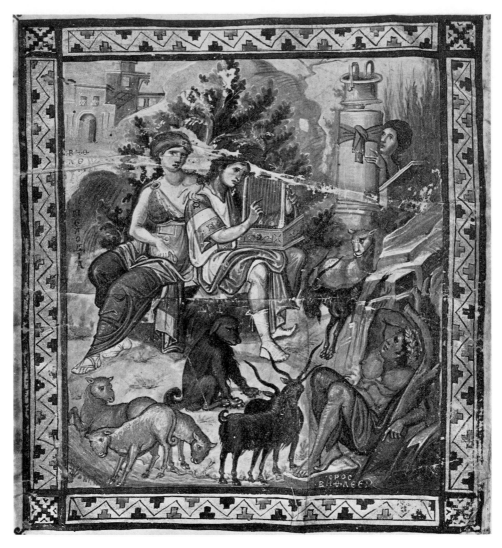

84. *David playing the harp*. From a Psalter executed at Constantinople in the middle
of the tenth century. *Paris, Bibl. Nat. gr. 139, fol. 1v.*

But it is not without interest that Constantine did not trouble to alter the
coinage or to return to the standards of the late antique *solidi*, and he was content
to retain the image established by his father Leo VI (Figs. 81-82).[6]

The miniature showing David playing the harp in the Paris Psalter (Paris, Bibl.
Nat. gr. 139), dating from the middle of the tenth century, would seem to be an
almost direct copy from a late antique model (Fig. 84). The original presumably
represented Orpheus charming the beasts but there seems every reason to believe
that there were intermediate stages during which Orpheus changed to David, the
precise significance of the nymph peering round the column was lost, and the

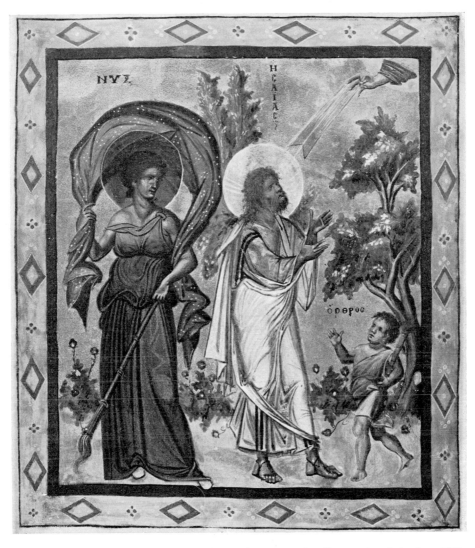

85. *Isaiah between Night and Dawn.* From a Psalter executed at Constantinople in the middle
of the tenth century. *Paris, Bibl. Nat. gr. 139, fol. 435v.*

mountain god—some scholars consider the original to have been a river god—was
named Bethlehem. In the prayer of Isaiah (Fig. 85), the prophet is shown between
the personifications of Night and Dawn. More than one scholar has argued that this
most beautiful miniature is an original creation of the 'Macedonian Renaissance'
built up from a combination of different elements but the opposing view that a pre-
iconoclastic model has been directly copied seems more acceptable. Rather than a
creation the miniature presents a re-animation of the classical ideals of formal,
sensuous beauty allied to a Biblical scene but the alliance must have been made in
the early stages of Byzantine art.[7]

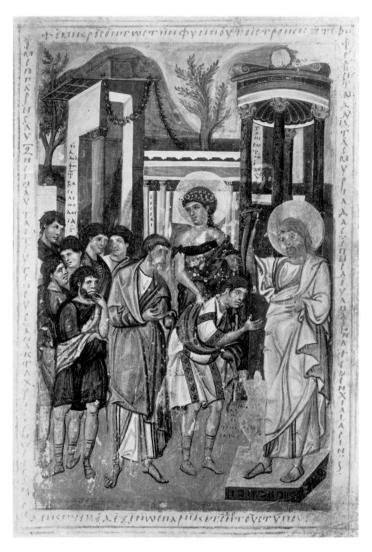

*86. The Anointing of David.*
From the Bible of Leo the Patrician executed at Constantinople in the second or third decade
of the tenth century. *Vatican, Reg. gr. 1, fol. 263r.*

The presence of a late antique or an early Byzantine original is suggested by the miniatures in the Bible of Leo the Patrician (Vat. Reg. gr. 1), which may probably be dated from the second or third decade of the tenth century. The scene showing the Anointing of David (Fig. 86) with its asymmetrical arrangement of figures before an architectural screen would seem to be a direct copy from an early Byzantine original. That these copies were made does not necessarily belittle the stature of the artists working for the Macedonian emperors; a number were of some eminence. The version of the scene showing Moses receiving the Tables of the Law (Fig. 87)

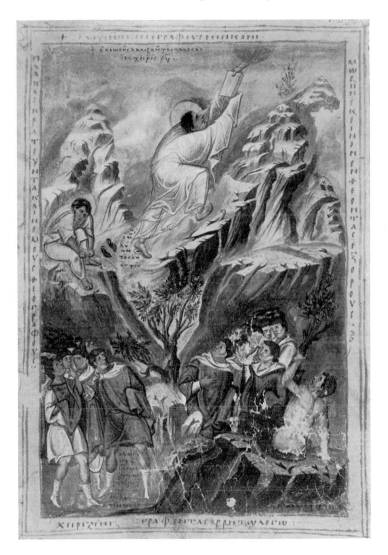

87. *Moses receiving the Tables of the Law.*
From the Bible of Leo the Patrician executed at Constantinople in the second or third decade
of the tenth century. *Vatican, Reg. gr. 1, fol. 155v.*

may have been copied from an earlier model but, for all the faulty proportions in the
foreshortening of limbs, it is clearly a superb work of art in its own right—the
extraordinary landscape, the running movement of Moses, the startled crowd below,
and the marvellous colour.[8]

One of the most remarkable productions of the Macedonian revival is the Joshua
Rotulus (Vat. gr. 431), probably made for Constantine VII in the imperial scrip-
torium. So deeply impregnated with the classical tradition is this work that even

F

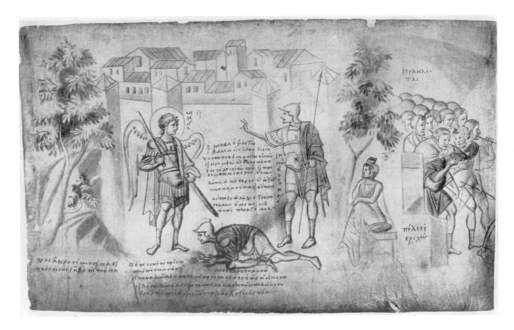

88. *Joshua's Meeting with the Archangel before Jericho.*
From the Joshua Rotulus executed at Constantinople about the middle of the tenth century.
*Vatican, gr. 431, Sheet IV.*

today scholars have assigned it to the sixth and seventh centuries. The illusion of landscape and architecture in the centre of Sheet 1,[9] the use of shadow and highlight and gradually diminishing tone, the modelling of face and form, the most delicate washes of brown, blue, white and purple establish these drawings as some of the greatest masterpieces of Byzantine art. The scene showing Joshua's meeting with the archangel before Jericho (Fig. 88) is astonishing by reason of the delicate treatment of trees and architectural background—the superimposition of the white foliage against the brown is particularly striking—the plasticity of the human form and its relation to space, and the exquisite shades of colour. On the other hand, the personification of Jericho on the right, sitting cross-legged on a cushioned chair, supports her chin thoughtfully with her right hand—a gesture with no particular meaning for a *tyche*. The mural crown fits badly as though it were an afterthought and the usual attributes of the personification of a city, a cornucopia or a sceptre, are missing. Such a misrepresentation would be unthinkable in the late antique period. It is instructive also to consider the drapery; the sharp angular lines of Joshua's cloak, the stiffly crumpled folds may be paralleled in numerous illuminations of the middle Byzantine period—similar examples may be found in the illustrations to the Homilies of St. Gregory of Nazianzus executed for Basil I. Moreover when Joshua falls down at the angel's feet, the act shown is a *proskynesis* in typical middle Byzantine style.

The full flavour of the classical heritage in the tenth and eleventh centuries is often to be found in scientific treatises. One of the most enchanting examples of this type of manuscript is the tenth-century version of Nicander of Colophon's didactic poems on snake bites, scorpion stings, and other forms of poison (Paris, Bibl. Nat. gr. Suppl. gr. 247). In the miniature showing a young man walking through a copse (Fig. 89), the figure is firmly and beautifully modelled, and he moves purposefully through an illusion of landscape. Only the drapery of the tunic betrays with its stylization of fold and pleat, the ornamental and unnaturalistic treatment of the hems, the tenth-century copyist.[10] In the eleventh century the figures become more like stiffly moving little puppets. A miniature in a copy of Oppian's *Cynegetica* (Venice, Marc. gr. 479) shows Maenads and a group of horses (Fig. 90) which, for all the liveliness of gesture and the reliance on a late antique prototype, have crystallized into a middle Byzantine idiom.[11]

89. *A young man walking through a copse.* From a copy of Nicander of Colophon's *Theriaca* executed at Constantinople about the middle of the tenth century. *Paris, Bibl. Nat. Suppl. gr. 247, fol. 48.*

90. *A hunting scene.* From a copy of Oppian's *Cynegetica* executed at Constantinople in the first half of the eleventh century. *Venice, Marc. gr. 479, fol. 12v.*

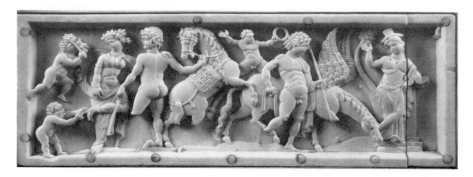

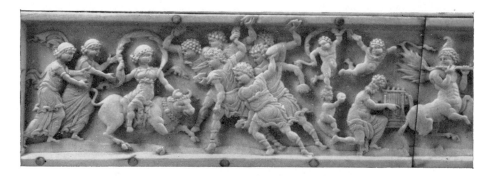

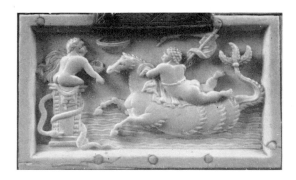

*91–93. Bellerophon with the winged horse Pegasus, the Rape of Europa, and other mythological scenes.*
Ivory panels from the Veroli Casket. Constantinople, tenth or eleventh century.
*London, Victoria and Albert Museum.*

But a document of primary importance for illustrating the purity of the classical
tradition at Constantinople at this time is the Veroli Casket, carved with illustra-
tions taken from classical literature (Figs. 91–96). The Sacrifice of Iphigeneia is a
scene from the end of Euripides' *Iphigeneia in Aulis.* Calchas is shown cutting the
lock from Iphigeneia's hair—the first stage in the sacrifice—and the heroine is
guided by Talthybius. On the left, Achilles holds a basket of barley; the figure
on the right is probably Menelaus. The fact that the beard of Menelaus is
omitted reveals a tendency of this tenth- or eleventh-century carver to be careless

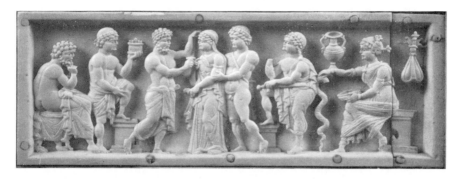

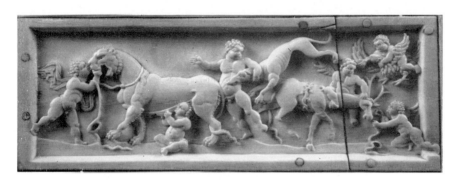

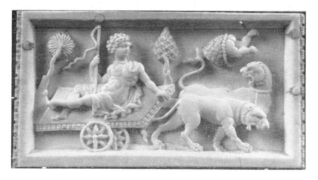

94–96. *The Sacrifice of Iphigeneia, children playing with animals, and Dionysus on a chariot.*
Ivory panels from the Veroli Casket. Constantinople, tenth or eleventh century.
*London, Victoria and Albert Museum.*

over details, and combines with another tendency to transform all classical types
into dolls, like the copyist of Oppian's *Cynegetica*. On the extreme right and left of
the Sacrifice are Asklepios and Hygieia—probably as decorative filling. In the panel
depicting the Rape of Europa, the group of stone-throwers on the right was copied
from the stoning of Achan in the Joshua Rotulus, but the scene of the Rape itself
was probably copied from illustrations to the poem *Europe*, written by the bucolic
poet Moschus of Syracuse, who lived about the second century B.C. Other classical

97. *The Deesis and Saints.* Ivory triptych. Constantinople, second quarter of the tenth century. *Rome, Museo del Palazzo Venezia.* [As shown here, the wings incorrectly mounted.]

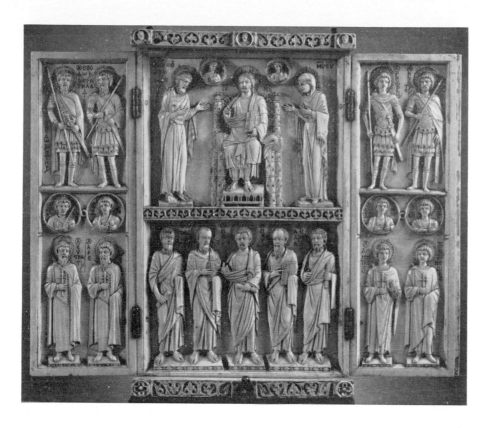

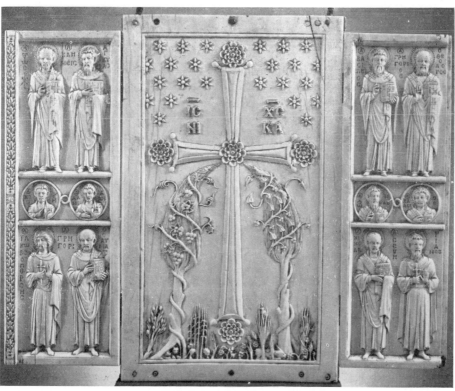

98. *The Deesis and Saints*. Ivory triptych. Constantinople, middle of the tenth century.
*Paris, Musée du Louvre.*

subjects on the casket are Bellerophon and Pegasus (Fig. 91), where the winged horse is shown drinking from the fountain of Peirene, while the young hero holds a lance in his left hand and in his right the golden reins given him by Athena for the taming of the horse. And there is Dionysus, adapted possibly from a representation of Rhea in a manuscript of Oppian but the source of which is in all probability a lost Hellenistic poem about the adventures of the god.[12] The drapery of all these figures is particularly characteristic of middle Byzantine style: the exaggerated quirks and pleats, the sharp points of fluttering hem, the network of folds across the body. The rosettes and masks which form the framework to the scenes from classical mythology, and to a certain extent the figure style are paralleled in a dark-red glass bowl, enamelled in white and grey, green, pale lilac, and red, in the Treasury of St. Mark's at Venice (Fig. 99). There can be no doubt that this bowl with its classical figures and masks is of late date since on the inside rim there is a pseudo-Kufic inscription. Similar glass has been found at Corinth and in Cyprus and it has been shown that two factories were set up at Corinth under strong Egyptian influence in the eleventh century and flourished until the Norman invasion of 1147 and possibly after.[13]

Among the religious carvings in ivory the most classical in feeling is the superb triptych in the Palazzo Venezia at Rome with an inscription which probably refers to Constantine VII (Fig. 97). The figures lack the extreme elongation of form present in a panel at Venice made for the same Emperor with a representation of St. John the Evangelist and St. Paul (Fig. 100). In the latter the drapery folds conform logically to the movement of the body but the accent placed on them in the cutting creates a kind of pattern which runs across the body. It would seem that the artist is no more conscious of the actual texture of the drapery as it falls about the form but

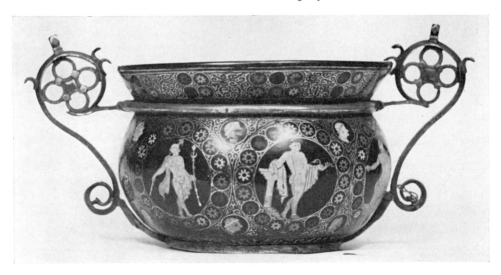

99. *Mythological figures.* Enamelled glass bowl. Corinth (?), eleventh century.
*Venice, Cathedral of St. Mark, Treasury.*

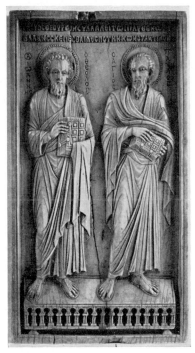

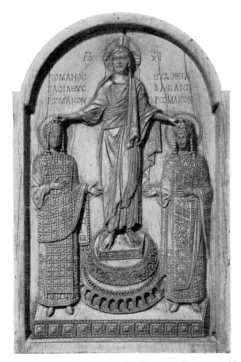

100. *St. John the Evangelist and St. Paul.*
Ivory panel. Constantinople, middle of the
tenth century. *Venice, Museo Archeologico.*

101. *The Coronation of the Emperor Romanus II
and the Empress Eudokia.* Ivory relief. Constan-
tinople, 945–949. *Paris, Cabinet des Médailles.*

is only concerned with the geometric spacing of line and contour; impressions have
long since ceased to be first hand. In the triptych the drapery falls naturalistically
with just the trace of affectation in the swirl of a hem, as in the figure of Christ, or in
the cascade of folds. It would seem probable that this triptych was carved early in
the reign of Constantine since it is close in style to a relief in jasper with a standing

102. *Christ blessing.* Jasper. Constantinople, 886–912.
*London, Victoria and Albert Museum.*

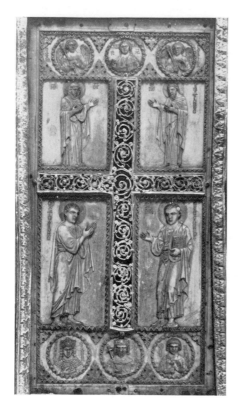

103. *The Deesis and Saints.* Ivory Reliquary of the True Cross. Constantinople, 963–969.
*Cortona, Church of San Francesco.*

figure of Christ blessing and an inscription referring to the Emperor Leo VI (Fig.
102). The cross on the central panel of the triptych displays all the severity of its pre-
iconoclast counterparts and the whole panel with its eloquent voids should be
contrasted with the lush preciosity of the Harbaville triptych (Fig. 98) which, on the
grounds of its supposed stylistic similarities with the relief of the Coronation of the
boy Emperor Romanus II and his child wife Eudokia (Fig. 101), is usually assigned
to a date early in the second half of the tenth century. With Constantine's triptych
should also be contrasted a triptych in the Vatican, again probably carved for his son
Romanus II, which in its *horror vacui* appears almost barbaric. Stylistically, these
reliefs differ from each other but the triptychs are so closely related in content that a
complete independence of one from another seems improbable; they must derive
from a common source and should be seen as the work of different artists in the
palace, carving in the most elegant of styles a litany or suffrage for the Emperor. The
common source was the imperial command. Different in style again is the superb
ivory reliquary of the True Cross (Fig. 103) carved with an inscription which would
seem to refer to the usurping Emperor Nicephorus Phocas (963–969) and to

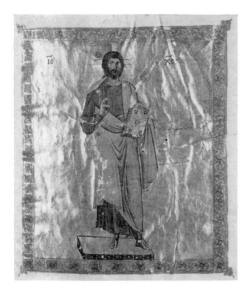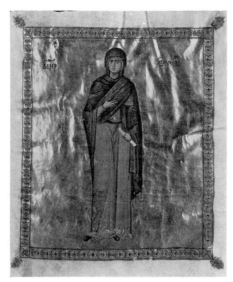

104. *Christ* and *the Virgin*. From a Gospel Lectionary executed at Constantinople in the second half of the tenth century. *Mount Sinai, Cod. 204.*

Stephen, Keeper of the Treasury of Agia Sophia, now in the Church of San Francesco at Cortona. The figures are larger in scale than those on the triptychs and the carving in general is executed in a more monumental style but it is difficult to believe that this is not the expression of the imperial workshops.[14]

Close in style to this tenth-century group of ivory carvings and of the same date is a sequence of manuscripts almost certainly executed in the workshops of the Great Palace. One of the finest, a Gospel Lectionary at Mount Sinai (Codex 204), shows by its treatment of the classically draped figures looming out of space, and by the modelling of the forms, the close copying of a late antique prototype, and yet in the delineation of the face of Christ or the Virgin (Fig. 104) a new form of religious feeling appears. The hunched solidity of the pre-iconoclast icon has given way to a more etiolated, ethereal representation. Divinity has become withdrawn, reserved, and makes no attempt to approach the spectator or to arouse his emotions. The forms, while harking back to those of the dedicatory portrait of Princess Juliana Anicia in the *Materia Medica* of Dioscurides or to the Apostles at the ends of the Sarigüzel sarcophagus, have become more disembodied; the elongation between shoulder and ankle accentuates the small delicate face gazing sombrely but not unkindly from out of the golden space; and still more, the hands and feet, of which the latter were never intended to bear the human weight of such apparitions, all propose a diagram of divinity rather than Christ the Son of Man or the human Mother of God. The relationship to late antique models is particularly well stated in a miniature depicting Jesus Shirach and Solomon (Fig. 109) which precedes their

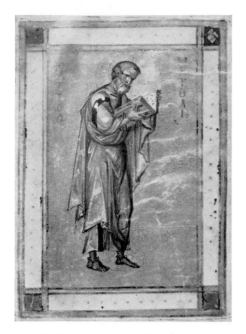
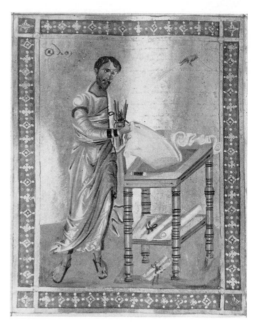

105. *St. Matthew.* From a Gospels executed at Constantinople about the middle of the tenth century. *Paris, Bibl. Nat. gr. 70, fol. 4v.*

106. *St. Luke.* From a Gospels executed at Constantinople about the middle of the tenth century. *London, British Museum, Add. Ms. 28815, fol. 162v.*

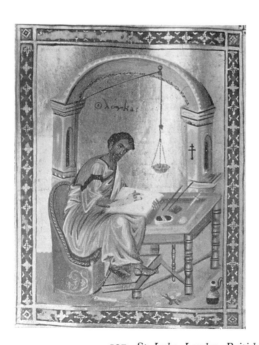
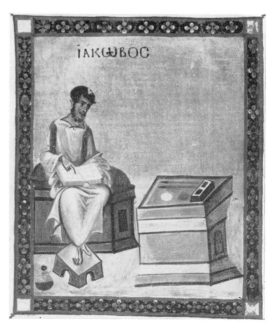

107. *St. Luke. London, British Museum, Add. Ms. 28815, fol. 76v.*

108. *St. James.* From a copy of the Acts and Epistles executed at Constantinople about the middle of the tenth century. *Oxford, Bodleian Library, Canon. gr. 110, fol. 106v.*

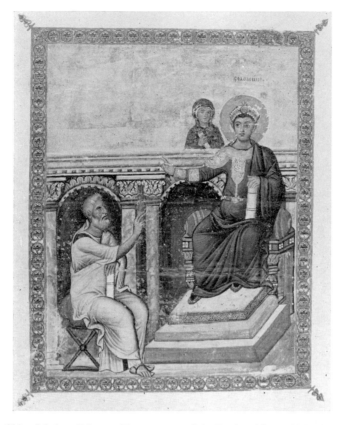

109. *Jesus Shirach before Solomon.* From a copy of the Books of Jesus Shirach and Solomon
executed at Constantinople about the middle of the tenth century.
*Copenhagen, G. Konigl. Samml. cod. 6, fol. 83v.*

books in Copenhagen, G. Konigl. Samml. cod. 6 fol. (Fol. 83v.). For here the
representation would seem to be adapted from the portrait of a prince of the
Theodosian house. When it came to the portrayal of the Apostles it was not
necessary to maintain the frontal pose of the divine or imperial portrait although the
atmosphere of reserve is constant. St. Matthew in Paris, Bibl. Nat. gr. 70, fol. 4v.
stands in a similar golden void but in three-quarter view, and the diagrams which
make do for the hands might conceivably have supported the book he reads so
intently (Fig. 105); St. Luke, in Brit. Mus. Add. Ms. 28815, whether standing before
a writing desk with a handful of pens and eyes directed towards the Hand of God,
or seated before an alcove reading by lamplight, is also shown in three-quarter pose
(Figs. 106 and 107). But in these cases, and in that of St. James in Oxford, Bodl.
Canon. gr. 110 (Fig. 108), there is also a conceptual approach to the draperies; the
quirks and pleats and fluttering edges which have only partial relation to the forms
they cover, or the scroll which tails off into an arabesque of white lines, show that

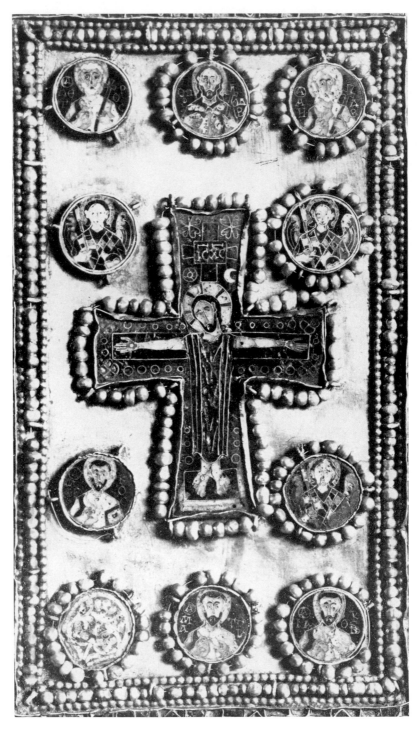

110. *Christ on the Cross amid Saints and Archangels.* Enamelled bookcover. Constantinople, 886–912.
*Venice, Marciana cod. lat. I. 101, gia Reserv. 56.*

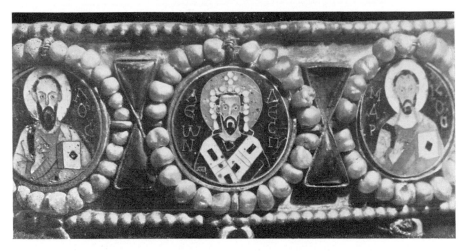

111. *Leo VI and Saints.*
Votive crown in enamel and silver-gilt. Constantinople, 886–912.
*Venice, Cathedral of St. Mark, Treasury.*

even when not representing the Divine Being, the court artists of Constantine VII were disinterested in the visual aspect of things. They never raised their heads to look at a man standing or sitting before committing the impression to the page; they were content with the traditions of the late antique manuscript before them and they transcribed the ideal forms of that period into the ideal forms of their own. In addition, it must be remembered that the decoration of manuscripts at Constantinople was confined, on the whole, to a small range of texts: the Gospels, the Psalter, the Menologion, and a few patristic works, in particular those of St. Gregory Nazianzen and St. John Chrysostom. This did not encourage a wide and cursive originality.[15]

This approach to art becomes further stressed when considering its transformation into gold and enamel. On the votive crown[16] of Leo VI the portrait of the Emperor is no more than a depersonalized pictograph (Fig. 111). The style of these enamels, pale colours on a green ground, is simpler and broader in treatment than the late tenth-century group and should be compared with a book-cover in the Marciana (Marc. cod. lat. I. 101, gia Reserv. 56) which shows, among other enamels, Christ on the Cross and the Virgin Orans against a cross (Fig. 110). On the magnificent onyx chalices decorated with gold, enamels, pearls, and inscriptions referring possibly to the Emperor Romanus II (959–963), now in the Treasury of St. Mark's at Venice, the saints and archangels have been transmuted into spiritual essences mapped out in segments of brilliant colour (Figs. 112 and 113).

The enamelled box (Figs. 114–116) made in 964–965 for Basil, the bastard son of Romanus I, created Proedros by General Nicephorus Phocas in gratitude for his

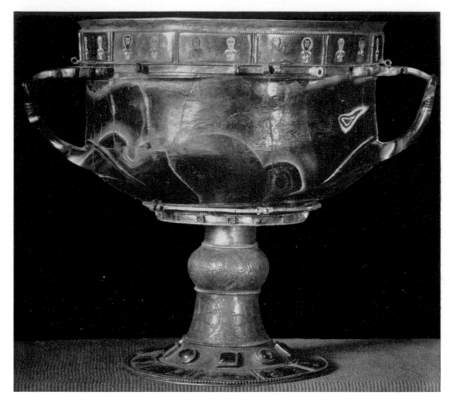

*112. Onyx chalice decorated with silver-gilt, enamels and pearls.*
Constantinople, second half of the tenth century.
*Venice, Cathedral of St. Mark, Treasury.*

help in the revolution which made him Emperor, is one of the great masterpieces of court craftsmanship. The box, now in the Treasury at Limburg, was made to contain a piece of the True Cross, mounted to the order of Constantine VII, and a

*113. Details from an onyx chalice decorated with silver-gilt, enamels and pearls.*
Constantinople, second half of the tenth century.
*Venice, Cathedral of St. Mark, Treasury.*

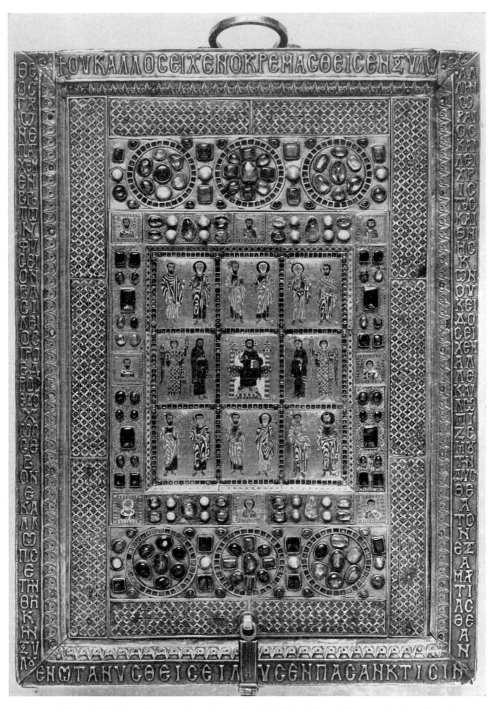

114. *Enamelled silver-gilt container for a relic of the True Cross.* Constantinople, 964–965.
*Limburg an der Lahn, Cathedral Treasury.*

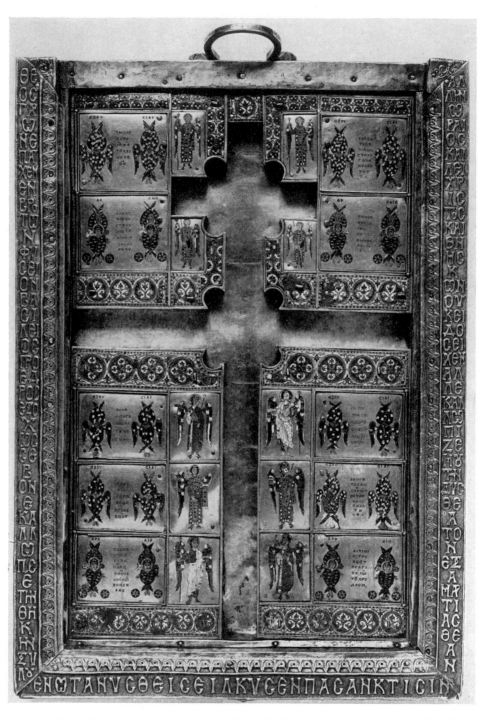

115. *Enamelled silver-gilt container for a relic of the True Cross.* Constantinople, 964–965.
*Limburg an der Lahn, Cathedral Treasury.*

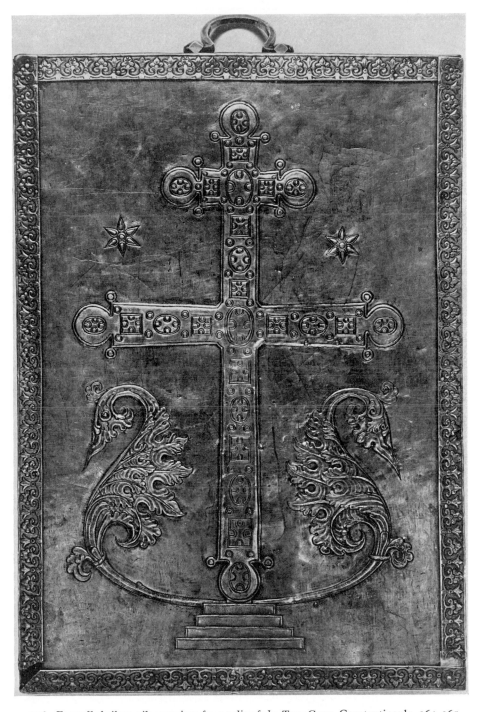

116. *Enamelled silver-gilt container for a relic of the True Cross*. Constantinople, 964–965.
*Limburg an der Lahn, Cathedral Treasury.*

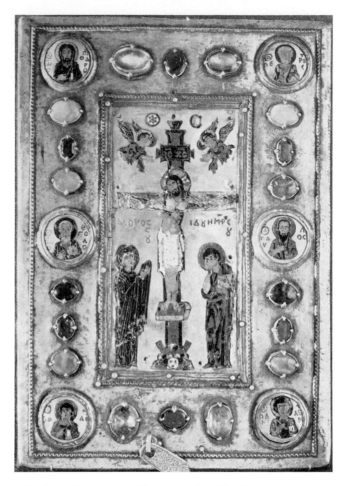

117. *Christk on the Cross between the Virgin and St. John.* Enamelled and silver-gilt cover
for a reliquary of the True Cross. Constantinople, second half of the tenth century.
*Venice, Cathedral of St. Mark, Treasury.*

number of other relics.[17] The subtle delineation of the heads, the treatment of the
drapery, and the setting of the figures in space propose a similarity of style with the
manuscripts executed in the Great Palace. Another reliquary of the True Cross,
now in the Treasury of St. Mark's, of which the cover bears a representation of
Christ on the Cross between the Virgin and St. John (Fig. 117), would seem to
approach in style the Limburg reliquary; the treatment of the drapery, the use of
two shades of blue, the sensitive modelling of the heads, all suggest a court workshop
in the late tenth century.[18] The gold and enamel icon of the half-figure of the
Archangel Michael (Fig. 118) in the same Treasury records another aspect of gold-
smith excellence with the enamels playing a subsidiary part to the elegant gold
relief. This and the reliquary of the True Cross formerly at Maastricht, now in the

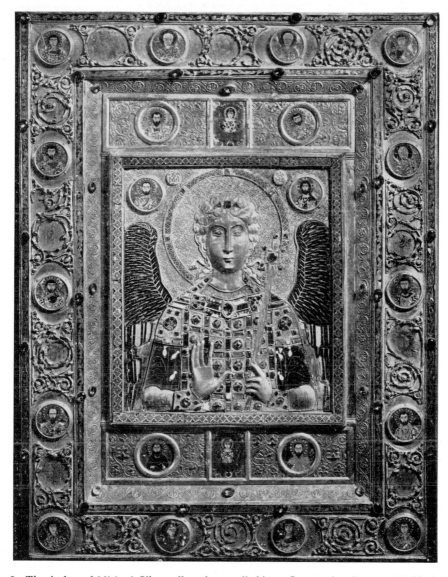

118. *The Archangel Michael.* Silver-gilt and enamelled icon. Constantinople, second half of the tenth century. *Venice, Cathedral of St. Mark, Treasury.*

Vatican,[19] with an inscription referring to Romanus II, also in gold relief, is a reminder that the palaces of the Emperor and the churches patronized by them were liberally furnished with such works of art. Constantine VII, in his Book of Ceremonies, makes frequent allusion to the gold tables at which the Emperor sat when entertaining his guests, to the golden throne and the golden vases in front of the pentapyrgion which housed some of the imperial treasures,[20] and these in conjunction with the golden trees inhabited by automatic singing birds set in the

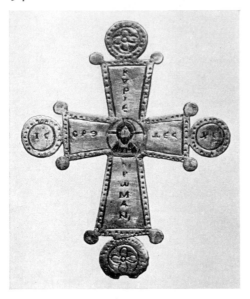

119. Silver cross for a court presentation.
Constantinople, 960–963. *Washington, D.C.,*
*The Dumbarton Oaks Collection.*

Palace of the Magnaura before an ascending throne of gold, the crowns and diadems of the Augusti, the robes of gold thread and pearls, the silks and furs of the patricians, were calculated to overwhelm the beholder and aroused, indeed, the cupidity of both East and West long before the sack of 1204.

Less ambitious works were also issued by the court. We know from the Book of Ceremonies that on the Vigil of the Feast of St. Elias, on the Vigil of Palm Sunday, and on Palm Sunday, the Emperor presented a number of silver crosses to certain officials. One of these (Fig. 119), with an inscription referring to the Emperors Romanus II and Basil II, now in the Dumbarton Oaks Collection, Washington, D.C., is comparatively simple in design, and the busts of Christ and the Virgin approach a schematization far removed from the splendours of the works done for Basil the Proedros. Even at the court in the second half of the tenth century there was not necessarily one style in gold and silver work; this diversity parallels that already noted in the ivory carvings.[21]

During the reign of Basil II (976–1025) the imperial scriptorium was moved from the Great Palace to the Palace of the Blachernae close to the land walls. In this palace the splendid but monotonous Menologion of Basil II (Vat. gr. 1613) was decorated by eight artists, of whom two, Michael and Simeon, are described as 'of the Blachernae'. Since the text contains no allusion to events later than 901, it has been assumed that the manuscript is a faithful copy of a synaxarium of the beginning of the tenth century, but there is also a miniature, without text or title, which almost certainly represents St. Luke the Stylite, who died in 979. No reference, however, is made to the serious earthquake which occurred at Constantinople in 989. It has been suggested plausibly, therefore, that the manuscript with its magnificent sequence of four hundred and thirty-six miniatures should be dated about 985 when, after a successful quelling of a palace conspiracy in which Basil the Proedros and Bardas Phocas were implicated, the Emperor Basil, who until that date had been more interested in the pleasures of the body than in those of the spirit, changed character and turned to a life of some austerity.[22] The Menologion is important on various levels: topographically for its representations of churches, the Holy Apostles, the Virgin *eis ta korou*, the Virgin *en Blachernais*, St. John of

120. *The Martyrdom of St. Simeon, Bishop of Jerusalem.* From a Menologion executed for Basil II in the Palace of the Blachernae about 985. *Vatican, gr. 1613, fol. 46.*

121. *Jonah.* From a Menologion executed for Basil II in the Palace of the Blachernae about 985. *Vatican, gr. 1613, fol. 59.*

122. *Basil II Bulgaroctonos*. From a Psalter executed for Basil II possibly after 1017.
*Venice, Marciana, gr. 17, fol. 1.*

Studius; archaeologically for its details of architecture, lamps, crowns and costume;
and iconographically for the various saints depicted—the Martyrdom of St. Simeon,
Bishop of Jerusalem, before a colonnade with naked classical figures holding spears
and shields (Fig. 120), St. Simeon the Stylite with Arabs making reverence, and the
Empress Theodora with an icon as the restorer of images. One of the most enchant-
ing, and least harrowing, is the miniature depicting part of the story of Jonah

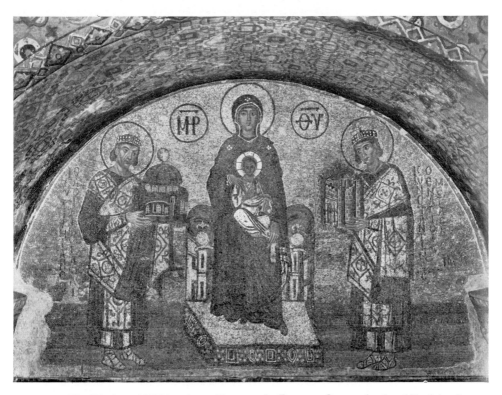

123. *The Virgin and Child enthroned between the Emperors Constantine I and Justinian I.*
Mosaic tympanum over the door leading from the South Vestibule into the narthex of Agia Sophia;
late tenth or early eleventh century. *Istanbul.*

(Fig. 121) by the artist called Pantaleon. Stylistically, there is a change from the
eloquent voids of the Great Palace school, a darkening of key, a more vivid narrative
interest, and a less etherealized treatment of the form. These characteristics are de-
veloped in the Psalter of Basil II (Venice, Marc. gr. 17) wherein the portrait of Basil II
Bulgaroctonos (Fig. 122) on the initial page gazing sternly over the backs of prostrate
Bulgars suggests a date later in his reign after the great triumph over that nation in
1017. In view of the high civilization predicated by so many Byzantine works of art
of the tenth and eleventh centuries it is salutary to remember that the history of the
East Romans is not infrequently darkened by acts of barbaric cruelty. At the end of
the campaign in 1014, 15,000 Bulgar prisoners of war were blinded and of this
number 150 alone were left a single eye to guide their comrades home.[23]

It would seem probable that between the time brackets set up by these two
manuscripts should be assigned the mosaic tympanum in the South Vestibule of
Agia Sophia which presents the Virgin enthroned between the Emperors Con-
stantine I and Justinian I (Fig. 123). Palaeographically, it has been suggested, the
inscriptions may belong to the second half of the tenth or to the beginning of the

eleventh century and a date between 986 and 994, when Agia Sophia was closed for repairs, has been advocated. The treatment of the idealized imperial faces is not far removed from miniatures in the Menologion of Basil II but the artists may also have had before them imperial portraits ranging from the time of Theodosius to that of Justinian, for the modelling of the cheeks, the lines framing the mouth and dividing the forehead, the treatment of the drapery, suggest a painstaking rescript of early Byzantine imperial images. The representation of the Virgin and Child, however, with its elongation of form but fuller, heavier modelling echoes characteristics in the manuscripts done for Basil II. On the other hand, the framing of the Virgin's head by the white edge of the veil seems reasonably close to the mosaic lunette with a bust of the Virgin Orans in the narthex in the Church of the Dormition at Nicea (1065–1067).[24] It has been suggested that the presence of the two greatest emperors of Byzantine history before the enthroned Virgin refers to the great victory of the usurping Emperor John I Tzimisces (969–976) over Svjatoslav, Prince of Kiev, in 971 which was attributed to the parading of the icon of the Virgin Theotokos before the Byzantine army. But it seems more likely that Basil II should wish to commemorate his own victories rather than those of his generals Nicephorus Phocas and John Tzimisces, who usurped power during his minority. Basil's victories, which broke the power of the great Tsar Samuel of the Bulgars and recovered Syria—even Antioch—and Mesopotamia from Islam, extended the Byzantine medieval empire to its widest limits. It is probable that this achievement was in the mind of the Emperor when the architects of the East Roman Empire, Constantine and Justinian, were commemorated over the door in the South Vestibule. A date after the victory of 1017 seems plausible for this mosaic.[25]

Other works of art have been related to this famous triumph. The silk tapestry found in the tomb of Bishop Gunther in the Cathedral of Bamberg was possibly acquired by him during his visit to Constantinople in 1064–1065—he died in Hungary on the return journey. The tapestry is woven with the figure of a mounted emperor holding a *labarum* and receiving on the one side a crown and on the other a *toufa*, a diadem crested with peacock's feathers, from personifications of cities (Fig. 124). We know that Basil II celebrated a double triumph in Athens and at Constantinople after the victory of 1017. Unfortunately there are no inscriptions on the tapestry to confirm the hypothesis that it relates to Basil and a large part of the figure of the Emperor, including his face, has been destroyed but the presence of the two personifications of cities makes the hypothesis tempting, particularly as we know from Zonaras[26] that when Basil II entered Constantinople by the Golden Gate he was offered the diadem crested with peacock's feathers. The figures are shown on a violet-purple ground sewn with small flowers in shades of pink and blue; at the top and bottom is a border of floral devices in interlaced roundels in yellow, pink, green, and blue on the same violet-purple ground. The Emperor is

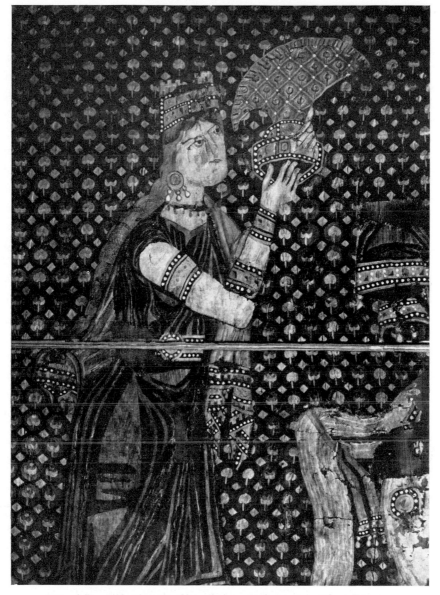

124. *A Personification of a City offering a toufa to a triumphant Emperor.*
From a silk tapestry possibly woven to celebrate the triumph of Basil II over the Bulgars in 1017.
Found in the tomb of Bishop Gunther (d. 1065) in the Cathedral of Bamberg.
*Bamberg, Cathedral Treasury.*

dressed in yellow imitating cloth of gold sewn with pearls and pink stones; the
*stemma*, surmounted by a small cross, is also composed of pearls. The personifica-
tion on the Emperor's left wears a long blue tunic, a shorter green tunic, and a
pink scarf; the one on his right wears a long pale yellow tunic, a shorter blue tunic,
and a similar scarf; both have long golden hair and wear crowns decorated with

pearls. While the technical quality of the tapes-
try is high, the style is rather coarse and there
is an element of doubt as to its origin in the im-
perial workshops.[27]

The second object which may refer to an
imperial triumph is the ivory casket now in the
Cathedral Treasury at Troyes. On the sides the
casket is remarkable for hunting scenes of con-
siderable power and for phoenixes in the
Chinese style (Fig. 125); on the lid two mounted
emperors placed symmetrically on either side
of a town are offered a city-crown by a woman
emerging from the gate followed by townsfolk
(Fig. 126). It has been suggested that this last

125. *A phoenix.*
End panel of an ivory casket.
Constantinople, middle of the eleventh
century. *Troyes, Cathedral Treasury.*

scene is related to the Triumph of Basil II but, although undoubtedly portraying
a victorious emperor, judging from the other scenes on the casket, it seems not to
be connected with any particular event. A date, however, in the eleventh century
is possible.[28]

More textiles may be assigned to the reign of Basil II. Several fragments of silk
woven in compound twill with representations of large stylized lions at Berlin,
Düsseldorf, Krefeld and Cologne (Fig. 127) bear inscriptions referring to the
Emperors Constantine VIII and Basil II, the sovereigns who love Christ. Con-
stantine VIII, younger brother of Basil II, idle and pleasure-loving like his father
Romanus II, ruled jointly with the Bulgaroctonos between 976 and 1025. Earlier
versions of this type of silk, however, were known at one time. In the Cathedral at
Auxerre under Bishop St. Gaudry (918–933) were two fragments of a Lion silk
bearing the inscription 'in the reign of Leo, the sovereign who loves Christ', which
must refer to the Emperor Leo VI (886–912). At Siegburg another great Lion silk,
now destroyed, bore an inscription referring to Romanus I Lecapenus and his son
Christopher, whose joint reign lasted from 921 to 923. A number of reduced,
coarser versions of these Lion silks have survived but without inscriptions and in
this case it is tempting to make a distinction between work done in the imperial
factory and work done in the city. The magnificent Elephant silk (Fig. 128), intro-
duced into the tomb of Charlemagne at Aachen by the Emperor Otto III during
the 'recognition' of the year 1000, must also date from the early part of the reign of
Basil II and Constantine VIII, although the Greek inscription refers only to the fact
that it was made 'under Michael, kitonite and eidikos, and Peter, archon of the
Zeuxippos'. In addition, two Eagle silks may claim to have come from the imperial
workshops under these emperors. The Chasuble of St. Albuin (975–1006) in the
Cathedral Treasury at Brixen is made up from a silk compound twill woven with a

126. *Mounted emperors offered a city crown.*
Lid of an ivory casket. Constantinople, middle of the eleventh century.
*Troyes, Cathedral Treasury.*

pattern of large stylized eagles in dark green on a rose-purple ground with large dark green rosettes in the intervening spaces—eyes, beaks, claws, and the ring in the beak are yellow (Fig. 129). The Shroud of St. Germain in the Church of Saint-Eusèbe at Auxerre bears an identical pattern but in colours of dark blue, dark blue-green, and yellow, and the quality is finer than the Brixen silk. Unfortunately neither of these superb silks bears an inscription.[29]

With the possible exception of the last two silks, which differ considerably from Islamic Eagle silks that have survived,[30] it may be said that Byzantine silk production of this time was heavily indebted to Persian and Abbasid models. The Elephant silk is clearly based on a Buwaiyid model for its subject matter and particularly for the stylized tree and its foliage behind the elephant,[31] though the border of the medallion contains more specifically Byzantine ornament. It may be that the introduction of the inscriptions referring to the emperors and used as part of the design is an adoption of Islamic *tiraz* protocol. Later in the century, when a series of particularly subtle silks, known for convenience as 'incised twills' because the pattern in a silk of one colour appears to be engraved, are known in several sequences, the problem of deciding which were made in the Byzantine world and which were made under Islam, or by Islamic craftsmen in the Byzantine Empire, becomes acute. Some bear fine Kufic inscriptions with the name of an Amir of Diyarbakr in northern Syria dating about 1025,[32] others bear polite wishes in Kufic, some have no inscriptions at all, and there is one remarkable silk, with the portrait of a Byzantine emperor, found in the tomb of St. Ulrich of Augsburg (d. 955), which seems to be without question of Greek manufacture.[33] The textiles found in the tomb of Pope Clement II (d. 1047) at Bamberg, of which one is closely related to a silk from the tomb of King Edward the Confessor (d. 1066), present similar problems.[34] There can be no doubt, however, that the imperial Byzantine silks have a power and a dignity, a feeling for design and texture, seldom rivalled in the

127. *Lions*. Silk compound twill. Constantinople, 976–1025. *Cologne, Cathedral Treasury.*

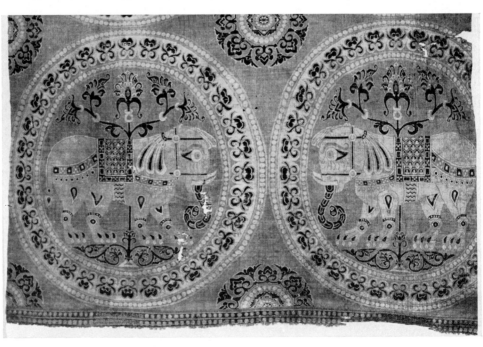

128. *Elephants*. Silk compound twill. Constantinople, late tenth century.
*Aachen, Cathedral Treasury.*

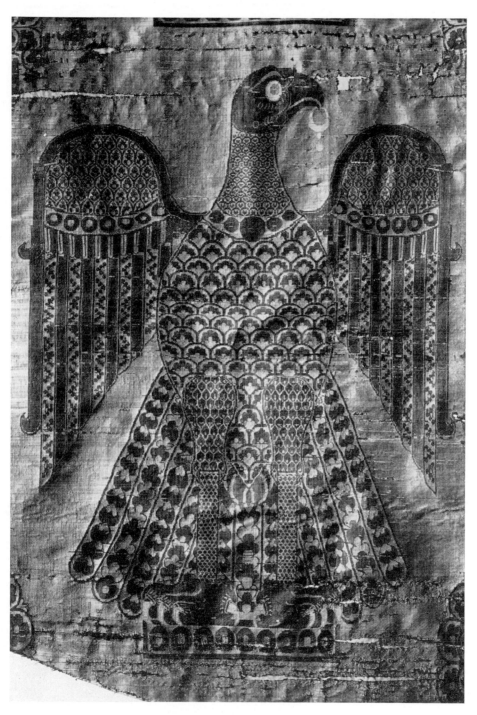

129. *An Eagle*. Silk compound twill. Constantinople, late tenth or early eleventh century.
*Brixen, Cathedral Treasury.*

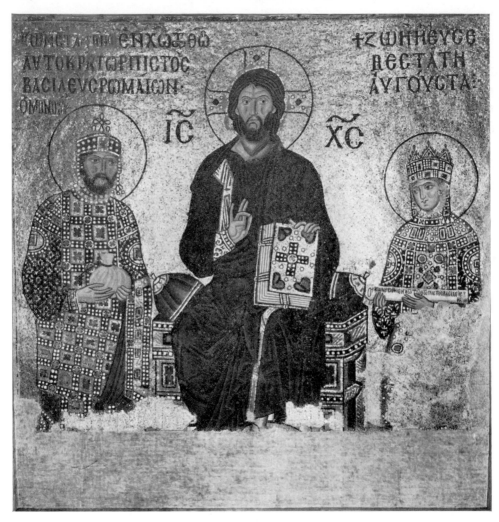

130. *Christ enthroned between the Emperor Constantine IX Monomachos and the Empress Zoe.*
Mosaic panel in the South Gallery of Agia Sophia probably executed between 1028–1034,
defaced in 1041, and restored shortly after 1042. *Istanbul.*

history of textiles. There is little wonder that Bishop Liutprand of Cremona was
tempted on his return from his unsatisfactory mission to the Emperor Nicephorus
Phocas to smuggle imperial silks through the Byzantine customs.[35]

The mosaic panel in the South Gallery of Agia Sophia at Constantinople with the
portraits of the Emperor Constantine IX Monomachos and the Empress Zoe stand-
ing on either side of the seated Christ presents certain problems (Fig. 130). It
continues the tradition of *ex-voto* mosaic panels representing the Augusti bearing
gifts familiar in San Vitale at Ravenna in the sixth century and panels of a less
exalted nature in the Church of St. Demetrius at Salonika in the seventh century.

But in this panel all three heads and the inscriptions are subsitutitons. It is probable that the original mosaic was executed between 1028 and 1034 and it represented the Empress Zoe (1028–1050), daughter of Constantine VIII, and her first husband Romanus III Argyrus (1028–1034). There is no documentary evidence, incidentally, that the Empress Zoe was interested in patronizing large-scale works of art though she had a fancy for expensive trinkets and chemical experiments,[36] but Romanus III instigated repairs to Agia Sophia and to the Church of St. Mary at Blachernae. His name would seem to fit the space allowed for the inscription better than that of Michael his successor and, since he was unpopular, it was more likely to be excised than that of Michael IV the Paphlagonian (1034–1041), who was well liked and the uncle of Michael V Kalaphates (1041–1042). Zoe, who was not fitted by temperament to govern, according to Michael Psellus,[37] retained the affection of the people in spite of her eccentricities. She had lived in retirement during the later years of Michael IV's rule and had been persuaded to adopt his nephew as Emperor. Michael V, however, induced the Senate to banish Zoe as a nun to the island of Prinkipo. It was presumably at this time that the mosaic panel was defaced. Michael V's triumph was brief. The people were not prepared to see a daughter born to the purple of the Macedonian house treated with such contumely and they rioted. The Empress was brought back from exile. She and her sister Theodora, who had long been a nun in the convent of the Petrion by the Phanar, were reinstated in the purple. Michael V was persuaded to leave the altar in the Church of St. John of Studius where he had taken refuge, and was blinded in a street of the city.[38] The two sisters, who had little love for one another, ruled for a few months as co-Empresses and coins were struck with their images (Fig. 131) but later in the year of 1042 Zoe at an advanced age took another husband, Constantine Monomachos (1042–1055), and Theodora was kept in the background of affairs. About this time the imperial portraits were restored. It is still far from clear, however, why it was necessary to restore the head of Christ.[39]

131. *The Empresses Zoe and Theodora.* Obverse: *Panagia Blachernitissa.* Gold coin struck at Constantinople in 1042. *London, British Museum.*

As opposed to the figures of Constantine and Justinian on the tympanum of Basil II (Fig. 123), which are seen in depth and modelled with some solidity, the bodies of the Augusti are little more than lay figures of imperial power. In contrast with the Virgin in the south vestibule the drapery of Christ has become considerably

H

more mannered with its cross-currents of folds and the face shows a marked difference of approach, more sketchy and schematic. But in view of the different styles current in Constantinople it would be rash to press these contrasts too far. The figures of Constantine and Justinian were probably copied from earlier imperial portraits, which would give them the definition that the Macedonian Augusti lack. The portrayal of the reigning Augusti behind a flat curtain of patterned dress and regalia establishes a convention of official portraiture which continued to the end. The heads in official portraiture, on the other hand, are presented in terms which presuppose recognition. While the restored heads in the Zoe panel have become considerably more conceptualized than all three heads in the tympanum of Basil II —the accentuation of the cheek-bones by circular devices, the broadening of the planes of the face—the Empress and her consort are rendered as plausible historic statements.

Constantine IX, brought back from exile in Mytilene to marry an aged Empress preoccupied with religion and making scents, flaunted a beautiful Caucasian mistress at public ceremonies, but for all his love of entertainment, he was by no means unaware of the responsibilities of his position. He built the church and convent of St. George of the Manganes and founded the Nea Moni on Chios after the miraculous discovery of an icon by hermits on Mount Privation. It is probable that mosaicists were sent from the capital to decorate the church on Chios. Fragments of their work have survived including a Virgin Orans in the apse, a few angels and saints, and fourteen scenes ranging from the Annunciation to the Pentecost.[40] But the sombre, forceful style of these mosaics has unfortunately no counterpart in the capital and contrasts strangely with the slightly inconclusive images of imperial power in Agia Sophia. The style at the Nea Moni does not resemble the work done at Osios Loukas in Phocis about the middle of the eleventh century, which seems to be the work of a provincial school,[41] nor the uneven quality of the work done in Agia Sophia at Kiev about 1045 with the help of mosaicists sent from Constantinople.[42] The style, moreover, contrasts with that of the mosaics executed in the narthex of the Church of the Dormition at Nicaea, now destroyed, under the patronage of the patrician Nicephorus after the earthquake of 1065. This decoration consisted of a double cross against a ground of stars within a roundel in the centre of the vault surrounded by medallions containing the busts of Christ Pantocrator, St. John the Baptist, St. Joachim and St. Anne; in the lunette over the door there was a bust of the Virgin Orans; in the four corners of the vault there were the four Evangelists. The meaning of this iconographical programme is far from clear and the absence of comparable programmes in the capital handicaps speculation. Stylistically the forms are rather broad and heavy; the face of the Virgin Orans in the lunette over the door seems to be a development of the Virgin and Child over the door in the south vestibule of Agia Sophia but the work, as far as one may judge

from the photographs, seems coarser.[43] In the portrayal of the Evangelists the bodies tend to disintegrate under the pattern of folds; in St. Matthew, for example, the relationship of the upper part of the body to the lower is uneasy and the right thigh seems unwarrantably stressed—this figure executed during the reign of Constantine X Dukas (1059–1067) looks forward to late Comnene art;[44] St. Luke, on the other hand, depends almost directly from the works executed in the palace scriptoria; in all four figures, the tendency of the drapery to create its own pattern counter to the form it covers echoes one of the main features of middle Byzantine style.

Constantine IX encouraged a renewed study of literature, refounded the University and endowed chairs of philosophy and law which were held by Michael Psellus and his friend John Xiphilinus. Under Psellus, who considered himself a Platonist, a classical revival was inaugurated. But there were less satisfactory trends and events in the reign. Quite apart from the frivolity of the Augusti, the exhaustion of the treasury, and the wilful encouragement of political corruption, the disagreements between the Patriarch Michael Cerularius and Cardinal Humbert were allowed to crystallize into a formal breach with Rome in 1054.[45] The subjection of Armenia only paved the way for the Seljuk Turks which ended in the disaster of Manzikert in 1071 under Romanus IV Diogenes (1067–1071), a defeat from which the Empire never recovered. In many ways the reign of Zoe and Constantine IX was a great divide.

In the world of art a decline in aesthetic standards visible in the mosaic panel of Zoe and Constantine seems evident in the so-called Crown of Constantine IX Monomachos, now in Budapest (Fig. 133). The diadem would seem to be that of an Augusta—the shape should be compared with the crown worn by the Empress Zoe in the mosaic panel and that worn by the Empress Irene in the Comnene imperial portrait in the same gallery (Fig. 161)—and was sent to Hungary as a gift to the wife of a Hungarian king, possibly at the time of the marriages of Andrew I of Hungary (1046–1061) to Anastasia of Russia and of her brother to a daughter of Constantine IX.[46] The portraits of the Empress Zoe, her sister Theodora, and Con-

132a. Detail from the Crown of Constantine IX Monomachos. Cf. Fig. 133.
132b. *The Empress Zoe*. Enamel and silver-gilt medallion. Constantinople, 1028–1050. *Venice, Cathedral of St. Mark, Treasury.*

133. *Diadem of an Augusta, known as the Crown of Constantine IX Monomachos.* Gold and enamels. Constantinople, 1042–1050. *Budapest, National Museum.*

stantine IX date the panels of the diadem to 1042–1050, and they should be compared with a small circular medallion bearing a portrait of the Empress Zoe in the Treasury of St. Mark's at Venice (Fig. 132b). The presence of dancers and the suggestion of a garden setting for the imperial figures establish unquestionable Islamic influence. There is an atmosphere of private entertainment about the diadem very different from the insistence upon supernatural virtue usual in imperial iconography. This is typical of the reign. Stylistically, the treatment is more schematic than in the tenth-century enamels; the figures of Sincerity, Humility, and the dancers are visualized as flat, angular patterns, and this interest in pattern is emphasized by a reluctance to think in terms of space. Where there are no inscriptions to cover the ground, a double scroll inhabited by birds has been used to clutter with detail the panels on which the otherwise imposing figures of the declining Macedonian house are revealed. They, too, are seen in terms of pattern rather than of form—note particularly the abstract scrolls at the elbows of the Emperor which bear no relation to the natural folds of the sleeve.

Similar characteristics are to be found in a gold and enamel reliquary with a

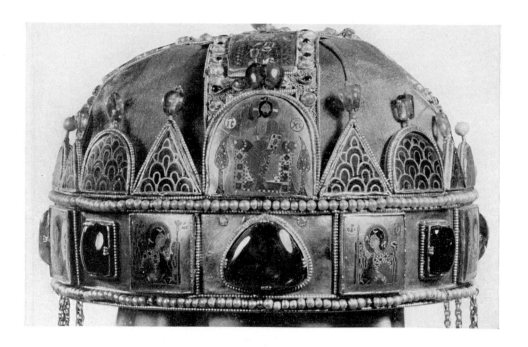

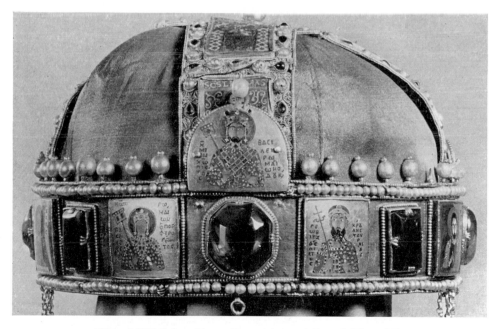

134. *Michael VII Dukas, his son Constantine, and Gèza I, King of Hungary.*
Details from the Holy Crown of Hungary. Gold and enamels. Constantinople, 1074–1077.
*Budapest.*

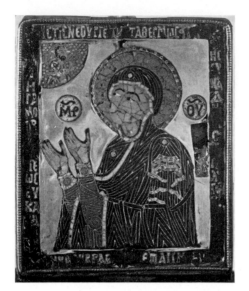
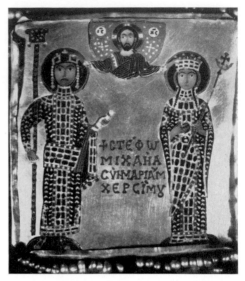

135. *The Panagia Chalcoprateia*. Enamel and silver-gilt reliquary. Constantinople, middle of the eleventh century. *Maastricht, Church of Our Lady, Treasury*.

136. *The Coronation of Michael VII Dukas and Maria of Alania*. Detail from the Khakhuli Triptych. Enamel and silver-gilt. Constantinople, 1071–1078. *Tiflis, National Museum*.

representation of the Virgin, now in the Treasury of the Church of Our Lady at Maastricht (Fig. 135), which would seem to date from the middle of the eleventh century,[47] and on the lower part of the Holy Crown of Hungary.[48] It is well known that the Byzantine emperors sent crowns as a claim to suzerainty to the Khazars, the Turks (Hungarians), the Russians and other Barbarian peoples but the Holy Crown is the only example to have survived. The portraits of Michael VII Dukas (1071–1078), his son Constantine Porphyrogenitus (1074–1078) and King Géza I of Hungary (1074–1077) set in proper hierarchy (Fig. 134)—the Emperor opposite Christ Pantocrator and accompanied by the patron Apostles of the Christian missions, the kings below the Emperor—leave little doubt as to the significance of the Crown. It was a symbol of the political and religious policy of the Emperor in relation to the Hungarian king. The figure of Christ enthroned between cypresses is clothed in drapery the folds of which are treated as an arbitrary network of lines becoming abstract scrolls at the knees. The exalted persons opposite Christ are represented as flat patterns of considerable intricacy. The decline in standards goes a stage further in certain plaques on the Khakhuli Triptych (Fig. 136). The square panel with the Coronation of Michael VII Dukas and his wife, Mary of Alania Princess of Georgia, the plaques of the Pantocrator, the Archangel Gabriel, and the cross in two parts bearing the name Kyrik seem of inferior workmanship in comparison with the Holy Crown of Hungary and the diadem of Constantine IX.[49]

Parts of the Khakhuli Triptych are Georgian work just as parts of the Pala d'Oro

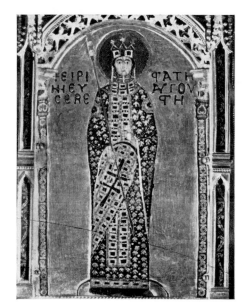 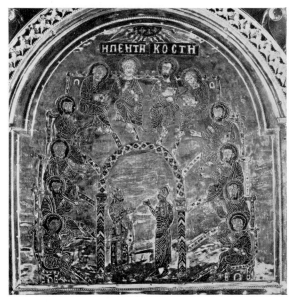

137. *The Empress Irene.* Detail from the Pala d'Oro. Enamel and silver-gilt. Constantinople, 1081–1118. *Venice, Cathedral of St. Mark.*

138. *The Pentecost.* Detail from the Pala d'Oro. Enamel and silver-gilt. Greek artist settled in Venice (?); 13th century. *Venice, Cathedral of St. Mark.*

at Venice are by Greek artists working in Venice and by Venetians. The earlier parts of the Pala d'Oro, some of which may be compared to the style of the Limburg reliquary of the True Cross, were probably ordered by the Doge Orseolo in Constantinople in 976 but it was restored by the Doge Ordelafo Falier between 1102 and 1117. Certain enamel plaques in the lowest register representing prophets and kings and an Empress Irene would seem to date from this period and are almost certainly Constantinopolitan (Fig. 137). The Empress has been identified as the wife of Alexius I Comnenus (1081–1118), whose own portrait has been replaced by the face of the Doge. She is presented as a flat pattern in the style of official portraiture already adumbrated by the Zoe panel in mosaic. Some large panels in the upper register in a coarse style but with Greek inscriptions—the scene of the Pentecost (Fig. 138) is an example—are probably by Greek artists settled in Venice, dating from the twelfth or thirteenth century, and with these should be considered the Esztergom reliquary of the True Cross, wherein debased naturalism combined with drapery treated as a meaningless network of lines—for example, the figure of St. John in the Deposition (Fig. 139)—proposes advanced provinciality of style.[50] The four Evangelists on the Pala d'Oro, and the smaller series with scenes from the life of St. Mark would seem to have been produced by artists of Venetian origin. This group is readily recognized by the curious striped robes of dark and light green or green and yellow and should be related with some book-covers in the Treasury of

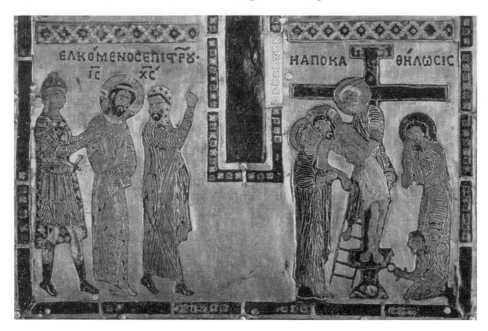

139. *The Esztergom Reliquary of the True Cross.* Enamel and silver-gilt.
Greek artist settled in Venice (?); thirteenth century. *Esztergom (Gran), Cathedral Treasury.*

St. Mark's and with that in the Reiche Kapelle in Munich.[51] The gold, pearl and
precious-stone setting of the Pala d'Oro, with Gothic enamels inserted in the
pilasters framing the larger saints, was made in 1345 during the reign of the Doge
Andrea Dandolo.

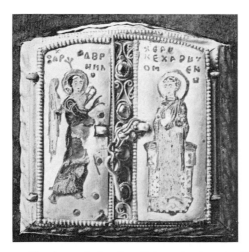

140. *The Annunciation.* Detail from the Stavelot Triptych. Enamel and silver-gilt. Constantinople,
second half of the eleventh century. *New York, Pierpont Morgan Library.*

141. *Reliquary of the True Cross.* Part of the Stavelot Triptych. Enamel and silver-gilt. Constanti-
nople, second half of the eleventh century. *New York, Pierpont Morgan Library.*

142-143. *A Stork* and *Scenes from the Life of David*. From a Psalter executed in the Monastery of St. John of Studius in 1066. *London, British Museum, Add. Ms. 19352, fol. 134* and *fol. 190.*

To some date between the Comnene enamels on the Pala d'Oro and the diadem of Constantine IX should probably be assigned two reliquaries enclosed in the Stavelot Triptych, now in the Pierpont Morgan Library (Figs. 140 and 141). It is possible that both these reliquaries are of later date than the Holy Crown of Hungary although the style of the Annunciation on the smaller reliquary would

144. *The Execution of St. John the Baptist.*
From a Gospels illuminated in the Monastery of St. John of Studius; middle of the eleventh century. *Paris, Bibl. Nat. gr. 74, fol. 75v.*

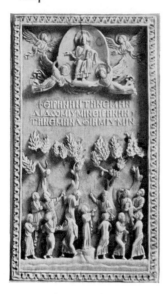  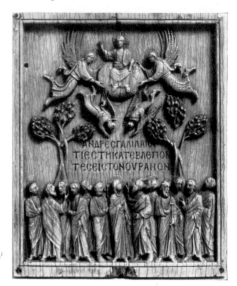

145. *The Ascension.* The lid of an ivory casket. Constantinople, middle of the eleventh century.
*Stuttgart, Würtembergisches Landesmuseum.*

146. *The Ascension.* From a Psalter executed in the Monastery of St. John of Studius in 1066.
*London, British Museum, Add. Ms. 19352, fol. 58v.*

147. *The Ascension.* Ivory relief. Constantinople, middle of the eleventh century.
*Florence, Museo Nazionale.*

seem to be connected with that of manuscripts illuminated in the Monastery of St.
John of Studius, in particular Brit. Ms. Add. Ms. 19352 dated to the year 1066.[52]

This manuscript, written and illuminated by Theodoros of Caesarea by com-
mand of Michael, Synkellos of the Studion, consists of a Greek Psalter, a metrical
life of David in the form of a dialogue, and some hymns and canticles including the
psalm traditionally composed by David when he killed Goliath.[53] There is marked
Islamic influence in the delicate miniatures, which are painted in brilliant but not
garish colours, and its thin, dry little figures scattered in the margins (Fig. 142) or
between the lines of text (Fig. 143) propose a quite separate style at Constantinople
in the middle of the eleventh century. A number of manuscripts have been related
to it, including the equally beautiful Paris, Bibl. Nat. gr. 74 (Fig. 144), wherein the
architectural framework is used like scenery to denote different acts of drama, and
the liveliness of the figures and the narrative content seem to foreshadow in con-
stricted miniature the mosaics of St. Saviour in Chora.[54] The drapery of this style
is apt to be delineated by narrow parallel lines of gold, probably in imitation of
cloisonné technique, and the sharp juxtapositions of colour also suggest that the
artists were in debt to the craftsmen in enamel.

It is tempting to align two ivory carvings with this group of manuscripts. The lid
of a casket with a representation of the Ascension, at Stuttgart (Fig. 145), has some
affinities with a miniature of the same subject in Brit. Mus. Add. Ms. 19352, fol.

58v. (Fig. 146): the same small-scale, slightly rectangular, lively figures, the trees in the background, the use of script as a compositional unit, the narrow parallel pleats of drapery.[55] At further remove an ivory panel with the same subject (Fig. 147) at Florence, although the forms are broader and the drapery folds freer, depends on similar stylistic mannerisms.[56]

The dangers of making a distinction between court and monastic schools have frequently been underlined.[57] Paris, Bibl. Nat. Coislin 224, dating from the late tenth or early eleventh century and once in the possession of the hierodeacon Manuel Xanthicos, grand cartophylax of the Great Church at Constantinople, is of such fine style that it would seem to be 'court' rather than high quality 'monastic'.[58] A *Parallela Patrum* (Paris, Bibl. Nat. gr. 922), executed at Constantinople about 1060 with portraits of the Virgin crowning Eudocia, her husband Constantine Dukas (1059–1067) and their two sons Michael and Andronicus, themselves crowned by angels, belonged to Eudocia and is presumably 'court' style, but it is clear from the twelfth-century Brit. Mus. Add. Ms. 11870 (Fig. 165) that a style of great elegance might be the product of the monasteries.[59] Paris, Bibl. Nat. gr. 71, is one of the landmarks of Constantinopolitan style in the second half of the eleventh century.[60] Portraits of the Evangelists of remarkable quality have opposite them ornamental pages of great beauty with delicately drawn animals and mythological beasts within multiple borders of rinceaux (Fig. 148). It should be compared on the one hand with an annotated Gospels (Paris, Bibl. Nat. gr. 64) dating from the

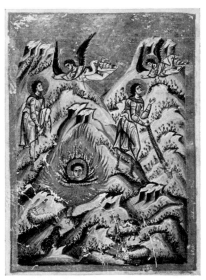

148. *Ornamental page*. From a Gospels executed at Constantinople in the second half of the eleventh century. *Paris, Bibl. Nat. gr. 71, fol. 71.*

149. *Moses on Mount Sinai*. From a copy of the Homilies on the Virgin by the monk James of Kokkinobaphos executed at Constantinople in the twelfth century. *Paris, Bibl. Nat. gr. 1208, fol. 73v.*

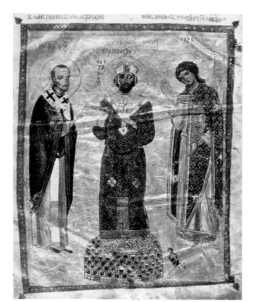 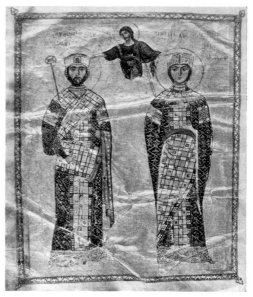

*150-151. The Emperor Nicephorus III Botaniates between the Archangel Michael and St. John Chrysostom and Christ crowning the Emperor Nicephorus III Botaniates and the Empress Maria. From a copy of the Homilies of St. John Chrysostom executed at Constantinople about 1078. Paris, Bibl. Nat. Coisl. 79, fol. 2v. and 2 bis v.*

beginning of the eleventh century, and, on the other, particularly in connection with the details of landscape and stretches of shrub, with the illustrated sermons of the monk James of Kokkinobaphos (Paris, Bibl. Nat. gr. 1208 and Vat. gr. 1162) dating from the twelfth century. The latter are typified by lively scenes evoked in brilliant colours with the effect of a miniature tapestry (Fig. 149). It has been stated with reason that in the eleventh and twelfth centuries the two styles 'court' and 'popular' existed side by side in the capital and that the former served 'court and feudal circles regardless of whether they were located in the capital or in the provinces, while the second served the masses of the people irrespective of whether they lived in the villages or in the large cities such as Constantinople, Salonika, or Nicaea'.[61] It might, indeed, be surmised that the majority of the manuscripts in the 'court' style were at this time done in the monasteries. The contrast of styles, however, is stressed by a manuscript of the Homilies of St. John Chrysostom executed about 1078, probably for Michael Dukas (1071–1078), but with four added miniatures of which two, illustrated here (Figs. 150 and 151), show the usurping Emperor Nicephorus III Botaniates (1078–1081) standing between St. John Chrysostom and the Archangel Michael, and the same Emperor with the Empress Maria, the former wife of Michael VII, crowned by Christ.[62] The style of the imperial figures, with their bodies conforming to a flat pattern with small hands and feet totally out of proportion to the body and the details of imperial costume glitteringly emphasized

against a gold ground, should be compared to the mosaic panel of Zoe and Constantine IX in Agia Sophia but it will be seen that in portraying the faces of the later Augusti the mannerisms of the mosaic have not been repeated. Instead, the delicate tones of the miniature evoke a more naturalistic image of imperial majesty. But the 'court' style is also emphasized by the elegance and nobility of the figures of St. John Chrysostom and the Archangel Michael, by a refined modelling of the faces based on the most delicate graduation of tones and a complicated system of lights. As opposed to the manuscripts

152. *The Virgin Orans.* Serpentine. Constantinople, 1078–1081. *London, Victoria and Albert Museum.*

executed in the Monastery of St. John of Studius, where contours are simplified and gestures exaggerated, the severe rhythms of the court style, the subtleties of the draperies and the classicism of the ornamental borders, quite apart from the imperial subjects and the sudden change from emperor to emperor, all proclaim an imperial workshop for this version of the Homilies.

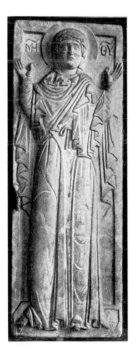 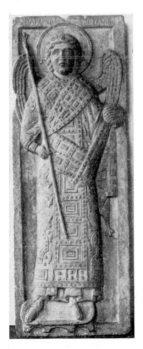 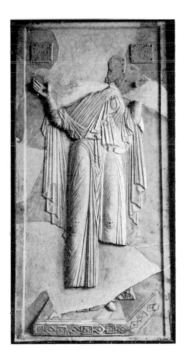

153–154. *The Virgin and the Archangel Michael.* Marble panels from the Church of the Theotokos Peribleptos in Psamatia. Probably 1078–1081. *Berlin, Staatliche Museen.*

155. *The Virgin Orans.* Marble panel from the Church of St. George of the Manganes; eleventh or twelfth century. *Archaeologial Museum, Istanbul.*

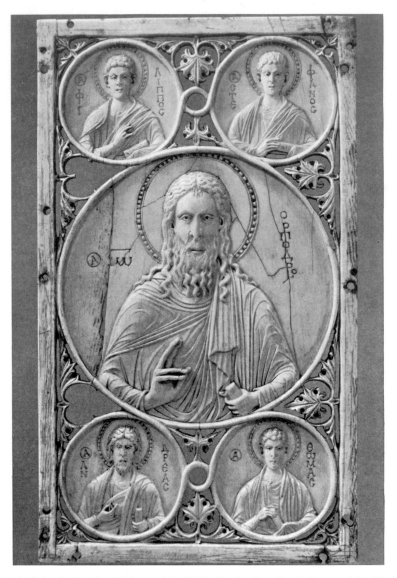

156. *St. John the Baptist with busts of St. Philip, St. Stephen, St. Andrew, and St. Thomas.*
*Ivory relief. Constantinople, eleventh or twelfth century.*
*London, Victoria and Albert Museum.*

A serpentine medallion in the Victoria and Albert Museum (Fig. 152) bears an inscription invoking the help of the Mother of God for the Emperor Nicephorus Botaniates.[63] The serpentine comes from the Marathonisi quarries in Sparta, so there is an element of doubt as to its manufacture in the capital. The broad planes of the Virgin's face and the drapery folds, which are possibly more elegant, may be compared with two marble panels of the Virgin and the Archangel Michael (Figs. 153 and 154), originally in the Church of the Theotokos Peribleptos (Sulu Mona-

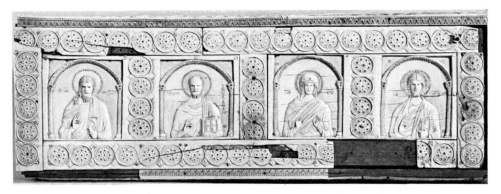

157. *Christ, the Virgin, St. John Chrysostom, and St. John the Baptist.* Ivory reliefs from a casket. Constantinople, eleventh or twelfth century. *Florence, Museo Nazionale.*

stir) in Psamatia, now in Berlin.[64] This church had been refounded in 1031 by Romanus III Argyrus but it was repaired by Nicephorus Botaniates and was the burial place of both emperors. The broad, heavy forms, the feeling for mass in modelling, and the coarse features have an air of provinciality. They contrast forcibly with a marble relief dating from the eleventh or twelfth century discovered in the ruins of the Church of St. George of the Manganes built by Constantine IX Monomachos between 1048 and 1054, now in the Archaeological Museum, Istanbul,[65] which reveals the Virgin Orans (Fig. 155) with an elegance of form, delicacy of drapery folds and severity of line recalling the ivory carvings and miniatures of the court workshops. It may be compared, for example, with a superb ivory relief with a representation of St. John the Baptist and the busts of St. Philip, St. Stephen, St. Andrew, and St. Thomas in the Victoria and Albert Museum (Fig. 156) and an

158–160. *Three Saints.* Sides of a marble capital. Constantinople, eleventh or twelfth century. *Paris, Musée de Cluny.*

ivory box carved with the busts of Christ, the Virgin, and a series of Saints (Fig. 157) in the Museo Nazionale at Florence.[66] The type of relief on these three objects is remarkably similar, as are the tight drawing of the folds across the body and the ethereal forms, stylized, elegant, and severe. These characteristics are echoed on a capital in the Musée de Cluny at Paris (Figs. 158–160) with a counterpart in the Archaeological Museum, Istanbul, which was found on the terrace of the Museum.[67] This elegance, this severity, this slight dryness would seem to represent a style current under the Comnenes.

Another aspect of Byzantine art at Constantinople in the second half of the eleventh century is represented by a series of large bronze doors, all now in Italy. They were executed mainly between 1062 and 1087 to the order of an Amalfitan family—the donors were either Pantaleon or Mauro[68]—and are to be found at Amalfi (1062), the abbey church of Monte Cassino (1066), San Michele in Gargano (1076) on Monte Sant'Angelo, and at the cathedrals of Atrani (1087) and Salerno (1099), the latter being presented by a noble of Salerno, Landolph Butromile and Princess Guisa. The finest of the group, given to San Paolo fuori le Mura (1070) at Rome by Pantaleon of Amalfi, suffered in the fire of 1823 and is now in a very damaged condition.[69] The silver and gold inlay has disappeared and the features of the saints are indecipherable but the subjects include, apart from the figures of saints and their martyrdoms, representations of the Twelve Feasts and various decorative panels. One of the panels portrays Pantaleon at the feet of Christ accompanied by St. Paul, which suggests that these doors were ordered with specific instructions as to the subject matter. There are Latin, Greek, and Syriac inscriptions; it is stated that the doors were made in the 'imperial city of Constantinople', they are signed in Greek by 'Staurachios the metal-caster' and in Syriac that 'this door was made through the grace of God by ... the metal-decorator'. The doors at Amalfi are signed by Simeon the Syrian. It seems reasonable to suppose, therefore, that all the doors of this class were the work of Syrian artists established in Constantinople and co-operating with Byzantine bronze-casters.[70] In addition the bronze doors at St. Mark's, Venice, would seem to have been commissioned by Leone da Molino, procurator of the church, at Constantinople shortly after 1085 but the artist is unknown.[71] The condition of the doors at San Paolo fuori le Mura is such that it is difficult to make any adequate stylistic assessment but those at Monte Sant'Angelo[72] suggest that in form and drapery the figures reflect early Comnene manuscript style but with more exaggerated movement and a certain coarseness of effect.

The main grounds for an assessment of Comnene style are provided by mosaic decoration and illuminated manuscripts but it should be recorded that there was also considerable building activity: the Church of St. Saviour Philanthropus, founded by Irene the daughter of Nicephorus Khoumnos; the Church of the

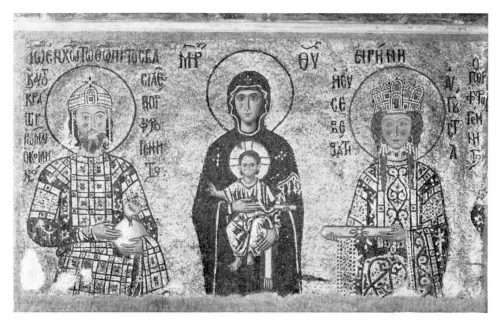

161. *The Virgin and Child between the Emperor John II Comnenus and the Empress Irene.*
Mosaic panel in the South Gallery of Agia Sophia, about 1118. *Istanbul.*

Theotokos Pammakaristos, possibly founded by the curopalates and grand domestic John Comnenus and his wife Anna Dalassena about the middle of the eleventh century—they were the parents of the Emperor Alexius I Comnenus (1081–1118); the Church of St. Saviour Pantocrator, founded by the Empress Irene, wife of the Emperor John II Comnenus (1118–1143) and daughter of St. Ladislas, King of Hungary, and later herself to be canonized;[73] and the Church of Saint Saviour in Chora was built for the first time by Maria Dukas, granddaughter of King Samuel of the Bulgars, niece of Isaac Comnenus (1057–1059) and mother-in-law of Alexius I. The palace of the Blachernae was considerably extended and part of the land walls were restored under the Emperor Manuel (1143–1180) about the middle of the twelfth century.[74]

The mosaic panel in the south gallery of Agia Sophia presents the Virgin and Child standing between the Emperor John II Comnenus, the Empress Irene, with the young prince Alexius accompanying them on a side panel (Fig. 161). It is probable that the panel showing the Emperor and the Empress was erected in 1118 to commemorate their accession and that the mosaic panel depicting Alexius was added in 1122 when he was proclaimed co-Emperor at the age of seventeen. The mosaic panel should be compared with a small miniature in Vat. Urb. gr. 2, fol. 20 which reveals in dark colours of blue, purple, red, and gold Christ enthroned between Mercy and Justice, crowning the Emperor John II and his son Alexius (Fig. 162). The two panels show considerably more refinement than the mosaic of

I

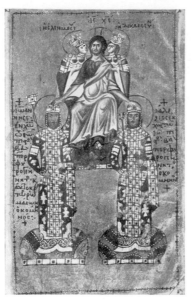

162. *Christ enthroned between Mercy and Justice and crowning the Emperor John II Comnenus and his son Alexius.* From a Gospel book executed at Constantinople about 1122. *Vatican, Urb. gr. 2, fol. 20.*

Zoe and Constantine IX. The forms are treated less like a flat pattern, the modelling of the faces is less diagrammatic and returns to a more naturalistic approach. The figure and face of the Virgin shows none of the sketchiness and roughness of line to be found in the Zoe panel. It would appear that Comnene patronage produced yet another of those periods of revival which are a constant factor in the course of Byzantine art.[75]

It is a period for which there is more evidence than at any other since Justinian of the extension of the imperial style into the provinces. The remains of the superb sequence of mosaics in the church at Daphni, about 1100, with its awe-inspiring Christ Pantocrator in the dome, are surely a reflection of this style and with the earlier sequences at the Nea Moni provide a valuable indication of the type of decoration current in the capital. By this time the whole programme of Byzantine church decoration had crystallized. The Byzantine church is both an image of the Cosmos in an ordered hierarchy and a Calendar of the Christian year. Christ Pantocrator reigns in the dome, the Virgin intercedes or shows the way in the apse, below her and in different parts of the church the saints and prophets of the Church are revealed in the order of reverence due to them, and the Twelve Feasts of the Church, which were sometimes elaborated into more than twelve scenes, adorn the walls of the catholicon and the narthex. Unlike Western schemes of decoration the programme was not intended to be primarily narrative or didactic; it was a mirror of the liturgy.[76] This scheme, with minor alterations, was extended beyond the bounds of the Empire. In 1108 artists were sent from Constantinople to the monastery of St. Michael at Kiev, where with the help of Russian masters the decoration was carried out.[77] Between 1143 and 1154 Greek artists were working in Sicily, and although an alteration of the iconographical scheme was made necessary by the shape of the South Italian basilica, we may be reasonably sure that the mosaics in the apse at Cefalù (about 1148), certain early parts of the decoration of the Cappella Palatina at Palermo (1143–1154) and the Church of Santa Maria del Amiraglio—La Martorana—(1143–1148) are directly connected with the metropolitan tradition at Constantinople. At the same time, it must be remembered that it is unlikely that the best artists were sent to Kiev or to Sicily, and beautiful though

the mosaics in the apse at Cefalù and in La Martorana may seem to us today, it is probable that the Dukases, the Comnenes, and the Angeli would have regarded them as, at best, second-rate. Moreover, the impressive sequence of mosaics in the Church at Monreale, begun about 1180, described as 'the largest and most important Greek decoration of the twelfth century which has survived' must be seen with the proviso in mind that it is far from certain that the artists came from Constantinople—in this case, some may have been brought over after Norman raids on the Greek mainland, of which one was directed against Salonika, a city with strong local traditions—and it is certain that the Greeks worked with local craftsmen over a period of some ten years.[78] In view of these cautionary statements about provincial schools, it is useful

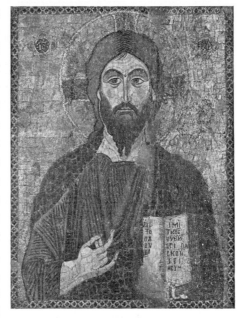

163. *Christ Pantocrator.* Miniature mosaic. Constantinople, middle or late twelfth century. *Florence, Museo Nazionale.*

to refer to the miniature mosaic of Christ Pantocrator in the Museo Nazionale at Florence (Fig. 163), which may date to the middle or late twelfth century and would seem to be Constantinopolitan work. It has been described as 'the nearest parallel to the Pantocrator mosaic at Cefalù.[79] The delicate modelling of the neck, face and hands, the attempt at plasticity of form, the exquisite colouring which transforms the severity of regard into a devotional image of the highest quality and poignance—all establish the level of metropolitan style under the Comnenes.

The problem of the intervention of local schools becomes even more acute when paintings in Serbia and South Russia are quoted as evidence of metropolitan traditions.[80] At Nerezi, in Macedonia, the mural paintings in the Church of St. Pantaleimon were executed at the command of Alexius Comnenus in 1164, and the style evinced there is of such novelty in its emotional range that without the necessary evidence forthcoming from Constantinople one is tempted to presume this to be the outcome of local taste.[81] On the other hand, the imperial connections of the patron and the quality of the work predicate metropolitan impulses. At Vladimir, in South Russia, some of the mural paintings in the Church of St. Dimitri which date from the last decade of the twelfth century were executed by a Constantinopolitan artist, who was responsible for the Twelve Apostles and the Angels on the south side of the large vault, while others are by a Russian artist who painted the Angels on the north side of the large vault and the frescoes representing Paradise covering the entire surface of the

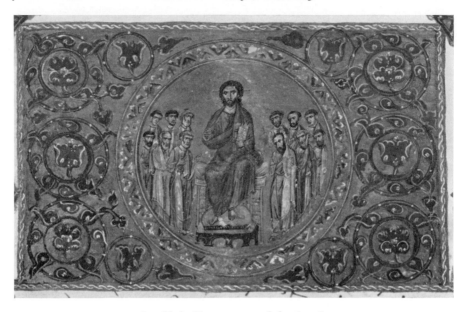

164. *Christ Pantocrator and the Apostles.*
From an Acts of the Apostles executed at Constantinople in 1101.
*Paris, Bibl. Nat. Suppl. gr. 1262, fol. 35.*

small vault.[82] Impressive though these frescoes appear to be, it is unlikely that the best painter in Constantinople was sent to Kiev, and without knowing the conditions under which he worked, the Kiev manifestation may only be regarded as Comnene in its widest sense. Until more mosaics or frescoes are revealed in the capital the difficulties of differentiating between Constantinopolitan style, the style of important cities of the Empire like Salonika, which had its own schools, and provincial centres given, so to speak, an injection from the metropolis, are formidable.

One of the most beautiful of the Comnene illuminated manuscripts, an Acts of the Apostles copied by John *o koulix* and dated 1101 (Paris, Bibl. Nat. Suppl. gr. 1262), came originally from the Meteora and belonged at one time, perhaps, to John Comnenus Synadenus, but it reflects the traditional style of Constantinople in its ornament (Fig. 164), in the elegant control of drapery folds, and in the delicate modelling of the planes of the face.[83] Also dating from the early twelfth century and possibly executed in a Bythinian monastery, Brit. Mus. Add. Ms. 11870 is in the tradition of the court style. The manuscript comprises the first ten books of the Lives of the Saints by Simeon Metaphrastes, who had been Logothete and Magister under Basil II. It is probably only a third of its original size since it deals with the saints associated with the twenty-five feasts of September and includes a table which deals with the saints of October covered in the second and third books.[84] The connection with a Bythinian monastery has been suggested by the choice for illustration of a relatively obscure Bythinian saint, St. Autonomos, whose cult

165. *St. Thecla.* From a copy of the Lives of the Saints by Simeon Metaphrastes executed possibly in a Bythinian monastery in the early twelfth century. *London, British Museum, Add. Ms. 11870, fol. 174v.*

166. *St. Luke and Theophilus.* In the roundel above: *the Ascension.*
From a New Testament executed at Constantinople in the early twelfth century.
*Oxford, Bodleian, Ms. Auct. T. infra I. 10 (Misc. 136), fol. 231v.*

centred round Limnae, the traditional site of his execution in the early fourth century. He is seldom represented in Byzantine art and his feast day on 12th September coincided with those of five saints of more established reputation—St Thecla, St. Serapion, St. Nicetas, St. Leontius, and St. Theodore of Alexandria. St. Thecla on fol. 174v. (Fig. 165) is painted in dark and bright blue robes with the drapery caught at the knee and emphasized by high-lights of white strokes; the dogs are brown, and there is a touch of red in the drapery slung over the blue architecture. The figure of the saint looms preternaturally tall out of the gold ground. A comparison of these manuscripts with a Gospels in the Bodleian Library, executed in the capital about the same date, shows that work in some of the monasteries outside the capital could equal that done within the walls. The Bodleian manuscript is one of the finest examples of illumination done under the Comnenes. The brilliant colouring, the elegance and variety of the design, the element of movement in the drapery, all look forward to the mosaics and frescoes of St. Saviour in Chora.

167. *The Baptism of Christ.* From a copy of the Homilies of St. Gregory Nazianzen executed at
Constantinople in the twelfth century. *Paris, Bibl. Nat. gr. 550, fol. 166v.*

Indeed, the Ascension roundel which crowns the frontispiece of the Acts of the
Apostles (Fig. 166) would seem to echo a mosaic in the vault of a dome; and the
representation of Theophilus, to whom the Acts are addressed, in the guise of an
Emperor standing before Luke, presents a freak of iconography which again looks
forward to the distinctive schemes in St. Saviour in Chora.[85]

A superb sequence of illustrations is also to be found in Paris, Bibl. Nat. gr. 550, a
version of the Homilies of St. Gregory Nazianzen[86] which combines small marginal
scenes with full or half-page miniatures and synthesizes Hellenistic and Islamic
elements. The baptismal scene on fol. 166v. is framed by a border of the most delicate
rinceaux which expand to define roundels in the four corners, each containing birds
and animals drawn with great vivacity (Fig. 167)—only the lion perched improbably
on the back of a bull in the bottom right-hand corner strikes a discordant note.

168. *The Ascension.* From a copy of the Homilies of the Virgin
by the monk James of Kokkinobaphos executed at Constantinople in the twelfth century.
*Paris, Bibl. Nat. gr. 1208, fol. 3v.*

But as always in Constantinople within certain conventions there was a variety of styles in the twelfth century. The enchanting miniature portraying the Ascension in front of a church, thought by some to be a reflection of the Church of the Holy Apostles at Constantinople, gives an example of the individual talents of the artist who illustrated the sermons of the monk James of Kokkinobaphos (Fig. 168), and the landscape scenes such as the Expulsion from Paradise,[87] fol. 47, or the background to Moses on Mount Sinai—note the rams in the thickets below the burning bush (Fig. 149)—introduce a narrative element which again looks forward to the Palaeologue revival.

So far the Comnene manuscripts have presented a type of miniature which presents small figures, either within a highly ornate frame or before an architectural setting, and the over-all scheme is a kaleidoscopic unity of pattern and picture. But a Gospels, copied by a certain Matthew in 1164 with portraits of the Evangelists

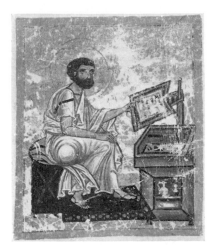 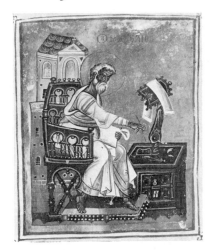

169. *St. Mark*. From a Gospels executed at Constantinople in 1164.
*Paris, Bibl. Nat. Suppl. gr. 612, fol. 135v.*

170 *St. Matthew*. From a Gospels executed at Constantinople in the third quarter
of the twelfth century. *London, British Museum, Cod. Burney, 19, fol. 1v.*

(Paris, Bibl. Nat. Suppl. gr. 612), which should be compared with Paris, Suppl. gr. 1262, and an Evangeliary in the Alliance Biblique Française,[88] confirms that the more conventional type of illustration still continued. Indeed, the portrait of St. Mark on fol. 135v. presents the last stage of the old style before 1204 (Fig. 169). This and Brit. Mus. Cod. Burney 19, illuminated in the third quarter of the twelfth century with its darkened tones—deep colours of blue, brown, red, and green— with its exaggerated movement, accentuated planes of the face, and growing isolation of different parts of the body—shoulders, knees, and head—(Fig. 170) forecast by the mosaics in the narthex of the Church of the Dormition at Nicaea, reveal the Byzantine artist still studying models hallowed by custom and their own antiquity. The force of this tradition was to survive even the disaster of the fourth Crusade.

## V

THE diversion of the fourth Crusade upon Constantinople and the sack of the city in 1204 must rank as one of the most wicked enterprises undertaken by civilized man. Rome had been sacked by the barbarians; East Rome was stormed and plundered by a Christian army gathered together for a Holy War. The Vandals plundered Rome for a fortnight; East Rome, apart from the fury of the three days' pillage, was stripped and rifled for forty years. In the course of the fighting a fire destroyed a large area of the most thickly populated part of the city running from the Golden Horn to the Sea of Marmara, and one night a drunken, hysterical mob

hacked to pieces the great statue of Athena, the work of Phidias, which Justinian had brought from the Acropolis and which stood in the forum facing the west, because the goddess seemed to be beckoning to the invader. In her agony the City turned against her heritage.[1]

When the Jew, Benjamin of Tudela, had visited Constantinople in 1161 he had been stunned by the magnificence of the city. No city, except Baghdad, was so rich or so full of business. All the traffic of Asia and the Near East, apart from the Mediterranean Sea, came naturally to Constantinople; her currency ran in India and in England; her works of art were prized by the most high in all lands. Gold covered the walls and pillars of the palaces, the tables and thrones of the Emperor, Agia Sophia was incandescent with it, and the vessels of the least church in the city were of gold and precious stones. The marble and stone palaces were the background to an ease of living barely perceived in the West. Even the palace of Basil Digenes Akrites on the Euphrates was decorated with scenes in mosaic which represented the exploits of Samson and David, the adventures of Achilles and Odysseus and Alexander.

> The floor of it he paved with onyx stones,
> So firmly polished that those who saw might think
> Water was there congealed in icy nature.[2]

There can be no doubt that the author of the eleventh-century epic was thinking of the palaces at Constantinople. The glittering parade of the imperial court on the great feast days of the Church, the exotic displays in the Hippodrome, and above all the profound sense of security and toleration which permitted Jews and Muhammadans to settle in the city and contribute to its civic life, were a source of envy and hatred to the West. 'It would have been right,' Geoffrey de Vinsauf decided, 'even to have razed the city to the ground for, if we believe report, it was polluted by new mosques, which the perfidious Emperor allowed to be built that he might strengthen the league with the Turks.' As it was, the grand design of the Emperor Constantine, embellished by Theodosius and Justinian, by Theophilus, by the great Macedonian and Comnene houses, was laid waste by a Doge partially blind and a horde of undisciplined Franks.

The godly East was shocked by the sacrilege done to its churches. The Church of Holy Wisdom, described by Nicetas Choniates the Grand Logothete as 'an earthly heaven, a throne of divine magnificence, an image of the firmament created by the Almighty', was transformed into a bare barn and defiled. The altars of gold and silver, the sacred vessels, the vestments, the carpets and hangings were carried away or broken up. The tombs of the Emperors were rifled and the body of Justinian was thrown in the dust. There was an obsessed hunt for relics. The Venetians, who knew the value of what they were after, seized what they could but the French and the

Flemings were filled with a lust for destruction. That which could not be carried away was given to the fire, including a statue of Helen which Nicetas mourned—'she who had formerly led all spectators captive could not soften the heart of the barbarians'. When the dust settled and the smoke drifted away, the city was a fraction of its former self. Churches, monuments and many of the porticoes had collapsed, the palaces, forums and churches had been stripped of their works of art, and more than half of the city had been burnt down. The sack of Constantinople was in the words of Pope Innocent III 'a work of darkness' and he confessed himself weakened by disappointment, shame, and anxiety. He chose his words well, for the light of Greek civilization, which had been kept burning at Constantinople for nearly nine centuries, was suddenly extinguished.

But the catastrophe, terrible though it was, was not quite final. Fragments of the old Empire survived as separate states. Alexius and David Comnenus, grandsons of the Emperor Andronicus, with the help of their aunt, Queen Thamar of Georgia, occupied Trebizond and established a dominion along the Black Sea shores of Asia Minor. A bastard of the Angeli made himself Despot of Epirus. Theodore Lascaris, who married Anna the daughter of Alexius III, set up a dominion at Nicaea, which, with the crowning of the porphyrogenite princess and her husband by the Patriarch Michael Autoreanus, became in the eyes of the Greeks the capital of the legitimate Empire. But the old imperial *mystique* which had been handed over from the Old to the New Rome, which had transfigured like a nimbus the names of Constantine, Theodosius, Justinian, Heraclius, and the great medieval dynasties, which made peasants into emperors and emperors into gods, had gone for ever.

There was a diaspora of artists into Serbia and Bulgaria. Some stayed in the ruined city to work for the Latin conquerors. There can be no doubt that the remarkable series of frescoes executed at Studenica (the Church of the Virgin, 1209; the south chapel, 1233–1234), at Mileševa (1234–1236), at Moráča (1252), Boiana in Bulgaria (1259), Peč (about 1250) and Sopočani (1258–1264), while partly the work of local artists and partly under the influence of artistic currents from Salonika, also owed their standards of quality to metropolitan impulses and the participation of artists from Constantinople. Outside the city work continued in great monasteries such as the Meteora in Thessaly, at Salonika and Kastoria, at Trebizond and Nicaea, but there can be no denying of its provincial quality.[3]

The basis of these provincial schools was the Comnene style which today has chiefly survived in manuscripts. The continuity of the metropolitan style is best studied in that medium. Thus, a manuscript at Athens (Nat. Lib. cod. 118) has been assigned to Constantinople in the first half of the thirteenth century. The text on the scrolls in the hands of St. Matthew, St. Luke, and St. John is written in Latin and for this reason it has been argued that the manuscript was either commissioned by one of the Latin conquerors or at least adjusted for a Latin customer.[4]

A chronology has been established on the basis of the Wolfenbüttel sketchbook written between 1230 and 1240. From this it would appear that the earliest phase is represented by Mount Athos, Philotheu, cod. 5, a Gospel book. In connection with Mount Athos, it has been pointed out that the monasteries there never played any leading part in the development of Byzantine art; it was merely a typical provincial school shining by the reflected light of metropolitan art or the art of Salonika or of Serbia.[5] An Acts and Epistles (Vat. gr. 1208), on the other hand, decorated with portraits of the authors standing, is of the highest quality (Fig. 171) and is modelled in all probability on Vatican cod. Chis. gr. VIII, 54. The Acts and Epistles are written in gold with decorative chapter headings. The double portraits of St. Luke and St. James, St. Peter and St. John the Evangelist,

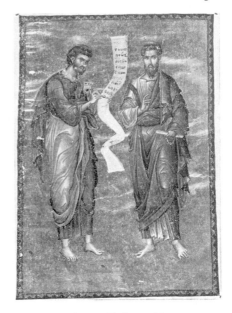

171. *St. Luke and St. James*. From a copy of the Acts and Epistles executed at Constantinople in the late thirteenth or early fourteenth century. *Vatican, gr. 1208, fol. 1v.*

St. Jude and St. Paul have been compared to the superb icon of the Twelve Apostles, in the Museum of Fine Art at Moscow (Fig. 191), and variously dated from

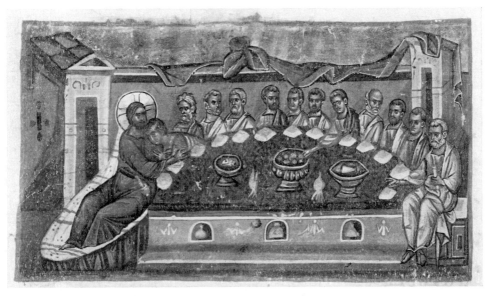

172. *The Last Supper*. From a Gospels executed at Constantinople in the thirteenth century. *Paris, Bibl. Nat. gr. 54, fol. 96v.*

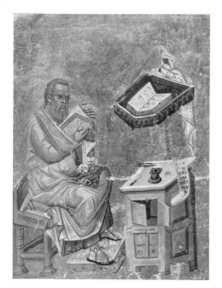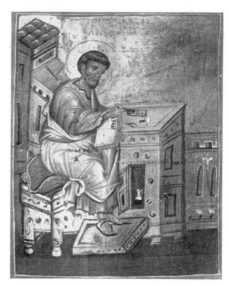

173. *St. John.* From a Gospels executed at Constantinople in the thirteenth century.
*Paris, Bibl. Nat. gr. 54, fol. 278v.*

174. *St. Luke.* From a Gospel book written by the monk Theophilus at Constantinople in 1285.
*London, British Museum, Cod. Burney 20, fol. 142v.*

the end of the twelfth to the first quarter of the fourteenth century, though the later date seems more acceptable. The figures are revealed with the same marvellous feeling for space as in the best tenth-century manuscripts and are painted in brilliant blues, greens and purples on a gold ground. There is the most delicate play of drapery folds. But characteristic of the later style is the swelling out about the calves with a swift tapering towards the ankles. The style is certainly metropolitan.

Princeton University, Garrett Ms. 2 (formerly Mount Athos, Andreaskiti cod. 753), and Mount Athos, Iviron cod. 5, with its pictures of the four Evangelists, about thirty illustrations from the life of Christ and some Latin inscriptions would also appear to have been executed before 1260 at Constantinople. It has been noted that the Latin inscriptions in the picture of St. John occur over an erased Greek inscription, which would seem to indicate that the Gospel book was adjusted for a Latin customer. Paris, Bibl. Nat. gr. 54, appears to be a direct copy of the Iviron codex with a bilingual text though the Latin version is incomplete. The script is Latin rather than French[6] and in the beautiful miniature of the Last Supper (fol. 96v.) an almost Italian quality emerges from the figure of Christ on the couch (Fig. 172). But the most tempting supposition is that Constantinople rather than Cyprus or Venice is the origin of the manuscript. The figure of St. John (fol. 278v.) is a good example of the development of style under the Latin rulers (Fig. 173). If a comparison is made with Brit. Mus. cod. Burney 19, dating from the middle or the third quarter of the twelfth century (Fig. 170), it will be seen that the figure in

Paris gr. 54 has become broader, more comprehensive in volume, with quirks and details of drapery harking back to tenth-century models, and the physiognomy is more naturalistic. These characteristics are repeated in a Gospel book written by the monk Theophilus in 1285 (Brit. Mus. cod. Burney 20) where on fol. 142v. St. Luke is depicted seated at a desk against an architectural background (Fig. 174). The treatment of the drapery conforms in principle to the structure of the body but serves to mask rather than to define it; the emergence of the ankles and feet of Holy Luke from out of the drapery comes as an ill-defined surprise. Little details such as the half-filled jug in a cupboard of the desk are typical of 'monastic' art and it is the 'monastic' art of the eleventh and twelfth centuries carried on through Latin rule which was to flower in the mosaics and frescoes of St. Saviour in Chora.

175. *St. Mark*. From a New Testament, Psalms, and Canticles executed at Constantinople about 1260–1270. *Paris, Bibl. Nat. Suppl. gr. 1335, fol. 43v.*

Vatican, gr. 1208, and Paris, gr. 54, are works of particularly high quality but much of the work done in the course of the thirteenth century represents a restricted phase within the development of a larger artistic movement whose landmarks are to be found in the frescoes of Serbia and Bulgaria. The well-established formulae are relayed in a slightly routine manner. A New Testament, Psalms, and Canticles (Paris, Bibl. Nat. Suppl. gr. 1335), executed at Constantinople between 1260 and 1270, which should be compared to Paris, gr. 134, a Commentary on Job, shows how this could degenerate towards the end of the Latin dominion into a hybrid (Fig. 175) stemming on the one hand from Paris, Suppl. gr. 612, dating from 1164 (Fig. 169), and from Latin influence in the treatment of face and hands. Yet a Gospel book (Paris, gr. 117) decorated at Constantinople between 1262 and 1263 with refined portraits of the Evangelists seated before architectural phantasies in a variety of delicate colours—in a key similar to those found in a version of the works of Hippocrates (Fig. 197) done for the Grand Duke Alexis Apocaucos (d. 1345)—is a reminder that a scriptorium had already been re-established in the Palace of the Blachernae in 1261, and the glories of the Palaeologue court art were about to arise like a phoenix from the ashes of the Empire.[7]

ON 15th August, 1261, Michael Palaeologus was welcomed back by the jubilant Greeks to the throne of the Augusti. The Emperor Michael VIII Palaeologus (1261–1282) walked the entire breadth of the city, preceded by the Icon of the Theotokos Odegetria, to the Church of Holy Wisdom. The Great Palace was chosen as his place of residence since the Palace of the Blachernae had been left filthy and dilapidated by Baldwin II (1228–1261). He restored the walls, began dredging the harbour of the Kontoscalion, and initiated repairs in the Panagia Peribleptos and in Agia Sophia. Whole quarters of the city were deserted; waste land stretched on all sides. Later, the west and middle of the town as far as the Valens aqueduct were gradually abandoned, and the inhabitants tended to huddle along the shores of the Golden Horn and the Sea of Marmara.[1]

Shortly after the return of the Augusti (within a year Michael VIII blinded the young John Dukas and banished him) the mosaic panel with a representation of the Deesis in the south gallery of Agia Sophia was restored (Fig. 176). The mosaic is of such astonishing quality that many scholars have been led to assign the panel to the late eleventh or early twelfth century.[2] It is probable that a panel of earlier date had existed but a comparison of details of the mosaic as it now survives with work done in the Church of St. Saviour in Chora in the second decade of the fourteenth century only serves to stress the similarities between the two. The faces of Christ, the Virgin, and St. John the Baptist are presented with the ingredients of grave emotion which never quite comes to the surface of what is known of Comnene style. The soft modelling of the facial contours, the semi-naturalistic treatment of beard and hair, in the case of Christ and St. John the Baptist, which should be compared with the heads of Christ and St. John in the fresco of the Anastasis (Fig. 188) in the parecclesion of St. Saviour in Chora, the stiff network of drapery, and the more naturalistic representation of hands—all point to the renewed style. There is visible a kind of plasticity, coruscated by the sharp pleats of drapery, entirely different from Comnene art.

Also dating probably from the last quarter of the thirteenth century is a miniature mosaic in silver, lapis lazuli, and other semi-precious stones of the Crucifixion, now in Berlin (Fig. 177). The whole scene is impregnated with an emotional stress new to the art of the capital: the sagging body of Christ on the Cross, the mourning angels and St. John,—the Virgin, on the other hand, looks strangely unmoved.[3] The drapery with its exaggerated cross-currents is typical of the development of Byzantine art at this time. The new plasticity, the new freedom of approach to form

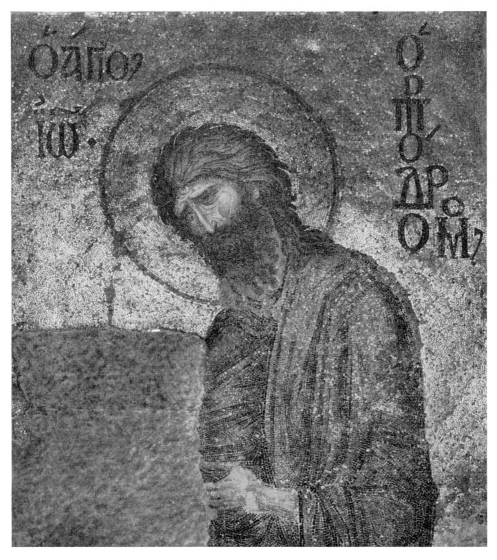

176. *St. John the Baptist.* Detail from the mosaic panel of the Deesis in the South Gallery of Agia Sophia; late thirteenth century. *Istanbul.*

is revealed in another miniature mosaic with a representation of the Forty Martyrs, now in the Dumbarton Oaks Collection, Washington, D.C. (Fig. 178), which should be compared with the fresco in the parecclesion of St. Saviour in Chora showing the Torments of the Damned (Fig. 179). It is also tempting to relate two ivory reliefs carved with figures of the Forty Martyrs, of which one is in the Hermitage Museum, Leningrad[4] and the other in Berlin (Fig. 180), and a drawing in Vatican cod. Barb. lat. 144, fol. 130, which seem to fit the contours of the Palaeologue style.[5] In the ivory carvings the emotional penetration into the subject

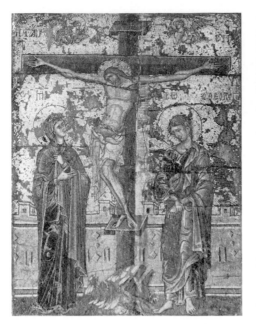

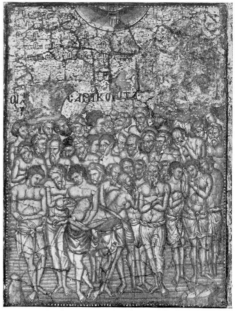

177. *Christ on the Cross between the Virgin and St. John.* Miniature mosaic. Constantinople; last quarter of the thirteenth century. *Berlin, Staatliche Museen.*

178. *The Forty Martyrs.* Miniature mosaic. Constantinople, early fourteenth century. *Washington, D.C., The Dumbarton Oaks Collection.*

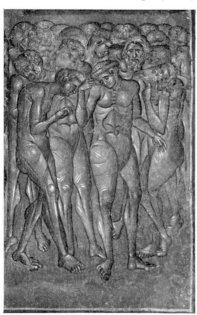

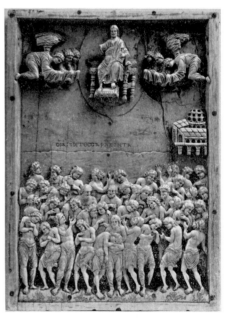

179. *The Torments of the Damned.* Detail from a fresco in the parecclesion of St. Saviour in Chora; second decade of the fourteenth century. *Istanbul.*

180. *The Forty Martyrs.* Ivory relief. Constantinople, early fourteenth century. *Berlin-Dahlem, Ehemals Staatliche Museen.*

is far removed from the frigid reliefs on the Veroli Casket (Figs. 91–96); this, and the diversity of attitudes, the subtle modelling of the body, the simulated landscape of flowers and grass in the foreground are akin to the miniature mosaics and the work at St. Saviour in Chora.

Of the miniature mosaics one of the finest, with a representation of the Annunciation, in the Victoria and Albert Museum (Fig. 181), worked in gold, silver, lapis lazuli and other semi-precious stones, is a reflection in miniature of the Kariye Djami style and was produced in the same workshop that made the two panels of miniature mosaic depicting the Twelve Feasts, in the Museo dell'Opera del Duomo at Florence.[6] The composition of the London panel repeats that of the analogous icon on the panel in Florence. The panels of the Twelve Feasts were given to the Church of San Giovanni in Florence in 1394 by a Venetian lady, Nicoletta da Grioni, the widow of a chamberlain of the Emperor John VI Cantacuzene (1341–1355). With these should be grouped a miniature icon in mosaic of St. Theodore Stratelates in the Hermitage Museum (Fig. 182), Christ Pantocrator in the Church of St. Peter and Paul at Chimay (Fig. 183), St. Theodore the Tyro in the Vatican, and St. John Chrysostom in the Dumbarton Oaks Collection.[7] It would seem more than likely that these panels, because of their preciosity and quality, were made in the court workshops.

The Church of the Theotokos Panimakaristos was extensively repaired between 1292 and 1295 by Michael Glabas Tarchaniotes and his wife Maria Ducaena Comnena Palaeologina Blachena. Their mosaic portraits still exist in the church and at one time there were also portraits of the Emperor Andronicus III (1328–1341) and the Empress Anna. Alterations were made in the pareeclesion about 1315, and it is possible that the mosaics of Christ and the Twelve Prophets in the dome and the Deesis in the conch of the main church date from this time. An inscription reads 'Martha the nun set up this thankoffering to God in memory of Michael Glabas her husband, who was a renowned warrior and worthy Protostrator'. In the church were the tombs of the Emperor Alexius Comnenus and his daughter, the learned Anna Comnena.[8]

The construction of the first church of St. Saviour in Chora must have preceded the erection of the Theodosian wall in 413, if 'in Chora'

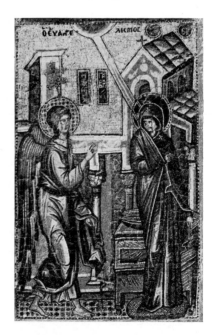

181. *The Annunciation.* Miniature mosaic. Constantinople, early fourteenth century. *London, Victoria and Albert Museum.*

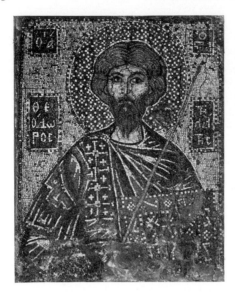 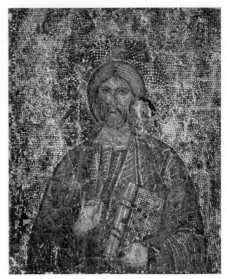

182. *St. Theodore Stratelates.* Miniature mosaic. Constantinople, early fourteenth century.
*Leningrad, Hermitage.*

183. *Christ Pantocrator.* Miniature mosaic. Constantinople, early fourteenth century.
*Chimay, Church of St. Peter and St. Paul.*

means outside the walls. It was restored by Justinian and rebuilt in the reign of
Alexius I Comnenus (1081–1118) by his mother-in-law Maria Dukas. But after the
expulsion of the Latins the church was sorely in need of attention. Restoration was
undertaken at the expense of Theodore Metochites (d. 1331), at the time Logothete
of the imperial treasury, later to become Grand Logothete and chief adviser to the
Emperor Andronicus II Paleologus (1282–1328). Theodore Metochites was not only
a patron of the arts but a scholar, a scientist, and a poet. His claims as patron of the
church are recorded in his poems and in those of his pupil and friend Nicephorus
Gregoras, but, in any case, the mosaic over the tympanum leading from the inner nar-
thex into the church depicts him kneeling before the seated Christ and offering a model
of the church (Fig. 184). He was, moreover, responsible for the additions of the exo-
narthex and the parecclesion. Others were also associated with the church. On the
large mosaic panel on the east wall beneath the southern dome in the exonarthex there
is a representation of Christ and the Virgin standing (Fig. 185), the head and shoul-
ders of Isaac Comnenus, 'the son of the high Emperor Alexius Comnenus Porphyro-
genitus', and the face, headdress and hands of a nun, 'the Kyra of the Mongoulion,
Melane the nun'. The portrait of Isaac Comnenus is commemorative of his
patronage and association with the Monastery of the Chora; he had first intended to
be buried in the church but later transferred his tomb to the Monastery of the
Theotokos Kosmosotira at Vera in Macedonia. Melane, the Kyra of the Mon-
goulion, was Maria Palaeologina half-sister of Andronicus II Palaeologus, a natural

daughter of Michael VIII, known, though not in the strict sense, as foundress and patroness of the convent of the Theotokos Panaghiotissa whose church was that of the Theotokos Mongoulion better known today as St. Mary of the Mongols. Maria Palaeologina was twice betrothed and once married to the Mongol Khans. She outlived her husband and returned to Constantinople. She was prepared in 1307 to marry the Khan Harbadan in an attempt to impress the Sultan Osman, who was menacing the city, though the marriage did not take place. After this gesture she seems to have dropped out of public life. It seems reasonable to suppose that the redecoration in mosaic of the Church of St. Saviour in Chora was carried out between 1310 and 1320.[9]

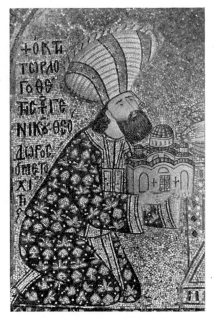

184. *Theodore Metochites, Logothete of the Imperial Treasury*. Detail from the mosaic tympanum in the Church of St. Saviour in Chora; second decade of the fourteenth century. *Istanbul.*

On the vaults and lunettes of the exonarthex the mosaics portray scenes from the life of Christ, and in the narthex scenes from the life of the Virgin taken from the canonical and the apocryphal Gospels. In the domes are busts of Christ and the Virgin surrounded by prophets. On the faces and soffits of the arches are figures of saints. In addition, there is a bust of Christ over the entrance door, opposite this lunette is another with the Virgin and Child between two angels, the large figures of Christ and the Virgin with vestiges of Isaac Comnenus and Melane the nun, and over the door leading into the naos Theodore Metochites offering his church to the enthroned Christ. In the catholikon, over the door, there is a mosaic panel with a representation of the Dormition. On either side of the chancel there is to the left a large mosaic panel with a standing figure of Christ Pantocrator, and to the right a mosaic panel with the standing figure of the Virgin and Child. Over the latter a sculptured tympanum was added later in the century; within the tympanum there is a bust of Christ Pantocrator executed in fresco. It would seem probable that the stone carving should date about the same time as the sculpture framing the arcosolia in the parecclesion which, since it cuts into the frescoes, must date about the middle or into the second half of the fourteenth century.

The scenes from the lives of Christ and the Virgin are presented, for what we know of metropolitan Byzantine art and its nearest refractors, with an extraordinary freedom of expression; they are in marked contrast with the austere, reserved statements of Divine and imperial power in Agia Sophia, the terse but

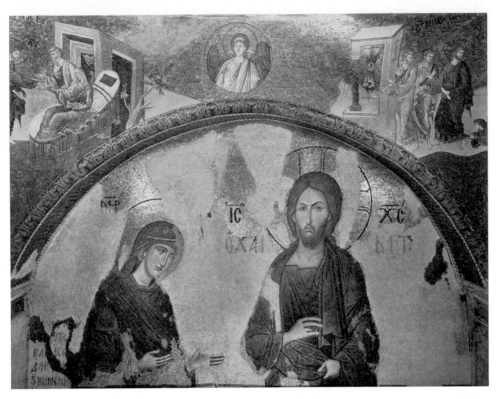

185. *Christ and the Virgin*. Detail from a mosaic panel on the east wall beneath the southern dome in the exonarthex of the Church of St. Saviour in Chora. *Istanbul*.

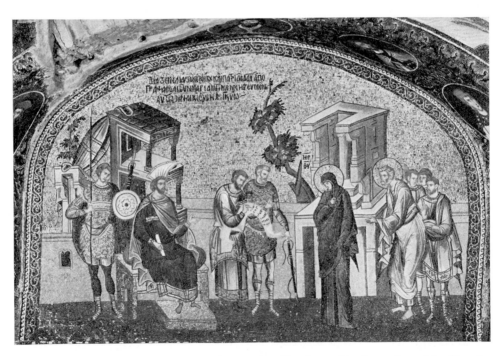

186. *The Virgin and St. Joseph enrolled for taxation*. Mosaic panel in the narthex of the Church of St. Saviour in Chora. *Istanbul*.

charged reminders of the Twelve Feasts in the Nea Moni on Chios or at Daphni. At the same time it must be remembered that we have no visual record of the decorations in Constantinopolitan churches and palaces before 1204 apart from the monuments previously quoted, and it is a reasonable supposition that, if they had survived, Kariye Djami would cease to surprise and the provincialism, not infrequently grossly restored, of South Russian, Sicilian and Venetian mosaics would be shown in its proper light. The increased detail in the Sicilian and Venetian scenes is undoubtedly a reflection of a series of traditions at Constantinople under the Comnenes which today survive only in the illustrations to the sermons of the monk James of Kokkinobaphos and the like. By the twelfth century the old post-iconoclast quasi-puritanical reservations had begun to lapse, the censorship was presumably less rigid, and the needs of the people for a more 'conversational' religious art were being gratified.

The mosaic panel with a representation of the Virgin and St. Joseph being enrolled for taxation illustrates this point (Fig. 186). Iconographically the scene is unusual and stylistically it presents the following new trends: a diminution of the figures in relation to their surroundings, a tendency to portray the human figure in action or in conversation, and an attempt to establish a convincing narrative scene in depth. There is no question of scientific perspective and the gold background, the platform of green mosaic on which the figures are set at varying distances, are constant for all the scenes so that reality never becomes natural. On the other hand, the gold ground and the green band serve to integrate the whole programme. In the Journey to Bethlehem (Fig. 187) the landscape emerges like a theatrical property from the gold background and, although the figures are seen in scale against it, they are not quite part of it. In the same way, the figures have no real relation to the ground over which they float, nor does the Virgin really sit on the ass. Yet the sum of the parts, the exquisite colours, the intrinsic beauty of the convention, makes a visit to the Church of St. Saviour in Chora one of the great aesthetic experiences of a lifetime.[10]

Mosaic is not the only form of decoration in the church. There is a small amount of sculpture: an icon frame on the south-eastern pier, an interior cornice over the main door of the church, a carved archivolt on the north side of the parecclesion, and another on the south wall with the epitaph of Michael Tornikes (d. 1328), Grand Constable and a relative through his mother of the Emperor Andronicus II.[11]

The great glory of the parecclesion is the cycle of frescoes culminating in the magnificent Anastasis in the apse (Fig. 188). The parecclesion was designed as a mortuary chapel; four flat niches once contained sarcophagi and above them, in the back and on the soffits of the arch, were portraits of the deceased. At the east end the frescoes of the Last Judgment, the Anastasis, and the Entry into Paradise combine in an iconographic programme which emphasizes the mortality and the salvation of

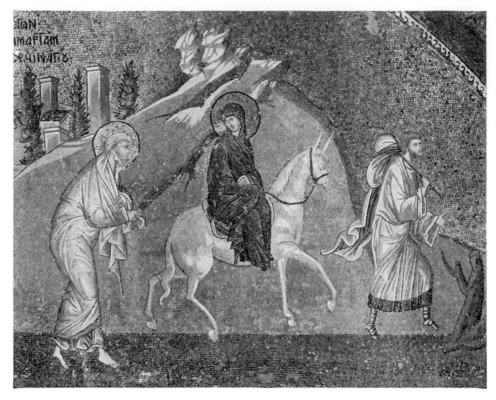

187. *The Journey to Bethlehem.* Detail from a mosaic panel in the narthex of the Church of St. Saviour in Chora. *Istanbul.*

man and presents the Virgin, who reigns over the entire chapel, as the bridge between death and life. In the composition of the Second Coming one of the most beautiful details is that of the angel in flight—reminiscent of the Sarigüzel sarcophagus—across the centre of the vault and rolling back the scroll of heaven which contains the sun, the moon, and the stars (Fig. 189). The flying movement of the angel is superbly interpreted with a wide sweep of wings and agitated drapery. The modelling of the face, arms and feet is graded with acute sensibility. The whole scene with Christ enthroned on a rainbow within a mandorla, surrounded by angels attended by the Virgin and St. John the Baptist, accompanied by the Apostles also enthroned in Judgment (Fig. 190), is one of the masterpieces of Byzantine painting.[12] The noble treatment of the diversity of the Apostles, the intricacy of postures and the serene fall of drapery, less mannered than that of the angel unrolling the scroll of heaven, is echoed in a small panel of remarkable quality in the Museum of Fine Art, Moscow. In the panel the Assembly of the Apostles is presented standing (Fig. 191), but the faces and the rendering of form, the subtlety of shades of colour, and an almost identical treatment of the drapery suggest that it was painted at

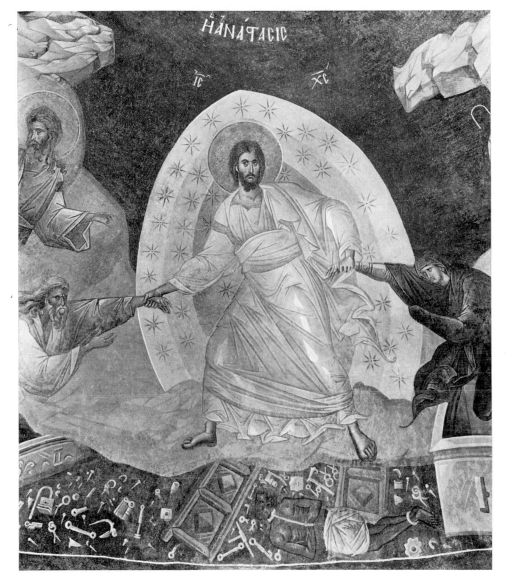

188. *The Anastasis*. Detail from a fresco in the parecclesion of the Church of St. Saviour in Chora. *Istanbul*.

Constantinople at a date close in time to that of the frescoes of the parecclesion of St. Saviour in Chora.[13]

A number of painted icons closely similar in style to the mosaics and frescoes of this church may with some confidence be assigned to Constantinople. An icon of the Annunciation from the Church of St. Clement of Ochrid (Fig. 192) presents similar characteristics: the architectural details, the treatment of the drapery, and the broad, swinging movement of the angel, the conception of form, echo the figure of Christ

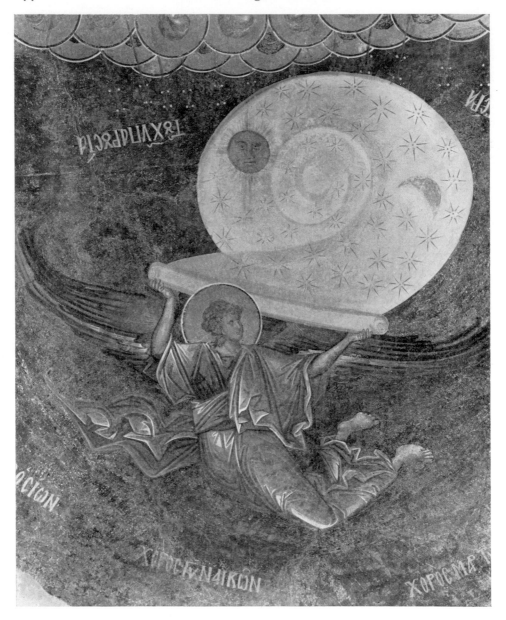

189. *An Angel rolling back the scroll of heaven.* Detail from a fresco in the parecclesion of the Church of St. Saviour in Chora. *Istanbul.*

in the fresco of the Anastasis.[14] Two panels in the Museum of Fine Art, Moscow, an Annunciation and a Dormition of the Virgin (Figs. 193 and 194), must have come from the same workshop at Constantinople.[15] The elaborate architectural background, the introduction of the servant girl peering round a column in the Annunciation, the chorus of Angels and Apostles in the Dormition are redolent of

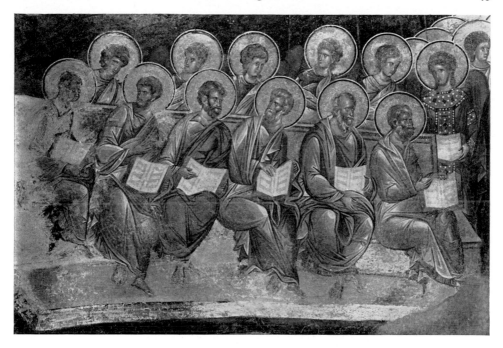

190. *The Apostles.* Detail from a fresco of the Last Judgment in the parecclesion of
the Church of St. Saviour in Chora. *Istanbul.*

the Kariye Djami style. Like the mosaics and frescoes there is never any question of
direct observation from nature but certain dynamic motifs and an elaborate com-
positional formula adapted from the heritage of antiquity make an arresting
synthesis.

Again on the grounds of stylistic relationship with the work at St. Saviour in
Chora the frescoes in the little church of St. Euphemia with fourteen scenes of the
*Passio Euphemiae* (Fig. 195), with representations of St. George and St. Demetrius,
dated in the past to the eighth and ninth centuries, should be seen as works of the
fourteenth century.[16]

It has already been pointed out that the mosaic representation of the Virgin and
Child enthroned in the apse of Agia Sophia should be regarded as largely a
fourteenth-century restoration (Fig. 196).[17] Indeed, this operation seems to have
been the last major undertaking before the Turkish Conquest. In the second half of
the fourteenth century dogmatic controversy and religious reaction on the one hand,
and the increased impoverishment of the Empire, which was gradually being
reduced to the walls of the city, brought an end to large-scale artistic achievement.
When John VI Cantacuzene gave his daughter in marriage to John Palaeologus, so
poor was even the imperial house that the bride and groom were crowned with lead
and at the wedding feast the guests were served on earthenware and pewter.

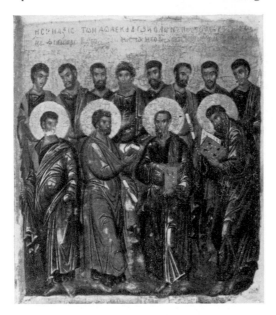
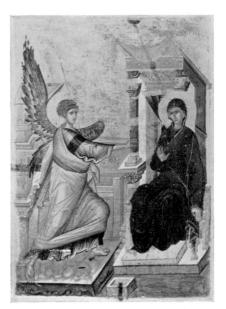

191. *The Assembly of the Apostles.* Icon. Constantinople, early fourteenth century.
*Moscow, Museum of Fine Art.*

192. *The Annunciation.* Icon from the Church of St. Clement, Ochrid. Constantinople,
early fourteenth century. *Skoplje, Macedonian State Collections.*

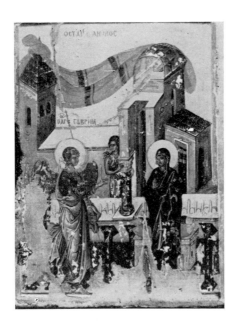
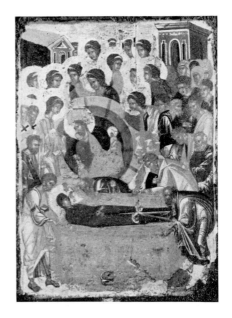

193. *The Annunciation.* Icon. Constantinople, early fourteenth century.
*Moscow, Museum of Fine Art.*

194. *The Death of the Virgin.* Icon. Constantinople, early fourteenth century.
*Moscow, Museum of Fine Art.*

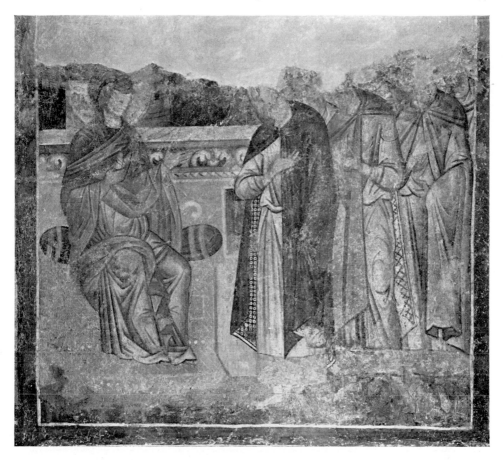

195. *Scene from the Life of St. Euphemia.* From a fresco in the Church of St. Euphemia; first half of the fourteenth century. *Istanbul.*

In manuscript illumination the imperial portrait and the pictures of the great courtiers continued. One of the most splendid is that of the Grand Duke Alexis Apocaucos (d. 1345) which appears in a version of the works of Hippocrates (Fig. 197) executed in the first half of the fourteenth century.[18] The curtains are drawn back to reveal the Grand Duke dressed in a long tunic patterned with a design which looks back to the eleventh century. The Apophthegms of Hippocrates are open before him with an attendant holding the pages. The flat patterns of the Comnene imperial portraits have developed into an incipient naturalism. There is a new solidity of form which dominates the uncertain perspective of chair and reading desk and the face is almost a portrait in the modern sense of the term. This court style continues with the portrait of the Emperor John VI Cantacuzene (1341–1355) in the theological works written after his abdication between 1370 and 1375 when he had become a monk.[19] The three angels above refer to the visit of Jehovah to

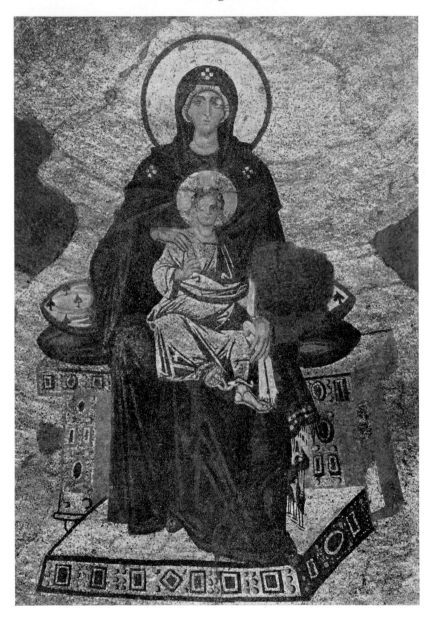

196. *The Virgin and Child*. Detail from the mosaic in the apse of Agia Sophia. *Istanbul.*

Abraham to which as a monk the Emperor points (Fig. 198), holding in his left hand his first Apologia against the Muhammadans. John VI, whether depicted as Emperor or as the monk Joasaph, is revealed in more developed terms of mass and line than the Grand Duke Alexis Apocaucos. This semi-naturalistic rendering is the more interesting when compared with another illumination in the same manuscript with a fine representation of the Transfiguration (Fig. 199), wherein the artist

197. *The Grand Duke Alexis Apocaucos.* From a copy of the works of Hippocrates executed at Constantinople in the first half of the fourteenth century. *Paris, Bibl. Nat. gr. 2144, fol. 11.*

198. *The Emperor John VI Cantacuzene.* From a copy of the theological works of the Emperor John VI Cantacuzene executed at Constantinople between 1370 and 1375.
*Paris, Bibl. Nat. gr. 1242, fol. 123v.*

retails the ingredients of Palaeologue religious style without any attempt to think of the scene afresh. There is always a retrospective aspect to Palaeologue art. While the portrait of the Emperor Manuel II Palaeologus (1391–1425) may be shown in the new 'naturalistic' tradition (Fig. 201) in the funeral oration for his brother Theodore, Despot of Morea (d. 1407),[20] yet in the family portrait of the same Emperor with the Empress Helena and their children John (the future John VIII Palaeologus), Theodore and Andronicus, executed between 1401 and 1408,[21] there is a return to the flat patterns of the Comnene imperial epiphanies (Fig. 200). One of the most beautiful of these court presentations is to be found in the Lincoln College Typicon.[22] This manuscript contains the monastic rule of the Convent of Our Lady of Good Hope at Constantinople, preceded by a preface of the foundress, Euphrosyne Comnena Ducaena Palaeologina, who was a grand-niece of the Emperor Michael VIII Palaeologus. The text is preceded by nine double portraits of the foundress, her parents and other members of her family, as well as by a picture of the Virgin and Child, and one of the whole monastic community. The portraits date towards the end of the fourteenth century; they give a remarkable picture of the imperial family shown in stiff, frontal postures (Fig. 202), their bodies masked in a series of flat patterns, out of which the heads and arms emerge into semi-realistic images. Like the Faiyum mummy portrait of more than twelve hundred years before, the

199. *The Transfiguration* From a copy of the theological works of Emperor John VI Cantacuzene executed at Constantinople between 1370 and 1375. *Paris, Bibl. Nat. gr. 1242, fol. 92v.*

200. *The Emperor Manuel II, the Empress Helena, and their children, John, Theodore and Andronicus.* From a copy of the works of St. Denys the Areopagite executed at Constantinople between 1401 and 1408. *Paris, Musée du Louvre.*

201. *The Emperor Manuel II Palaeologus.* From a copy of the funeral oration delivered by the Emperor Manuel on the death of his brother Theodore, Despot of the Morea (d. 1407). *Paris, Bibl. Nat. Suppl. gr. 309, p. vi.*

202. *A Palaeologue prince and princess.* From a Typicon of the Convent of Our Lady of Good Hope at Constantinople, late fourteenth century. *Oxford, Lincoln College.*

face appears above the stylized, abstract form demanding to be recognized. As far as the official portrait was concerned it might seem that Byzantine art would never change.

And yet almost on the eve of the Turkish Conquest there are signs of a new orientation in the long history of Byzantine style. In one of the arcosolia in the exonarthex of St. Saviour in Chora there are the remains of a tomb painting which

203. *The Virgin and Child and a Woman*. Fragment of a fresco in the parecclesion of the Church of St. Saviour in Chora; middle of the fifteenth century. *Istanbul*.

shows the deceased, probably a woman, standing alone before the Virgin and Child (Fig. 203). The Virgin, for once, is not shown frontally but in three-quarter view and is in the same scale as the woman. Within the perspective of the setting the Virgin appears to be in conversation with the dead. This extraordinary scene is unique in Constantinopolitan art. Emperors and empresses were shown frontally either with Christ as in the Zoe panel or with the Virgin as in the Comnene mosaic but never in colloquy with Divinity or His Mother. In addition, the woman is standing on a marble floor, of which the front edge becomes part of the frame of the picture. Her dress is treated with a firm naturalism of fold and pleat and is patterned from an Italian silk tissue or velvet. The Virgin sits in a chair, her feet on a foot-

stool, each of which conforms to reasonable laws of perspective—unlike the setting for the Grand Duke Alexis Apocaucos. The drapery of the Virgin and the form beneath have a naturalistic quality previously unthinkable in Byzantine art. All these factors may be accounted for by the assumption that the artist was familiar with fifteenth-century art in the West, probably Italy. As the Turks drew nearer to the city, the Emperors made several attempts to enlist the help of the West. John V Palaeologus (1341–1355; 1379–1391) went to Rome in 1369; Manuel II visited Venice, London, and Paris in 1399 and it was in memory of his visit to the Abbey of Saint-Denis that he sent the works of St. Denys the Areopagite which contained the portrait of the imperial family (Fig. 200); John VIII led a delegation of several hundred to the Council of Ferrara, and later of Florence, in 1439. It is possible that the artist of the fresco in St. Saviour in Chora was a member of the retinue. We know, too, that in the fifteenth century there were a number of humanists such as Gemistus Plethon at Constantinople who were capable of astounding their counterparts in the West by their learning. Under the influence of such as these, and with the direct impact of the Italian Renaissance within the walls, Byzantine art might have turned to new glories after more than a thousand years of creative activity. But there was no longer any money and the Turks were outside the walls.[23]

On 29th May 1453 the Turks entered the city. The Emperor Constantine XI Dragases (1448–1453) was killed after a heroic resistance near the gate of St. Romanus and his body was later recognized only by the red buskins on his feet. His head was exposed during Wednesday, 30th May, at the foot of the column which bore the statue of Justinian and which had originally borne the statue of St. Helena. The Palace of the Blachernae had been burnt down in the assault upon the city. The Great Church of Holy Wisdom was once more stripped of its treasure and the Koran was read for the first time beneath the dome of Justinian. The population which had survived the massacre—at the time of the Conquest it numbered some fifty thousand souls—was sent to Adrianople, Bursa, Gallipoli, and Philippopolis. The new townsmen introduced by the Greek-speaking Mehmet II, who claimed that his Byzantine ancestors gave him the right to conquer Constantinople, knew nothing of the old city, neither its customs, nor the names of its streets, nor its monuments, and all that had been handed down from father to son from time immemorial sank into oblivion.[24] Oblivion? Just as the Great Church of Holy Wisdom was to inspire the most brilliant of Turkish architects, just as that which has survived through the mystery of Turkish respect becomes visible to the astonished eye of the twentieth century archaeologist, so too the complexities of the protocol of the Topkapu Saray and the Sublime Porte were to refract, as through broken glass, the serene order of the palatine rites of the Byzantine Emperors.

# NOTES

# GLOSSARY

# CHRONOLOGICAL TABLE

# INDEX

L

# NOTES

## I

1. A. Grabar, *L'Empereur dans l'Art Byzantin*, Paris, 1936; F. Dvornik, *The Idea of Apostolicity in Byzantium and the Legend of St. Andrew*, Dumbarton Oaks Studies IV, Harvard University Press, Cambridge, Mass., 1948, p. 4.
2. E. Kitzinger, 'The Cult of Images in the Age Before Iconoclasm,' *Dumbarton Oaks Papers*, VIII, 1954, pp. 90 ff., 122 ff.
3. Dvornik, *op. cit.* pp. 73–74, 81.
4. The Nichomachi-Symmachi diptych, now divided between the Musée de Cluny, Paris, and the Victoria and Albert Museum, London. For this and related pieces, cf. W. F. Volbach, *Elfenbeinarbeiten der Spätantike und des frühen Mittelalters*, Mainz, 1952, Nos. 55, 57, 62, 108, 110, 111, 116.
5. E. Coche de la Ferté, *L'Antiquité Chrétienne au Musée du Louvre*, Paris, 1958, p. 42.
6. A. A. Vasiliev, *Justin I*, Dumbarton Oaks Studies I, Harvard University Press, Cambridge, Mass., 1950.
7. Doro Levi, *Antioch Mosaic Pavements*, Princeton University Press, 1947.
8. E. M. Forster, *Alexandria, A History and a Guide*, Alexandria, 1922, pp. 52 ff.
9. K. A. C. Creswell, *Early Muslim Architecture*, I, Oxford University Press, 1932.
10. R. W. Hamilton, *Khirbat al-Mafjar: An Arabian Mansion in the Jordan Valley*, Oxford, 1959.
11. H. A. R. Gibb, 'Arab-Byzantine Relations under the Umayyad Caliphate,' *Dumbarton Oaks Papers*, XII, pp. 219 ff.
12. H. Buchthal, 'The Paintings of the Syrian Jacobites in its relations to Byzantine and Islamic Art,' *Syria*, XX, 1939, pp. 136 ff.; Buchthal, ' "Hellenistic" Miniatures in Early Islamic Manuscripts,' *Ars Islamica*, VII, 1940, pp. 125 ff.; P. du Bourguet, S. J., 'La fabrication des tissus aurait-elle largement survécu à la conquête arabe?' *Bulletin de la Société Archéologique d'Alex-*

andrie, XL, 1953, pp. 1–31; du Bourguet, 'Un groupe de tissus coptes del'époque musulmane,' *Cahiers de Byrsa (Revue du Musée Lavigerie à Carthage)*, III, 1953, pp. 167–197.

## II

1. The baths of Zeuxippos were destroyed, together with the Church of Agia Sophia, parts of the Great Palace, and some quarters of the city, during the Nika riots of 532.
2. In the Hippodrome, along the *spina*, under the arcades above the stalls, among the seats on all levels were statues from all parts of the Greco-Roman world, ranging from the works of Phidias to the statue of Diocletian.
3. Cf. A. van Millingen, *Byzantine Constantinople, The Walls of the City and Adjoining Historical Sites*, London, 1899; R. Janin, *Constantinople Byzantine, Développement Urbain et Répertoire Topographique*, Archives de l'orient Chrétien, IV, Institut français d'études byzantines, Paris 1950.
4. Eusebius, *Life of Constantine*, iii, c. 48.
5. Cf. A. A. Vasiliev, 'Imperial Porphyry Sarcophagi in Constantinople,' *Dumbarton Oaks Papers*, IV, 1948, pp. 1 ff. Nine porphyry sarcophagi are listed in the *Book of Ceremonies* (c. 42) as being in the Church of the Holy Apostles; among which are noted those of Constantine I, buried with his mother Helena (324–337), Constantius II (337–361), Julian the Apostate (361–363), Jovian (363–364), Theodosius I (379–395), Arcadius (395–408) and his wife Eudoxia, Theodosius II (408–450), Marcian (450–457) and his wife Pulcheria. Five porphyry sarcophagi were at one time in the grounds of the Church of St. Irene, of which three and two lids were transported in 1916 to the Archaeological Museum. In 1910 a rectangular body of a porphyry sarcophagus without its lid, which had been found near the Column of Marcian, was transferred to the same museum. The body of

a sarcophagus found in the yard of the Nuri-Osmaniye mosque, a fragment near the railway bridge, and a sculptural fragment—probably that of Constantine I—found in the precincts of St. Irene brings the total to nine.

6. Cf. F. Gnecchi, *I Medaglioni Romani*, I, Milan, 1912, p. 58, No. 13.

7. Cf. J. M. C. Toynbee, 'Roma and Constantinopolis in Late Antique Art,' *Journ. Rom. Stud.*, XXXVII, 1947, pp. 135 ff.

8. Cf. Gnecchi, op. cit., I, p. 30, No. 10.

9. London, British Museum, *Catalogue of Roman Medallions*, by Herbert A. Grueber, ed. by R. S. Poole, 1874, No. 2.

10. R. Delbrueck, *Spätantike Kaiserporträts*, Berlin-Leipzig, 1933, p. 206, pl. 105, fig. 70; Gerda Bruns, *Staatskameen des 4. Jahrhunderts nach Christi Geburt*, Winckelmannsprogramm, No. 104, Berlin, 1948, pp. 31 ff.; E. Coche de la Ferté, *Le Camée Rothschild: un chef d'oeuvre du IVe siècle aprés J. C.*, Paris, 1957, who gives a full bibliography, pp. 57–58.

11. Cf. E. Gibbon, *Decline and Fall of the Roman Empire*, Milman edition, London, 1846, II, p. 115. The primary source is Ammianus, I, xvi, c. 10.

12. Cf. L. Matzulewitsch, 'A Silver Dish from Kertch,' *Monuments of the Hermitage*, II, Leningrad, 1926, (in Russian); L. Matzulewitsch, *Byzantinische Antike*, Berlin, 1929, pp. 95–97, pl. 23; H. Peirce and R. Tyler, *L'Art Byzantin*, Paris, 1932, I, pl. 27; A. Grabar, *L'Empereur dans l'art byzantin*, Paris, 1936, pp. 43–48.

13. Cf. Matzulewitsch, *Byzantinische Antike*, pp. 95–100, pls. 23–25.

14. Cf. Matzulewitsch, *Byzantinische Antike*, p. 132, pls. 36–43; E. Buschor, 'Bronzekanne aus Samos,' *Abh. Ak. Berlin*, 1943, *Phil-hist.* No. 17, pp. 7, 9, 13, 24, 26.

15. Cf. J. P. C. Kent, 'Notes on some fourth-century coin types,' *Numismatic Chronicle*, Sixth Series, XIV, 1954, pp. 216–217.

16. Cf. J. W. E. Pearce, *Roman Imperial Coinage*, IX, London, 1951, p. 209, No. 1.

17. Cf. Comte Jean Tolstoi, *Monnaies Byzantines*, St. Petersburg, 1912–1914, I, pl. I, No. 1.

18. Cf. *Numismatic Chronicle*, XIX, 1955; Frolow in *Archives de l'orient Chrétien*, I, *Memorial Louis Petit*, 1948, p. 78; Blanchet in *Revue Numismatique*, XI, 1949, p. 155.

19. Cf. J. M. C. Toynbee, *Roman Medallions*, American Numismatic Society, Numismatic Studies No. 5, New York, 1944, p. 183; W. Wroth, *Catalogue of the Imperial Byzantine Coins in the British Museum*, London, 1908, I, p. 25.

20. Cf. G. Bruns, *Der Obelisk und seine Basis auf dem Hippodrom zu Konstantinopel*, Deutsch. arch. Inst., Istanbuler Forschungen, VII, Istanbul, 1935; W. F. Volbach, *Frühchristliche Kunst*, Munich, 1958, p. 56.

21. G. Mendel, *Catalogue . . . Musées Impériaux Ottomans*, No. 506; Delbrueck, *Spätantike Kaiserporträts*, pp. 195–197; J. Kollwitz, *Oströmische Plastik der Theodosianischen Zeit*, Berlin, 1941, pp. 81–83; M. Squarciapino, *La Scuola di Afrodisia*, Museo dell' Impero Romano, Rome, 1943, p. 73; Volbach, op. cit., p. 54.

22. Cf. N. Firatli in *A.J.A.*, LV, 1951, pp. 67–71; N. Firatli, *Short Guide to the Byzantine Works of Art in the Archaeological Museum of Istanbul*, 1955, pl. I, 2; Volbach, op. cit., p. 56.

23. R. Delbrueck, *Die Consulardiptychen und verwandte Denkmäler*, Berlin, 1929, No. 62; Delbrueck, *Spätantike Kaiserporträts*, p. 200; H. P. L'Orange *Studien zur Geschichte des spätantiken Porträts*, Berlin, 1933, p. 67; Volbach, op. cit., pp. 55–56.

24. Kollwitz, *Oströmische Plastik*, p. 121; Squarciapino, op. cit., pp. 75–76.

25. Mendel, *Catalogue*, No. 507; L'Orange, *Studien*, p. 81; Kollwitz, *Oströmische Plastik*, p. 84; Squarciapino, op. cit., p. 95; Volbach, op. cit., pp. 57–58.

26. Mendel, *Catalogue*, No. 508; L'Orange, *Studien*, p. 80; Kollwitz, *Oströmische Plastik*, pp. 83–84; Squarciapino, op. cit., p. 74; Volbach, op. cit., p. 58.

27. Arif Müfit Mansel, *Ein Prinzensarkophag aus Istanbul*, Istanbul, 1934; H. von Schönebeck in *Röm. Mitt.*, LI, 1926, p. 326; Kollwitz, *Oströmische Plastik*, pp. 132 ff.; Volbach, op. cit., p. 59; E. Kitzinger, 'A Marble Relief of the Theodosian Period', *Dumbarton Oaks Papers*, XIV, 1960, pp. 19 ff.

28. G. Wilpert, *I Sarcophagi Cristiani*, Rome, 1929, pl. 188, 189; Volbach, op. cit., p. 54.

29. A. M. Schneider, *Die Grabung im Westhof der Sophienkirche zu Istanbul*, Deutsch. Arch. Inst., Istanbuler Forschungen, XII, Berlin, 1941, pl. 17, 1, pl. 18, 3.

30. Kollwitz, *Oströmische Plastik*, pp. 153 ff.

31. Mendel, *Catalogue*, No. 667; Kollwitz, *Oströmische Plastik*, pp. 77–80; Volbach, *op. cit.*, p. 58.

32. Kollwitz, *Oströmische Plastik*, pp. 67 ff., and pl. 12.

33. A. A. Vasiliev in *Dumbarton Oaks Papers*, IV, 1928, pp. 27–50; A. Grabar, *L'Iconoclasme Byzantin*, Paris, 1957, pp. 157–158.

34. Kollwitz, *Oströmische Plastik*, pp. 166 ff.; K. Wessel, *Rom, Byzanz, Russland, Ein Führer*, Berlin 1957, p. 123; Volbach, op. cit., pp. 58–59.

35. C. R. Morey, *Sardis V, The Sarcophagus of Claudia Antonia Sabina and the Asiatic Sarcophagi*, Princeton University Press, 1924.

36. Mendel, *Catalogue*, No. 661; Peirce and Tyler, *L'Art Byzantin*, I, No. 87; Volbach, op. cit., p. 59.

37. Mendel, *Catalogue*, No. 670; Kollwitz, *Oströmische Plastik*, pp. 163 ff.; and of Note 63.

38. Mendel, *Catalogue*, No. 668; Kollwitz, *Oströmische Plastik*, p. 174.

39. A. Grabar, *L'Empereur dans l'Art Byzantin*, Paris, 1936, p. 16; Delbrueck, *Spätantike Kaiserporträts*, p. 219; Kollwitz, *Oströmische Plastik*, pp. 93–94; Volbach, op. cit., p. 58; Michele Cassandro, *Il Colosso di Barletta*, Barletta 1959.

40. A similarity in style between the head of the Barletta Colossus and the head of a saint or a philosopher from Ephesus, now in the Kunsthistorisches Museum at Vienna, would suggest that the usual fifth-century date attributed to this carving is also too early. The arched brows over the staring eyes, the heavy lines framing the upper lip, the pinched nose and mouth link the two heads into some period outside the fifth century.

41. *The Great Palace of the Byzantine Emperors, First Report*, Oxford University Press, 1947. For summary of counter-suggestions made after the First Report, c.f. *The Great Palace of the Byzantine Emperors, Second Report*, Edinburgh, The University Press, 1958, pp. 161 ff.

42. *The Great Palace, Second Report*, pp. 161–167; C. Mango and I. Lavin's review of the Second Report in *Art Bulletin*, XLII, 1960, pp. 67 ff. Mango suggests the possibility of a date for the mosaics in the reign of Tiberius II (578–582). Lavin prefers a sixth to a fifth century date.

43. A. van Millingen, *Byzantine Churches in Constantinople*, London, 1912; F. W. Deichmann, *Studien zur Architektur Konstantinopels im 5. und 6. Jh. n. Chr.*, Deutsche Beiträge zur Altertumswissenschaft, Heft 4, Baden-Baden, 1956; R. Janin, *La Géographie Ecclésiastique de l'Empire byzantin, III, Les Églises et les Monastères*, Institut français d'Etudes byzantines, Paris, 1953.

On the Church of Agia Sophia: G. Fossati, *Aya Sofia*, Constantinople-London, 1852; W. Salzenberg, *Altchristliche Baudenkmäle von Konstantinopel*, Berlin, 1854; W. R. Lethaby and H. Swainson, *The Church of Sancta Sophia, Constantinople, a Study of Byzantine building*, London, 1894; E. M. Antoniades, *Hagia Sophia*, Athens, 1907–1919; W. R. Zaloziecky, *Die Sophienkirche in Konstantinopel und ihre Stellung in der Geschichte der abendländischen Architektur*, Rome, Pont. Ist. di Arch. crist., 1936; A. M. Schneider. *Die Hagia Sophia*, Berlin, 1939; E. H, Swift, *Hagia Sophia*, New York, 1940; Glanville Downey, 'Justinian as a builder,' *Art Bulletin*, XXXII, 1950, pp. 262–263.

44. J. Strzygowski and Forchheimer, *Die Wasserbehälter von Konstantinopel*, Vienna, 1893; A. M. Schneider, Byzanz, *Vorarbeiten zur Topographie und Archäologie der Stadt.*, Deutsch. Arch. Inst. Istanbuler Forschungen, Berlin, 1936; F. Dirimtekin, 'Adduction de l'eau à Byzance,' *Cahiers Archéologiques*, X, 1959, pp. 217 ff.

45. E. Kitzinger, 'Byzantine Art in the Period between Justinian and Iconoclasm,' *Berichte zum XI. Internat. Byz. Kongress*, Munich, 1958, p. 42.

46. E. Kitzinger, 'The Cult of Images in the Age before Iconoclasm,' *Dumbarton Oaks Papers*, VIII, 1954, pp. 129 ff.

47. O. M. Dalton, *Catalogue of Ivory Carvings. . . . in the British Museum*, London, 1909, No. 11; Volbach, *Elfenbeinarbeiten*, No. 109; Talbot Rice, *Art of Byzantium*, No. 48.

48. A. A. Vasiliev, *Justin I*, Dumbarton Oaks Studies, 1, Harvard U.P., Cambridge, Mass., 1950, pp. 418 ff.

49. Delbrueck, *Consulardiptychen*, Nos. 9–15, 16, 18–21; Volbach, *Elfenbeinarbeiten der spätantike und des frühen Mittelalters*, Mainz, 1952, Nos. 8–14, 15, 17–22.

50. E. Diez, Die Miniaturen des Wiener Dioscurides, *Byzantinische Denkmäler*, III, 1903, pp. 1 ff.; A. von Premerstein, 'Anicia Juliana im Wiener Dioscurides Kodex,' *Jb. der kunsthist. Samml. des allerhöch. Kaiserh.* XXIV, 1903, pp. 103 ff.; A. von Premerstein, K. Wessely, J. Mantuani *Dioscurides, Codex Aniciae Julianae. . . . phototypice editus*, Leyden, 1906; H. Gerstinger, *Die griechische Buchmalerei*, Vienna, 1926, I, pp. 19 ff. P. Buberl, Die antiken Grundlagen der Miniaturen des Wiener Dioscurideskodex, *Jb. des deutsch. arch. Inst.*, LI, 1936; pp. 114 ff.

51. Delbrueck, *Consulardiptychen*, No. 22; Volbach, *Elfenbeinarbeiten*, No. 24.

52. Delbrueck, *Consulardiptychen*, No. 51; Peirce and Tyler, *L'Art Byzantin*, No. 27; A. Grabar, *L'Art byzantin*, Paris, 1938, fig. 36; de Loos-Dietz, *Bulletin*, 's-Gravenhage, XXIX, 1954, p. 77; Volbach, *Elfenbeinarbeiten*, No. 51; Ravenna, *Mostra degli Avori dell'Alto Medioevo, Catalogue*, 1956 (2nd edition), No. 53.

For a summary of the various opinions about the identity of this Empress, cf. Edinburgh-London, *Masterpieces of Byzantine Art*, 1958, No. 39. To this should be added that Rumpf has suggested Galla Placidia or her daughter-in-law Licinia Eudoxia (who married Valentinian III) and a date about 450. Cf. A. Rumpf, *Stilphasen der spätantike Kunst. Ein Versuch*, Köln, 1957, p. 32. Volbach in 'Les Ivoires sculptés de l'époque carolingienne au XIe siècle,' *Cahiers de Civilisation Médiévale, X–XII*

*siècles*, I, 1958, p. 19, assigns the two panels to the middle of the sixth century.

53. Delbrueck, *Consulardiptychen*, No. 48; Grabar, *L'Empereur dans l'Art byzantin*, pp. 48–49; Volbach, *Elfenbeinarbeiten*, No. 48; Coche de la Ferté, *L'Antiquité Chrétienne au Musée du Louvre*, Paris, 1958, pp. 95–96; Volbach, *Frühchristliche Kunst*, p. 87.

54. Delbrueck, *Consulardiptychen*, No. 49; Volbach, *Elfenbeinarbeiten*, No. 49; Ravenna, *Mostra degli Avori*, No. 52; Edinburgh-London, *Masterpieces*, Nos. 41, 42.

55. C. Cecchelli, *La Cattedra di Massimiano*, Rome, 1936–1944; Volbach, *Elfenbeinarbeiten*, No. 140; Ravenna, *Mostra di Avori*, No. 65; Volbach, *Frühchristliche Kunst*, pp. 88–89. The Chair was almost certainly a gift from the Emperor Justinian to Bishop Maximian of Ravenna about 547 and must, therefore, be regarded as Constantinopolitan work.

56. Delbrueck, *Consulardiptychen*, No. 26; Volbach, *Elfenbeinarbeiten*, No. 25; Edinburgh-London, *Masterpieces*, No. 50.

57. Delbrueck, *Consulardiptychen*, No. 34; Volbach, *Elfenbeinarbeiten*, No. 33; A. Grabar, *L'Iconoclasme Byzantin*, Paris, 1957, pp. 18, 24; Edinburgh-London, *Masterpieces*, No. 52.

58. Volbach, *Elfenbeinarbeiten*, No. 68; Volbach, *Frühchristliche Kunst*, p. 88.

59. A. Matzulewitsch, *Byzantinische Antike*, pp. 112 ff., p. 31; A. Alföldi and E. Cruikshank, 'A Sassanian Silver Phalera at Dumbarton Oaks,' *Dumbarton Oaks Papers*, XI, 1957, pp. 237 ff., esp. p. 242.

60. Dumbarton Oaks Collection, *Handbook*, 1955, No. 132.

61. Matzulewitsch, *Byzantinische Antike*, pp. 75 ff. and pl. 16, pp. 101 ff. and pls. 26–27; Edinburgh-London, *Masterpieces of Byzantine Art*, No. 28, for the Dish of Paternus.

62. Matzulewitsch, *Byzantinische Antike*, pp. 25 ff., 39 ff. and pls. 3, 4.

63. For the Cross of Justin II, cf. M. Rosenberg, 'Ein goldenes Pektoralkreuz,' *Pantheon*, I, 1928, pp. 151 ff.; Pierce and Tyler, *L'Art Byzantin*, II, pls. 136, 199b; D. Talbot Rice, *The Art of Byzantium*, London, 1959, No. 71.

For the Stuma paten, cf. J. Ebersolt, 'Le Trésor de Stuma au Musée de Constantinople,' *Revue Archéologique*, 4e séries, XVII, 1911, pp. 407 ff.; L. Bréhier in *Gazette des Beaux Arts*, 5e période, I, 1920, pp. 173 ff.; Peirce and Tyler, *L'Art Byzantin*, II, pl. 140, A. Alföldi and E. Cruikshank, 'A Sassanian Silver Phalera at Dumbarton Oaks,' *Dumbarton Oaks Papers*, XI, 1957, p. 244, n. 30; Volbach, *Frühchristliche Kunst*, p. 91; Talbot Rice, *Art of Byzantium*, pl. 69. For the Riha paten, cf. Peirce and Tyler, *L'Art Byzantin*, II, pl. 144; Dumbarton Oaks Collection, *Handbook*, No. 129.

Cf. also E. Kitzinger, in *Berichte zum XI. Internationalen Byzantinisten-Kongress*, 1958, pp. 18 ff.

There is a tradition that the small reliquary of the True Cross in the convent of Sainte-Croix at Poitiers was a gift from Justin II and the Empress Sophia to St. Radegonde. The case with six enamelled roundels depicting the busts of saints and the casket disappeared during the French Revolution. The style of the existing reliquary is perplexing and doubt has been expressed over the identification of the reliquary with the gift of Justin II. Cf. M. Rosenberg, *Geschichte der Goldschmiedekunst. Zellenschmelz*, III, Frankfurt am Main, 1921, pp. 16 ff.; Sir Martin Conway, 'St. Radegund's Reliquary at Poitiers,' *Antiquaries Journal*, III, 1923, pp. 1 ff.; Talbot Rice, *Art of Byzantium*, pl. 70 (above).

64. G. Downey, 'The Inscription on a Silver Chalice from Syria in the Metropolitan Museum of Art,' *A.J.A.*, LV, 1951, pp. 349 ff.

65. Cf. A. Grabar in *Actes du VIe Congrès Int. d'Études Byzantines*, Paris, 1951, II, p. 135.

66. *Numismatic Chronicle*, Sixth Series, XV, 1955, p. 55; Marvin C. Ross, 'A Byzantine Gold Medallion at Dumbarton Oaks,' *Dumbarton Oaks Papers*, XI, 1957, pp. 247 ff.; Volbach, *Frühchristliche Kunst*, p. 92.

67. Matzulewitsch, *Byzantinische Antike*, pp. 18 ff., 59 ff., pl. 2; pp. 65 ff., pls. 12–15; pp. 38 ff., pls. 7–11, pp. 9 ff., 45 ff., pl. 1; Edinburgh-London,

*Masterpieces of Byzantine Art*, No. 47; Volbach, *Frühchristliche Kunst*, pp. 93, 92; Talbot Rice, *Art of Byzantium*, pl. 75.

68. O. M. Dalton in *Archaeologia*, LX, 1906, p. 1; M. Rosenberg, *Der Goldschmiede Merkzeichen*, 3rd edition, IV, Berlin, 1928, pp. 613 ff.; Matzulewitsch, *Byzantinische Antike*, *passim* for the control stamps; E. Kitzinger in *Berichte zum XI. Internationalen Byzantinisten-Kongress*, Munich, 1958, pp. 3 ff.; Volbach, *Frühchristliche Kunst*, p. 92; Talbot Rice, *Art of Byzantium*, pls. 72–73; E. Cruikshank Dodd, *Byzantine Silver Stamps, Dumbarton Oaks Studies VII*, 1961, pp. 136 ff.

## III

1. A. Grabar, *L'Iconoclasme Byzantin*, Paris, 1957, ch. I.

2. E. Kitzinger, 'The Cult of Images in the Age Before Iconoclasm,' *Dumbarton Oaks Papers*, VIII, 1954, pp. 85 ff.; E. Kitzinger, 'Byzantine Art in the Period between Justinian and Iconoclasm,' *Berichte zum XI. Internationalen Byzantinisten-Kongress*, Munich, 1958, esp. pp. 14 ff. for a review of the problems connected with the mosaics of the Church of the Dormition at Nicaea.

3. Kitzinger in *D.O.P.*, VIII, 1954, esp. pp. 95 ff.

4. Paul J. Alexander, *The Patriarch Nicephorus of Constantinople*, Oxford University Press, 1958, ch. I.

The inscription of the Emperor Leo III over the Chalke Gate is quoted in Lethaby and Swainson, *Sancta Sophia*, p. 281. but cf C. Mango, *The Brazen Gate*, Copenhagen, 1959, pp. 122 ff., who suggests that the inscription dates from 815 and refers to Leo V and his son Symbolios-Constantine.

5. *Theophanes Continuatus*, ed. Bonn, p. 99.

6. For the Church of St. Irene, cf. W. S. George, *The Church of St. Eirene at Constantinople*, Oxford University Press, 1913, pp. 47 ff., and pl. 17; for the mosaics in Agia Sophia, cf. Paul A. Underwood, 'Notes on the Work of the Byzantine Institute in Istanbul, *c.* 1954,' *Dumbarton Oaks Papers*, X, 1956 pp. 292 ff.

7. A. Grabar. *L'Iconoclasme Byzantin*,

Paris, 1957, ch. V and VI; A. Grabar, 'Le Succès des arts orientaux à la Cour byzantine sous les Macédoniens,' *Münchner Jahrbuch*, 3rd Series, II, 1951, pp. 56 ff.

8. K. A. C. Creswell, *Earl Muslim Architecture*, I, Oxford, 1932.

9. O. von Falke, *Kunstgeschichte der Seidenweberei*, Berlin, 1913, I, p. 68 and fig. 87; Peirce and Tyler, *L'Art Byzantin*, I, pl. 187a; for a brief review of preceding literature and for arguments in favour of an eighth century date, cf. Edinburgh-London, *Masterpieces of Byzantine Art*, No. 56.

10. Falke, *Seidenweberei*, II, p. 4; A. F. Kendrick, *Catalogue of Early Mediaeval Woven Fabrics*, London, 1925, No. 1012; A. Grabar, *L'Empereur dans l'art byzantin*, pp. 62–63, pl. IX; Peirce and Tyler, 'Three Byzantine Works of Art,' *Dumbarton Oaks Papers*, II, 1941, p. 23, and pl. 10b; Edinburgh-London, *Masterpieces of Byzantine Art*, No. 64.

11. Falke, *Seidenweberei*, II, p. 4, and fig. 219; Grabar, *L'Iconoclasme Byzantin*, p. 180.

12. Constantine VII Porphyrogenitus, *Le Livre des Cérémonies*, ed. A. Vogt, Paris, 1935, I, ch. 26 (17), pp. 92–93—where the Emperor mounts a horse to the feet and tail of which are attached silk ribbons. These ribbons are well known on Sasanid rock-sculptures at Taq-i-Bostan in Persia and on a Sasanid textile, cf. A. U. Pope, *Survey of Persian Art*, Oxford University Press, 1938, IV, pl. 154 B, 165 A, 202 B.

13. K. Weitzmann, *Die Byzantinische Buchmalerei des IX. und X. Jahrhunderts*, Berlin, 1935, pp. 1 ff., and figs. 1–5.

14. Grabar, *L'Iconoclasme Byzantin*, pp. 115 ff.

15. C. R. Morey, 'The Mosaics of Hagia Sophia,' *The Bulletin of the Metropolitan Museum of Art*, N.S. II, 1944, pp. 201 ff.; T. J. Whittemore, 'On the Dating of Some Mosaics in Hagia Sophia,' *Bull. Met. Mus.*, N.S. V, 1946–1947, pp. 34 ff. and cf. also *A.J.A.*, XLVI, 1942, pls. I-IV, pp. 169 ff.; S. der Nersessian, 'Le décor des églises du IXe siècle,' *Actes du VIe Congrès Int. des Études byzantines*, Paris, 1948, II, pp. 315–320; A. Frolow, 'La mosaique murale byzantine,' *Byzantinoslavica*, XII, 1951, pp. 189–190; C. A. Mango, 'Documentary evidence on the Apse mosaics of St. Sophia,' *Byzantinische Zeitschrift*, XLVII, 1954, pp. 395 ff.; F. Dvornik, 'The Patriarch Photius and Iconoclasm,' *Dumbarton Oaks Papers*, VII, 1953, pp. 77 ff.; R. J. H. Jenkins and C. A. Mango, 'The Tenth Homily of Photius,' *Dumbarton Oaks Papers*, X, 1956, pp. 139–140; Grabar, *L'Iconoclasme Byzantin*, pp. 185 ff., 241 ff. In 1964 scaffolding was set up in the apse of Agia Sophia and a detailed survey was made of the mosaic decoration. Professor Cyril Mango and Mr. Ernest Hawkins have now established that there were only two phases of work undertaken, one in the sixth century and one in the ninth. There is no sign of later restoration, cf. C. Mango and E. J. W. Hawkins, 'The Apse Mosaics of St. Sophia at Istanbul,' *Dumbarton Oaks Papers*, XIX, 1965, pp. 115 ff. On the mosaics in the apse of the Church of the Dormition at Nicaea, cf. P. A. Underwood, 'The Evidence of Restorations in the Sanctuary Mosaics of the Church of the Dormition at Nicaea,' *Dumbarton Oaks Papers*, XIII, 1959, pp. 235. Underwood establishes three stages: 1. the work of the founder Hyakinthos, 2. iconoclast changes, 3. post-iconoclast restorations. He concludes that both the Virgin in the apse and the angels were restored by Naukratios some time after 843.

## IV

1. Thomas Whittemore, *The Mosaics of St. Sophia at Istanbul, Preliminary Report on the First Year's Work, 1931–1932, The Mosaics of the Narthex*, Oxford University Press, 1933; C. Osieczkowska, 'La mosaique de la Porte Royale à Sainte-Sophie de Constantinople et les litanies de tous les Saints,' *Byzantion*, IX, fasc. 1, 1934, pp. 41 ff.; V. N. Lasarev, *History of Byzantine Painting*, Moscow, 1948, (in Russian), I, pp. 86 ff., pls. XVII, II, pls. 86–89; A. Grabar, 'La Représentation de l'Intelligible dans l'Art Byzantin du Moyen Age,' *Actes du VI Cong. Int. d'Etudes byzant. Paris*, 1951, pp. 127 ff.;

Grabar, *L'Iconoclasme Byzantin*, pp. 183 ff., esp. pp. 239–241; L. Mirković, 'Das Mosaik über der Kaisertür im Narthex der Kirche der M. Sophia in Konstantinopel,' *Atti dello VIII Congresso internazionale di Studi bizantini*, Rome, 1953, II, pp. 206 ff.; Jean Meyendorff, 'L'Iconographie de la Sagesse Divine dans la tradition byzantine,' *Cahiers Archéologiques*, X, 1959, pp. 259 ff., esp. p. 264. V. N. Lasarev, in *Art Bulletin*, XVII, 1935, p. 215, n. 57. In the somewhat coarse style of this mosaic with its heavy, large-headed angel, Lasarev discovers the influence of the popular art of the iconoclastic period, which flooded Constantinople in the second half of the ninth century after the re-establishment of icon worship. He compares the work with the mosaics in Agia Sophia at Salonika, with the images in the Khludov Psalter (Moscow, Historical Museum), and the ivory sceptre of Leo VI.

2. P. A. Underwood, 'A Preliminary Report on some unpublished mosaics in Hagia Sophia: Season of 1950 of the Byzantine Institute,' *A.J.A.*, LV, 1959, pp. 367 ff.; for the recently uncovered mosaic portrait of the Emperor Alexander (912–913), brother of Leo VI, in the North gallery of Agia Sophia, cf. Underwood, 'Notes on the Work of the Byzantine Institutes in Istanbul: 1957–1959', *Dumbarton Oaks Papers*, XIV, 1960, pp. 213–214, fig. 14.

3. A. Goldschmidt and K. Weitzmann, *Die Byzantinischen Elfenbeinskulpturen des X. bis XIII. Jahrhunderts*, Berlin, 1934, II, No. 88, No. 35; Edinburgh-London, *Masterpieces of Byzantine Art*, No. 59, No. 63; and cf. A. Goldschmidt in *Speculum*, XIV, 1939, pp. 260–261 on the title borne by the Emperor Constantine VII Porphyrogenitus.

4. Weitzmann, *Byzantinische Buchmalerei*, pp. 3 ff. and figs. 11–15, 17; a summarized bibliography is to be found in Paris, Bibliothèque Nationale, *Byzance et la France Médiévale*, 1958, No. 9; Talbot Rice, *Art of Byzantium*, pls. I, VI, VII, 84–85.

5. Lib. VI, *De Const. Porph.*, c. 22, ed. Bekker (Bonn-Corpus), 1838, p. 450, quoted by K. Weitzmann, *The Joshua Roll, Studies in Manuscript Illumination*, 3, Princeton, 1948, p. 88.

6. W. Wroth, *Imperial Byzantine Coins*, II, pl. LIII, 7, p. 462.

7. H. Buchthal, *The Paris Psalter*, London, 1938; a summarized bibliography, chiefly references to studies which have appeared since Buchthal's publication, is to be found in Paris, Bibliothèque National, *Byzance et la France Médiévale*, 1958, No. 10; D. Talbot Rice, *Art of Byzantium*, pls. VIII, IX, 86–87.

8. *Miniature della Bibbia cod. Vat. Regina Gr. 1 e del Salterio cod. Vat. Palat. Gr. 381. Collez. Paleogr. Vat. Facs*, 1, Milan, 1905; Weitzmann, *Byzantinische Buchmalerei*, pp. 40 ff., figs. 278–284; Talbot Rice, *Art of Byzantium*, pls. 94–95.

9. K. Weitzmann, *The Joshua Roll, A Work of the Macedonian Renaissance*, Princeton, 1948, pl. 1, fig. 1. Weitzmann and Buchthal have always maintained this Roll to be a work of the tenth century as opposed to the theories of C. R. Morey and his school, who considered it to date from the seventh century, cf. C. R. Morey, *Early Christian Art*, Princeton, 1953, pp. 69 ff., and in *Speculum*, XIV, 1939, pp. 139 ff.; V. N. Lasareff, *A History of Byzantine Painting*, Moscow, 1947, I, pp. 55 ff. and figs. 18–20 preferred the earlier date but Weitzmann's analysis and conclusions seem more acceptable. For a criticism of Weitzmann's method, however, cf. V. N. Lasarev, 'Gli Affreschi di Castelseprio,' *Sibrium*, III, 1956–1957, pp. 87 ff.

10. Weitzmann, *Byzantinische Buchmalerei*, p. 33, fig. 228; Weitzmann, *Greek Mythology in Byzantine Art*, Princeton, 1951, pp. 17 ff., 27 ff., 94 ff., 195; for a summary of literature, cf., Paris, Bibliothèque Nationale, *Byzance et la France Médiévale*, 1958, No. 3.

11. Weitzmann, *Greek Mythology in Byzantine Art*, *passim*, for a bibliography, cf., p. 93, n. 6.

12. Longhurst, *Catalogue of Ivory Carvings*, I, p. 34; Goldschmidt u. Weitzmann, *Byzantinische Elfenbeinskulpturen*, I, No. 21; Peirce and Tyler, *Byzantine Art*, London, 1926, pl. 93, who noticed the stylistic similarities with the glass bowl

in the Treasury of St. Mark's at Venice; Weitzmann, *Greek Mythology in Byzantine Art, passim.*

13. A. Pasini, *Il Tesoro di San Marco*, VIII, Venice, 1886, p. 100, and pls. XL, 78, XLI, 82; Weitzmann, *Greek Mythology*, p. 203; cf., also G. R. Davidson, 'A Mediaeval Glass-Factory at Corinth,' *A.J.A.*, XLIV, 1940, pp. 297–324; A. H. S. Megaw, 'A Twelfth Century Scent Bottle from Cyprus,' The Corning Museum of Glass, N.Y., *Journal of Glass Studies*, I, 1959, pp. 59 ff.

14. Goldschmidt u. Weitzmann, *Byzantinische Elfenbeinskulpturen*, II, Nos. 31, 32, 33, 34, 43, 44, 45, 77; A. Goldschmidt in *Speculum*, XIV, 1939, p. 260; E. Kantorowicz, 'Ivories and Litanies,' *Journal of the Warburg and Courtauld Institutes*, V, 1942, pp., 56 ff., esp. pp. 70 ff.; Edinburgh-London, *Masterpieces of Byzantine Art*, Nos. 68, 73, 75, 84; Talbot Rice, *Art of Byzantium*, pls. 97–103, 120–121.

For the jasper of Leo VI, cf. *V. and A. Annual Review, 1932* (1933), p. 1, fig. 1 and p. 8; H. Wentzel, 'Datierte und datierbare byzantinische Kameen,' *Festschrift Friedrich Winkler*, Berlin, 1959, p. 12; Wentzel, 'Die byzantinischen Kameen in Kassel. Zur Problematik der Datierung byzantinischer Kameen,' *Mouseion Studien aus Kunst und Geschichten für Otto H. Förster*, Köln, 1961, esp. pp. 90 ff.

15. Weitzmann, *Byzantinische Buchmalerei*, pp. 7 ff., 26, 28 ff.; O. Pächt, *Byzantine Illumination*, Oxford, 1952, pls. 5, 9; G. Mathew, *Byzantine Painting*, London, p. 6–7; Paris, *Bibliothèque Nationale, Byzance et la France Médiévale*, No. 11, with brief bibliography for Paris gr. 70.

16. Bárány-Oberschall suggests, incorrectly, that the 'crown' of Leo VI is an ornamental edging from a chalice, cf. M. Bárány-Oberschall, *The Crown of the Emperor Constantine Monomachos*, *Archaeologia Hungarica*, XXII, Budapest, 1937, p. 80, n. 82. Grabar accepts it as a crown, cf. A. Grabar, 'L'Archéologie des Insignes Médiévaux du Pouvoir,' *Journal des Savants, Académie des Inscriptions et Belles Lettres*, Paris, Jan-March, 1957, p. 30.

Cf. also Pasini, *Tesoro*, pl. L, No. 111, and p. 68; Lethaby and Swainson, *Sancta Sophia*, p. 73. According to Anthony of Novgorod, just before the Fourth Crusade there were thirty crowns suspended from the ciborium of Agia Sophia at Constantinople.

17. For the chalices, cf. Pasini, *Tesoro*, pl. XLI, No. 83 and p. 58, pl. L, No. 113 and p. 57. For the reliquary of Basil the Proedros, cf., J. Rauch, Schenk zu Schweinsberg and J. Wilm, 'Die Limburger Staurothek,' *Das Münster*, VIII, 7–8, 1955, pp. 201 ff.; Marvin Ross, 'Basil the Proedros, Patron of the Arts,' *Archaeology*, XI, 4, 1958, pp. 271–275; H. Schnitzler, *Rheinische Schatzkammer*, Düsseldorf, 1958, p. 24, No. 12, pls. 38–47; Talbot Rice, *Art of Byzantium*, pls. 124–126.

18. Pasini, *Tesoro*, p. 33 and pl. XXII; Edinburgh-London, *Masterpieces of Byzantine Art*, No. 191.

19. S. G. Mercati, 'La Stauroteca di Maestricht,' *Atti della Pont. Acc. Rom. di Arch. Memorie*, I, Part II, Rome, 1924, pp. 45 ff.; M. A. F. C. Thewissen, *Twee Byzantijnsche H. Kruis-relicken uit der Schats der voort-Kapitalkerk te Maestricht*, Maestricht, 1939.

20. Cf. Constantine VII Porphyrogenitus, *Le Livre des Cérémonies*, ed. A. Vogt, I, Paris, 1935, ch. 9. For the Feast of the Pentecost, p. 64, the Emperor sat at the little gold table, near to the pentapyrgion (where the chief treasures of the imperial workshops were housed), the ambassadors of 'great nations' sat at the big gold table; ch. 20 (11), p. 80; ch. 22 (13), p. 83, refers to the Patriarch and his clergy dining with the Emperor at 'the precious gold table'; ch. 23 (14), p. 85, refers to the household officials ranging themselves on either side of the gold table near the golden vases in the presence of the Emperor who sat on a golden throne in front of the pentapyrgion—the doors of the Chrysotriclinos were of silver; ch. 24 (15), p. 89, refers to the golden table in the Chrysotriclinos; ch. 34 (25), p. 132. For a sceptical, but not entirely unawed witness, cf. *Liudprandi Opera*, Hannover and Leipzig, 1915, *Antapodosis*, VI, 5, pp. 154–155; for a spiteful account of

Byzantine protocol, cf. *Relatio de legatione constantinopolitana*, pp. 175 ff.

21. Dumbarton Oaks, *Handbook*, No. 135; Marvin C. Ross, 'An Emperor's Gift— and Notes on Byzantine Silver Jewellery of the Middle Period,' *Journal of the Walters Art Gallery*, XIX-XX, 1956–1957, pp. 22 ff.

22. *Codices e Vaticanis Selecti, VIII, Il Menologio di Basilio II* (Cod. Vat. gr. 1613), 2 vols., Turin, 1947; S. der Nersessian, 'Remarks on the Date of the Menologion and the Psalter written for Basil II,' *Byzantion*, XV, 1940–1941, pp. 104–125.

23. Talbot Rice, *Art of Byzantium*, pl. XI, 127.

For Byzantine clemency to prisoners, which was the rule, cf. R. H. Dolley, 'Naval tactics in the hey-day of the Byzantine thalassocracy,' *Atti dello VIII Congresso Internazionale di Studi bizantini*, Rome, 1953, I, p. 334.

24. Thomas Whittemore, *The Mosaics of St. Sophia at Istanbul, Second Preliminary Report, Work done in 1933 and 1934, The Mosaics of the Southern Vestibule*, Oxford University Press, 1936; E. Weigand in *Byzantinische Zeitschrift*, XXXVIII, 1938, pp. 467–471, advocates a date about 1050; V. N. Lasarev, *History of Byzantine Painting*, I, pp. 88 ff. and pls. XIX-XX, II, fig. 90–96, accepts a date in the tenth century; Cyril Mango, 'The Date of the Narthex Mosaics of the Church of the Dormition at Nicaea,' *Dumbarton Oaks Papers*, XIII, 1959, pp. 245 ff. For the Church of the Dormition at Nicaea, cf. Theodor Schmit, *Die Koimesis-Kirche von Nikaia*, Berlin and Leipzig, 1927.

25. Talbot Rice, *Art of Byzantium*, pl. 129, accepts a date between 986 and 994.

26. Zonaras, *Epit.*, XVII, 9, 566, Bonn.

27. A. Grabar, 'La Soie byzantine de l'évêque Gunther à la Cathédrale de Bamberg,' Technischer Exkurs von Sigrid Müller-Christensen, *Münchner Jahrbuch der bild. Kunst*, 3rd Series, VII, 1956, pp. 7 ff.

28. Goldschmidt u. Weitzmann, *Byzantinische Elfenbeinskulpturen*, I, No. 122; A. Grabar, *L'Empereur dans l'art byzantin*, pp. 50 ff.; Edinburgh-London,

*Masterpieces of Byzantine Art*, No. 135.

29. Falke, *Seidenweberei*, II, pp. 10 ff.; A. Grabar, 'Le Succès des Arts Orientaux à la Cour Byzantine sous les Macédoniens,' *Münchner Jb. d. bild. Kunst*, 3rd Series, II, 1951, pp. 33 ff.; Sigrid Müller-Christensen, *Sakrale Gewänder des Mittelalters*, Catalogue, Munich, 1955, esp. No. 17; Edinburgh-London, *Masterpieces of Byzantine Art*, No. 103.

30. G. Wiet, *Soieries Persanes*, Cairo, 1948, p. 64, pl. X; A. C. Weibel, *Two Thousand Years of Textiles*, New York, 1952, No. 106, 107.

31. D. S. Rice, *The Unique ibn al-Bawwab Manuscript in the Chester Beatty Library*, Dublin, 1955, pls. II, IV.

32. A. F. Kendrick, *Catalogue of Muhammadan Textiles of the Medieval Period*, Victoria and Albert Museum, 1924, No. 965; A. de Capitani d'Arzago, 'Antichi Tessute della Basilica Ambrosiana,' *Biblioteca de 'L'Arte,'* Nuova Serie, I, Milan, 1945, pp. 24 ff.; U. Monneret de Villard, 'Una iscrizione marwanide su stoffa del secolo XI nella basilica di S. Ambrogio a Milano,' *Oriente Moderno*, Anno XX, no. 10, ottobre, 1940— XVIII, pp. 1 ff.

33. Sigrid Müller-Christensen, 'Liturgische Gewänder mit den Namen des hl. Ulrich,' *Augusta*, 955–1955, pl. 12, fig. 2, pp. 53 ff.

34. Sigrid Müller-Christensen, *Sakrale Gewänder*, No. 27.

35. Dalton, *Byzantine Art and Archaeology*, p. 587.

36. Michael Psellus, *Chronographia*, trans. by E. R. A. Sewter, London, 1953, p. 138.

37. Ibid., p. 115.

38. Ibid., p. 108.

39. Thomas Whittemore, *The Mosaics of Haghia Sophia at Istanbul, Third Preliminary Report, Work done in 1935–1938, The Imperial Portraits of the South Gallery*, Oxford University Press, 1942; Grabar, *Byzantine Painting*, Geneva, 1953, pp. 98, 102; Talbot Rice, *Art of Byzantium*, pl. XIII, 133. The solidus of Zoe and Theodora is so far unpublished.

40. V. N. Lasarev, *History of Byzantine Painting*, I, p. 91, II, figs. 102–105;

Grabar, *Byzantine Painting*, pp. 109 ff.

41. E. Diez and O. Demus, *Byzantine Mosaics in Greece, Hosios Lucas and Daphne*, Harvard University Press, 1931; Lasarev, *History of Byzantine Painting*, I, pp. 91 ff., II, figs. 106–111.

42. Lasarev, *History of Byzantine Painting*, I, pp. 92 ff., pls. XXII-XXIII, II, figs. 112–119; Lasarev in *Art Bulletin*, XVII, 1935, pp. 184–232; Lasarev in *History of Russian Art*, Academy of Sciences NAUK CCCP, Moscow, 1953, I, pp. 155 ff.; Lasarev, 'Novye dannye o mozaikach i freskach Sofii Kievskoj,' *Vizant. Vremennik*, X, 1956, p. 164, dates the mosaics to c. 1045; Lasarev, 'Nouvelles découvertes dans la cathédrale Sainte Sophia à Kiev,' *Byzantinoslavica*, XIX, 1958, pp. 85 ff., emphasizes the local character of the mosaics, p. 95; O. Powstenko, *The Cathedral of St. Sophia in Kiev*, New York, 1954, pp. 111 ff., pls. 32 ff.

43. Schmit, *Die Koimesis-Kirche von Nikaia*, pp. 48 ff. and pls. XXVIII-XXXV; Lasarev, *History of Byzantine Painting*, I, pp. 90 ff., pl. XXI, II, figs. 97–101; Cyril Mango in *Dumbarton Oaks Papers*, XIII, 1959, pp. 245 ff.

44. Cf., for example, Paris, Bibl. Nat. Suppl. gr. 612, fol. 135v., St. Mark, (Fig. 149).

45. S. Runciman, *The Eastern Schism*, Oxford, 1955.

46. M. Bárány-Oberschall, *The Crown of Constantine Monomachos*, Archaeologica Hungarica, Acta Archaeologica Musei Nationalis Hungarici, XXII, Budapest, 1937; P. J. Kelleher, *The Holy Crown of Hungary*, American Academy in Rome, 1951, pp. 68 ff.; Grabar, 'Le Succès des Arts Orientaux à la Cour Byzantine sous les Macédoniens,' *Münchner Jahrbuch*, 3rd Series, II, 1951, pp. 42 ff.; Talbot Rice, *Art of Byzantium*, pl. 134.

47. Bock and Willemin, *Die mittelalterlichen Kunst und Reliquienschätze in Maastricht*, 1872, p. 149, figs. 59, 60; Dalton, *Byzantine Art and Archaeology*, p. 522; Volbach in *Zeitschr. f. bild. Kunst*, 1931, p. 104; Edinburgh-London, *Masterpieces of Byzantine Art*, No. 194.

48. Kelleher, *Holy Crown of Hungary*, *passim*; P. E. Schramm, *Herrschaftszeichen und Staatssymbolik*, III, Stutt-

mosaic panel in the south gallery of gart, 1956, A. Boeckler's article on the Holy Crown of Hungary, pp. 730 ff.; Grabar, 'L'Archéologie des Insignes Médiévaux du Pouvoir,' *Journal des Savants, Acad. des Inscr. et Belles Lettres*, Jan. March, 1957, pp. 29 ff.

49. Kelleher, *Holy Crown of Hungary*, pp. 69, 71, 91, pl. XVII, 41; Bárány-Oberschall, *Crown of Constantine Monomachos*, pp. 56 ff., 84.

50. Pasini, *Tesoro*, pp. 141 ff., pls. XIV-XXI; Moravcsik in *Erasmus*, I, 1947, p. 370, distinguished between the Irene with black hair on the enamel plaque and the Irene with fair hair in the Agia Sophia; Kelleher, *Holy Crown*, pp. 70–71; F. Rademacher, 'Ein byzantinisches Goldemail-Medaillon aus dem Grab des Kölner Erzbischofs Sifrid von Westerburg in der Bonner Münsterkirche,' *Festschrift Erich Mayer*, Hamburg, 1959, pp. 39 ff.; O. Demus, *The Church of San Marco in Venice*, Dumbarton Oaks Studies, VI, 1960, pp. 23 ff.

51. Bárány-Oberschall, op. cit., p. 59; for Sicilian enamel and goldsmith work, cf. A. Lipinsky, 'Sizilianische Goldschmiedekunst im Zeitalter der Normannen und Staufer,' *Das Münster*, X, 1957, pp. 73 ff., 158 ff.

52. Baltimore, The Walters Art Gallery *Early Christian and Byzantine Art*, 1947, *Catalogue*, No. 530, pls. LXX, LXXI. It is believed that the relics and the Byzantine reliquaries were brought back from Constantinople in 1155 or 1157 by Willibald, Abbot of Stavelot (1130–1158).

53. It is possible that one of the earliest of the Studite manuscripts is the famous Khludov Psalter in the Historical Museum at Moscow and dating from the second half of the ninth century. In this manuscript the general principles of Studite decoration are adumbrated for the first time but some scholars have queried a Constantinopolitan provenance for the Khludov Psalter. Cf. Grabar, *Iconoclasme Byzantin*, pp. 198 ff. To his bibliography on p. 198, n. 1, should be added V. N. Lasarev, 'Einige kritische Bemerkungen zum Chludov-Psalter,' *Byzantinische Zeitschrift*, XXIX, 1929–1930, pp. 279 ff.

For Brit. Mus. Add. Ms. 19352, cf. Gervase Mathew, *Byzantine Painting*, London, 1950, pls. 3, 4.

54. Paris, Bibl. Nat. *Byzance et la France Médiévale*, No. 21, with bibliography.

55. Goldschmidt u. Weitzmann, *Byzantinische Elfenbeinskulpturen*, II, No. 24; Edinburgh-London, *Masterpieces of Byzantine Art*, No. 151.

56. Goldschmidt u. Weitzmann, *Byzantinische Elfenbeinskulpturen*, II, No. 58; Edinburgh-London, *Masterpieces of Byzantine Art*, No. 130.

57. Cf. in particular V. N. Lasarev in *Art Bulletin*, XVII, 1935, pp. 184–232.

58. Paris, Bibl. Nat., *Byzance et la France Médiévale*, No. 17, with bibliography.

59. Paris, Bibl. Nat., *Byzance et la France Médiévale*, No. 28.

60. Paris, Bibl. Nat., *Byzance et la France Médiévale*, No. 23.

61. Paris, Bibl. Nat., *Byzance et la France Médiévale*, No. 19 and No. 36; C. Stornajuolo, *Codices e Vaticanis selecti, Miniature delle omilie di Giacomo monaco*, Rome, 1910. The quotation is from Lasarev in *Art Bulletin*, XVII, pp. 208–209.

62. Paris, Bibl. Nat., *Byzance et la France Médiévale*, No. 29.

63. Edinburgh-London, *Masterpieces of Byzantine Art*, No. 100; H. Wentzel, 'Datierte und datierbare byzantinische Kameen,' *Festschrift Friedrich Winkler*, Berlin, 1959, pp. 10–11.

64. Wulff and Volbach, *Mittelalterliche Bildwerke aus Italien und Byzanz*, Berlin, 1930, 2429 a and b; G. Sotiriou in *Recueil d'Études dédiées à la mémoire de N.P. Kondakov*, Prague, Sem. Kondakov, 1926, pp. 125–138; L. Bréhier, *La Sculpture et les arts mineurs*, pl. XI, p. 64; cf. Talbot Rice, *Art of Byzantium*, pl. 151, for a Virgin and Child in marble relief found near the Mosque of Sokullu Mehemet Paça and now in the Archaeological Museum, Istanbul; for a marble relief of the Virgin, of about the same date, now in the Dumbarton Oaks Collection, cf. Sirarpie der Nersessian, 'Two Images of the Virgin in the Dumbarton Oaks Collection,' *Dumbarton Oaks Papers*, XIV, 1960, esp. p. 78 ff.

65. R. Demangel and E. Mamboury, *Le Quartier des Manganes et la première région de Constantinople*, Paris, 1939, p. 155, pl. XIV; *Archäologischer Anzeiger*, 1931, p. 196, fig. 10.

66. Longhurst, *Catalogue*, p. 41, pl. XVIII; Goldschmidt u. Weitzmann, *Byzantinische Elfenbeinskulpturen*, II, No. 68, I, No. 99; Edinburgh-London, *Masterpieces of Byzantine Art*, No. 82.

67. Mendel, *Catalogue*, II, No. 757; Edinburgh-London, *Masterpieces of Byzantine Art*, No. 168.

68. C. Angelillis, *Le Porte di bronzo bizantine nelle chiese d' Italia*, 1924.

69. A. L. Frothingham, 'A Syrian Artist Author of the Bronze Doors of St. Paul's, Rome,' *A.J.A.*, XVIII, 1914, pp. 486 ff.

70. For the bronze doors of earlier date, restored by the Emperor Theophilus and the Emperor Michael in 841, in Agia Sophia at Constantinople, cf. E. H. Swift, 'The Bronze Doors of the Gate of the Horologium at Hagia Sophia,' *Art Bulletin*, XIX, 1937, pp. 137 ff.; Carlo Bertelli, 'Notizia Preliminare sul Restauro di alcune porte di S. Sofia a Istanbul,' Attività dell'Istituto all'Estero *Bollettino dell'Istituto Centrale del Restauro*, nn. 34–35, 1958, pp. 3 ff., who points out that the three central doors between the exonarthex and the narthex are, in fact, made up from plates of brass.

In the Dome of the Rock at Jerusalem the bronze door of Ma'mun is dated to the year 831, cf. Bertelli, op. cit., p. 14.

71. Angelillis, op. cit., p. 15.

72. Hermann Leisinger, *Romanesque Bronzes, Church Portals in Medieval Europe*, London, 1956, pls. 125–128.

73. According to Scarlatus Byzantinus and the Patriarch Constantinus, a mosaic in the building portrayed the Emperor Manuel Comnenus (1141–1180) in the act of presenting a model of the Church to Christ. In the Church, today, there still survives an interesting inlaid mosaic pavement.

74. For the churches built under Comnene patronage, cf. Van Millingen, *Byzantine Churches in Constantinople*, London, 1912; R. Janin, *La Géographie Ecclésiastique de l'Empire byzantin*, III, *Les Églises et les Monastères*, Institut français d'Etudes byzantines, Paris, 1953. In the Palace of the Blachernae

the Emperor Manuel ordered to be made a series of representations in mosaic or fresco of the great victories against the enemies of the Empire achieved by him and his ancestors and of the triumphs which glorified their reigns. Cf. Charles Diehl, 'La société byzantine à l'époque des Comnènes,' *Conférences faîtes à Bucarest (avril, 1929), Extrait de la Revue Historique du Sud-Est Européen,* Nos. 7–9, 1929, p. 24; cf. also, pp. 43 ff. for Comnene religious foundations.

75. Whittemore, *Imperial Portraits of the South Gallery;* Grabar, *Byzantine Painting,* pp. 99 ff.; Talbot Rice, *Art of Byzantium,* pl. 164–165. Cf. XXIII, Also, E. T. de Wald, 'The Comnenian Portraits in the Barberini Psalter,' *Hesperia,* XIII, 1944, pp. 78 ff.

76. E. Diez and O. Demus, *Byzantine Mosaics in Greece, Hosios Lucas and Daphne,* Harvard University Press, 1931; O. Demus, *Byzantine Mosaic Decoration,* London, 1947.

77. Lasarev, *History of Byzantine Painting,* I, p. 119; pl. XXXI, XXXII; II, fig. 169–176.

78. O. Demus, *The Mosaics of Norman Sicily,* London, 1949; Lasarev in *Art Bulletin,* XVII, 1935, pp. 184–232; Lasarev, *History of Byzantine Painting,* I, pp. 121 ff., pls. XXXIV, XXXV; II, figs. 177–184; Grabar, *Byzantine Painting;* E. Kitzinger, *The Mosaics of Monreale,* Palerm 1960.

79. O. Demus, *Mosaics of Norman Sicily,* p. 393; Edinburgh-London, *Masterpieces of Byzantine Art,* No. 218; Talbot Rice, *Art of Byzantium,* 80. O. Demus, 'Die Entstehung des Paläologenstils in der Malerei,' *Berichte zum XI. Internationalen Byzantinisten-Kongress,* Munich, 1958, pp. 24 ff.

81. It may be presumed that this style existed at Constantinople if the tradition concerning the icon of Our Lady of Vladimir is correct. For a brief review of the evidence, cf. Talbot Rice, *Art of Byzantium,* p. 330.

For the frescoes at Nerezi, cf. Lasarev, *History of Byzantine Painting,* I, pp. 122 ff.; II, figs. 185–187; Demus in *Berichte zum XI. Int. Byz. Kongr.* p. 21, n. 86 gives further literature.

82. Lasarev, *History of Byzantine Painting,*
I, p. 123, pl. XXXVI; II, figs. 188–194.

83. Paris, Bibl. Nat., *Byzance et la France Médiévale,* No. 33.

84. Gervase Mathew, *Byzantine Painting,* p. 12.

85. O. Pächt, *Byzantine Illumination,* pls. 3, 8, 9, 11, 17.

86. Paris, Bibl. Nat., *Byzance et la France Médiévale,* No. 40.

87. Paris, Bib. Nat., *Byzance et la France Médiévale,* No. 36; Stornajuolo, *Miniature delle Omilie di Giacomo monaco,* Rome, 1910.

88. Paris, Bibl. Nat., *Byzance et la France Médiévale,* No. 45.

V

1. S. Runciman, *A History of the Crusades,* III, Cambridge University Press, 1954, p. 120; for a summary of the disastrous consequences of the Fourth Crusade, cf. pp. 130–131.

For the semi-magical, semi-superstitious attitude of the people of Constantinople towards antique sculptures, cf. C. Diehl, 'La société byzantine à l'époque des Comnènes,' pp. 70–73. For a summary of sculptures looted by the Venetians from Constantinople, cf. O. Demus, *The Church of San Marco in Venice,* Dumbarton Oaks Studies, VI, 1960, esp. pp. 120 ff.

2. *Digenes Akrites,* ed. John Mavrogordato, Oxford, 1956, pp. 218–219, ll. 3365–3368.

3. O. Demus in *Berichte zum XI. Int. Byz. Kongr.,* Munich, 1958, pp. 26 ff.

4. K. Weitzmann, 'Constantinopolitan Book Illumination in the Period of the Latin Conquest,' *Gazette des Beaux Arts,* XXV, April, 1944, pp. 196 ff.; Lasarev, *History of Byzantine Painting,* I, pp. 157 ff., II, pls. 247 ff.

5. Lasarev in *Art Bulletin,* XVII, 1935, p. 206.

6. Paris, Bibl. Nat., *Byzance et la France Médiévale,* No. 79. I should like to thank Dr. Otto Pächt for drawing my attention to the script.

7. Paris, Bibl. Nat., *Byzance et la France Médiévale,* No. 46, 83, 82, and 64.

VI

1. W. H. Hutton, *Constantinople*, London, 1900, pp. 120 ff.; D. I. Geanakoplos, *Emperor Michael Palaeologus and the West*, Harvard University Press, Cambridge, Mass., 1959, pp. 119 ff.

2. Thomas Whittemore, *The Mosaics of Haghia Sophia at Istanbul, Fourth Preliminary Report, Work Done in 1934–1938, The Deesis Panel of the South Gallery*, Oxford University Press, 1952; Lasarev, *History of Byzantine Painting*, I, p. 116, pls. XXVIII, XXIX; Demus in *Berichte zum XI. Int. Byz. Kongr.*, Munich, 1958, p. 55; Talbot Rice, *Art of Byzantium*, pls. XXV–XXVII, 172.

3. V. N. Lasarev, 'Duccio and Thirteenth Century Greek Ikons,' *Burlington Magazine*, LIX, 1931, p. 159; Lasarev, 'Early Italo-Byzantine Painting in Sicily,' *Burlington Magazine*, LXIII, 1933, p. 279; D. Talbot Rice, 'New Light on Byzantine Portative Mosaics,' *Apollo*, XVIII, 1933, p. 266; Lasarev, *History of Byzantine Painting*, I, p. 169, pl. XLI; Demus, *Mosaics of Norman Sicily*, p. 431; Edinburgh-London, *Masterpieces of Byzantine Art*, No. 220; Talbot Rice, *Art of Byzantium*, pl. 178; Demus, 'Two Palaeologue Icons in the Dumbarton Oaks Collection,' *Dumbarton Oaks Papers*, XIV, 1960, pp. 89 ff.

4. Dumbarton Oaks, *Handbook*, No. 290; Goldschmidt und Weitzmann, *Byzantin Elfenbeinskulpturen*, II, Nos. 9, 10; Edinburgh-London, *Masterpieces of Byzantine Art*, No. 132; but cf. a curious ivory pyx in the Dumbarton Oaks Collection carved with imperial portraits datable to the years 1348–1352, cf. Grabar, 'Une pyxide en ivoire de Dumbarton Oaks', *Dumbarton Oaks Papers*, XIV, 1960, pp. 123 ff.

5. W. F. Volbach, 'Le Miniature del codice Vatic. Pal. lat. 1071, "De arte venandi cum avibus," ' *Rendiconti della Pont. Accad. Rom. di Arch.*, XV, 1939, p. 21, fig. 22, p. 22, fig. 23.

6. Longhurst, *Catalogue*, I, p. 48; V. N. Lasarev, 'Byzantine Ikons of the Fourteenth and Fifteenth Centuries,' *Burlington Magazine*, LXXI, 1937, pp. 250 ff.; S. Bettini, 'Appunti per lo studio dei mosaici portatili bizantini,' *Felix Ravenna*, XLVI, 1938, pp. 7 ff.

7. Edinburgh-London, *Masterpieces of Byzantine Art*, Nos. 199, 201, 197; Dumbarton Oaks, *Handbook*, No. 291.

8. Van Millingen, *Byzantine Churches*, p. 153 and pl. XLI; R. Janin, *Églises et Monastères*, pp. 217 ff.; P. A. Underwood in *Dumbarton Oaks Papers*, IX and X, 1955–1956, pp. 298 ff.; XIV, 1960, pp. 215 ff.

9. Van Millingen, *Byzantine Churches*, pp. 321 ff.; Th. Schmitt, *Kakhrie-Dzhami, Constantinople*, Russky Arkheologichesky Institut, Izvestiya, XI, and Album, 1906; Janin, *Églises et Monastères*, pp. 549 ff.; P. A. Underwood, 'First Preliminary Report on the Restoration of the Frescoes in the Kariye Camii at Istanbul by the Byzantine Institute, 1952–1954,' *Dumbarton Oaks Papers*, IX and X, 1955–1956, pp. 253 ff.; Underwood, 'Second Preliminary Report,' *Dumbarton Oaks Papers*, XI, pp. 172 ff.; Underwood, 'Third Preliminary Report,' *Dumbarton Oaks Papers*, XII, pp. 235 ff. and cf. also pp. 267 ff.; Underwood, 'Fourth Preliminary Report,' *Dumbarton Oaks Papers*, XIII, 1959, pp. 187 ff.; Underwood, 'The Deesis Mosaic in Kahrie Camii at Istanbul,' *Late Classical and Mediaeval Studies in Honor of Albert Mathias Friend, Jnr.*, Princeton, 1955, pp. 254 ff.; David Oates, 'A Summary Report on the Excavations of the Byzantine Institute in the Kariye Camii: 1957–1958,' *Dumbarton Oaks Papers*, XIV, 1960, pp. 223 ff.

10. P. A. Underwood, 'Palaeologue Narrative Style and an Italianate Fresco of the Fifteenth Century in the Kariye Djami,' *Studies in the History of Art dedicated to William E. Suida on his 80th Birthday*, London, 1959, pp. 1 ff.; cf. also, A. Grabar, 'La Décoration des coupoles à Karye Camii et les peintures italiennes du Dugento,' *Jb. d. österreich. byz. Gesellschaft*, VI, 1957, pp. 111 ff.

11. Schmitt, *Kàkhrie-Dzhami*, pls. LXXXIII–LXXXVIII.

12. *Dumbarton Oaks Papers*, IX and X, 1955–1956, figs. 63–75; XII, 1958, figs. 2–22.

13. Lasarev, *History of Byzantine Painting*, I, p. 221, pl. XLVI; II, fig. 305;

Lasarev in *Burlington Magazine*, LXXI, 1937, p. 250 and pl. II A; Weitzmann in *Gazette des Beaux Arts*, XXV, 1944, p. 212; Edinburgh-London, *Masterpieces of Byzantine Art*, No. 208.

14. M. Corović-Ljubinković, *The Icons of Ochrida*, Belgrade, 1953, pl. 2; Talbot Rice, *Art of Byzantium*, pls. XLI–XLIII p. 337; cf. also, S. Radojčić, 'Die serbische Ikonenmalerei vom 12. Jahrhundert bis zum Jahre 1459,' *Jb. d. österreich. byz. Gesellschaft*, V, 1956, pp. 61 ff.

15. Lasarev in *Burlington Magazine*, LXXI, 1937, p. 250, pl. III D; Lasarev, *History of Byzantine Painting*, II, pls. 308, 306; Edinburgh-London, *Masterpieces of Byzantine Art*, Nos. 231, 2 33.

16. A. M. Schneider, 'Das Martyrion der Hl. Euphemia beim Hippodrom zu Konstantinopel,' *Byzantinische Zeitschrift*, XLII, 1942–49, pp. 178–185. For other wall-paintings in or near Constantinople: a mural in the Church of the Panagia (1341–1373) on the Isle of Khalki, one of the Princes Islands, cf. Zidkov in *Byzantinische-Neugriechischer Jahrbücher*, 1928, pp. 521–528, and Lasarev in *Burlington Magazine*, LXXI, 1937, p. 256; a wall-painting in a funerary chapel between the Davut pacha Gate and Samatya in Etyemez tekkesi square, cf. F. Dirimtekin, 'Découverte d'une fresque de la Vierge à Istanbul,' *Cahiers Archéologiques*, X, 1959, pp. 307 ff., J. Majewski, 'The Conservation of a Byzantine Fresco discovered at Etyemez,' *Dumbarton Oaks Papers*, XIV, 1960, pp. 219 ff. There were three layers of fresco of which the second stage dating from the eleventh or twelfth century has been largely pre-served and a small portion of the fourteenth-century layer. The fresco of the Virgin Blachernitissa is now in the Aya Sofya Museum.

17. Cf. Notes, III, 15.

18. Paris, Bibl. Nat., *Byzance et la France Médiévale*, No. 64; Talbot Rice, *Art of Byzantium*, pl. XXXIV, 188.

19. Paris, Bibl. Nat., *Byzance et la France Médiévale*, No. 50; Talbot Rice, *Art of Byzantium*, p. XXXIX, 190.

20. Paris, Bibl. Nat., *Byzance et la France Médiévale*, No. 52.

21. Paris, Bibl. Nat., *Byzance et la France Médiévale*, No. 51.

22. H. Delahaye, *Deux typica byzantines de l'époque des Paléologues*, Brussels, 1921, p. 148, shows on internal evidence that the typicon was not composed until well after 1310; Janin, *Églises et Monastères*, p. 166, believes that it was not composed before 1345; Mathew, *Byzantine Painting*, pl. 9; Pächt, *Byzantine Illumination*, figs. 21, 22; Edinburgh-London, *Masterpieces of Byzantine Art*, No. 195; cf. also Underwood in *Dumbarton Oaks Papers*, XII, 1958, p. 272, n. 17; Talbot Rice, *Art of Byzantium*, pl. XL, 191–192.

23. P. A. Underwood in *Studies. . . to William E. Suida*, pp. 1 ff.; Underwood, 'Notes on the Work of the Byzantine Institute in Istanbul: 1957,' *Dumbarton Oaks Papers*, XIII, 1959, pp. 215 ff., esp. pp. 225–228.

24. E. Mamboury, *Istanbul touristique*, Istanbul, 1951, p. 98. Mehmet II was descended from a John Comnenus who had married a Turkish princess; his mother was also a Christian. Cf. C. Diehl, 'La société byzantine à l'époque des Comnènes,' p. 41.

# GLOSSARY

Agia, Hagia: Holy.

Anastasis: Resurrection. The pictorial representation of this Feast is usually the Harrowing of Hell.

Archon: Governor.

Arcosolium: A niche for a tomb.

Augustus, Augusta: Title given to the Emperor and Empress and sometimes to other members of the imperial family.

Aureus: The standard Roman gold coin.

Bema: Chancel arch.

Bulgaroctonos: Slayer of the Bulgars, epithet given to the Emperor Basil II.

Catholikon: Central nave of a church.

Cartophylax: Keeper of manuscripts.

Chlamydatus: Dressed in a cloak.

Curopalates: A court official of high rank.

Decennalia: Festival celebrated from the time of Augustus on the tenth year of the imperial reign.

Deesis: Christ represented between the Virgin and St. John the Baptist.

Diptych, consular, imperial: Two panels of ivory joined together, carved on one side with a representation of the Emperor, the Empress, or a Consul, and on the other side hollowed out to receive wax. The diptychs were issued as a rule by Consuls on taking office in the New Year.

Djami: Mosque.

Eidikos: Master of the Wardrobe.

Exonarthex: The outer hall or vestibule of a church.

Iconoclast: Destroyer or breaker of images, opposed to images.

Iconodule: The servant of images, in favour of images.

Kitonite: Chamberlain.

Koimesis: Dormition. The Death of the Virgin.

Labarum: The Christian standard. A Roman military standard decorated with the monogram of Christ ( ☧ )—Chi-Rho—probably introduced by Constantine the Great after his vision before the Battle of the Milvian Bridge (A.D. 312).

Litany: A public form of prayer in which God, the Virgin, and the Saints are invoked.

Logothete: Counsellor to the Emperor, sometimes in command of the Treasury.

Menologion: Lives of Saints arranged according to the Church's calendar.

Naos: Church, temple, nave.

Narthex: Antechamber to the main body of a church.

Osios, Hosios: Holy, saintly.

Pammakaristos: Most blessed.

Panagia: Most holy.

Parecclesion: Side-chapel.

Pentapyrgion: Cupboard with five turrets, possibly five compartments.

Peribleptos: Admired by all, notable.

Proedros: President of the Council.

Proskynesis: An act of homage before the Emperor or his image, and later before the image of Christ, which entailed falling onto the knees and touching the ground with the forehead, the hands held out in supplication. Introduced to the West possibly by the Emperor Elagabalus (218–220), the act became a matter of custom from the Emperor Diocletian (286–305) onwards. Diocletian adopted a great deal of Persian court protocol from which the act originated.

Protostrator: General.

Rinceau: Scroll of foliage.

Quadriga: A chariot drawn by four horses.

Solidus: The standard Roman gold coin of which the name superseded that of aureus.

Stemma: An imperial crown.

Suffrage: A form of prayer, an intercession.

Synaxarium: A collection of Lives of the Saints.

Synkellos: Abbot.

Tabula ansata: Lit. a panel with handles. On consular diptychs the panel bears the name and style of the consul.

Theotokos: Mother of God.

Theotokos Odegetria, Hodegetria: Mother of God showing the Way (i.e. pointing to, or displaying, the Infant Christ).

Tiraz: A textile factory. Also an embroidered or woven inscription giving sometimes the names of the Caliph, his Vizir, the place and date of manufacture.

Toufa: An imperial diadem with a crest of peacock's feathers.

Typicon: A monastic rule.

# CHRONOLOGICAL TABLE

THE BYZANTINE EMPERORS

14. Death of Augustus.
70. The Sack of Jerusalem.
117–138. The Emperor Hadrian.
138–161. The Emperor Antoninus Pius.
161–180. The Emperor Marcus Aurelius.
293. The Tetrarchy. Diocletian and Maximian co-emperors, Constantine and Galerius, Caesars in the East and West respectively.

## DYNASTY OF CONSTANTINE

Constantine I, the Great, 306–337; sole emperor, 324–337.

306. Elevation of the Emperor Constantine the Great at York.
313. 'Edict of Milan.' Imperial recognition of Christianity.
325. First Ecumenical Council of Nicaea.
330. Dedication of Constantinople as the capital of the Empire.

Constantius II, 337–361; sole emperor, 353–361.
Julian, 361–363.

## INTER DYNASTY

Jovian, 363–364.
Valens, 364–378.

374–397. St. Ambrose, Bishop of Milan.

## DYNASTY OF THEODOSIUS

Theodosius I, the Great, 379–395.
Arcadius, 395–408.

Theodosius II, 408–450.

407. Withdrawal of the Roman legions from Britain.
410. Sack of Rome by Alaric.
430. Death of St. Augustine.
455. Sack of Rome by the Vandals.

Marcian, 450–457, married to the daughter of Arcadius, the Empress Pulcheria (d. 453).

## DYNASTY OF LEO

Leo I, 457–474.
Zeno, 474–491, married to the daughter of Leo, the Empress Ariadne (d. 515).
Leo II, 474.
Anastasius I, 491–518, married to the Empress Ariadne.

472. Capture of Rome by Ricimer.
476. Deposition of the Western Emperor, Romulus Augustulus, by Odovacar the Ostrogoth.

## DYNASTY OF JUSTINIAN

Justin I, 518–527.

Justinian I, the Great, 527–565.

Justin II, 565–578.
Tiberius II, 578–582, the adopted son of Justin II and the Empress Sophia.
Maurice, 582–602, married to the daughter of Tiberius II, the Empress Constantina.

## USURPER

Phocas, 602–610.

## DYNASTY OF HERACLIUS

Heraclius, 610-641.

Constantine II and Heraclonas, 641.
Constantine III (Constans II), 641–668.

Constantine IV Pogonatus, 668–685.

Justinian II Rhinotmetus, 685–695 and 705–711.

## USURPER

Leontius, 695–698.
Tiberius, 698–705.

## NON-DYNASTIC

Philippicus Bardanes, 711–713.
Anastasius II, 713–716.
Theodosius III, 716–717.

A.D.

525. Destruction of Antioch by an earthquake.
529–534. The Code of Justinian the Great.
540. Sack of Antioch by the Persians.
547. St. Benedict, founder of western monasticism, dies at Monte Cassino.

590–603. Pope Gregory the Great.

611. Capture of Antioch by the Persians.
614. Capture of Jerusalem by the Persians.
617. Capture of Alexandria by the Persians.
627. Defeat of the Persians by the Emperor Heraclius at Nineveh.
632. Death of the Prophet Mahomet. The Rise of Islam.
635. Arab conquest of Persia.
636. Arab conquest of Mesopotamia.
637. The Arabs capture Jerusalem.
641. Arab conquest of Egypt.
646. Alexandria finally occupied by the Arabs.
661. The foundation of the Umayyad dynasty in Syria.

673–677. The Arabs attack Constantinople.

697. The Arabs capture Carthage.

713. The first Venetian Doge elected.

## ISAURIAN OR SYRIAN DYNASTY

Leo III, 717–741.

717–718. The Arabs besiege Constantinople. The victory of the Emperor Leo III over the Arab army and the Arab fleet.

726. The beginning of the Iconoclast Controversy.

732. The victory of Charles Martel over the Arabs at Poitiers.

Constantine V Copronymus, 741–775.

750. The fall of the Umayyad dynasty. Foundation of the Abbasid Caliphate.

751. Capture of Ravenna by the Lombards.

756. The last surviving Umayyad prince 'Abd ar-Rahman establishes an amirate in Spain.

762. Baghdad founded by the Abbasid Caliph al-Mansur.

Leo IV, the Khazar, 775–780, married to the Empress Irene, 797–802.
Constantine VI, 780–797.

768–814. Charlemagne.
778. Roncevalles.
787. Council of Nicaea. Condemnation of Iconoclasm.
800. Coronation of Charlemagne as Emperor of the West in Rome.
809. Death of the Caliph Harun ar-Rashid.

## USURPER

Nicephorus I, 802–811.
Stauracius, 811.
Michael I Rhangabe, 811–813, married to the daughter of Nicephorus I, the Empress Procopia.
Leo V, the Armenian, 813–820.

815. Iconoclast synod of Constantinople.

## AMORIAN OR PHYRGIAN DYNASTY

Michael II, the Stammerer, 820–829.
Theophilus, 829–842.
Michael III, the Drunkard, 842–867.

843. Final restoration of Images.
857–891. Photius, Patriarch of Constantinople.
859. Islamic conquest of Sicily completed.

## MACEDONIAN DYNASTY

Basil I, 867–886.
Leo VI, the Wise, 886–912.
Alexander, 886 (912)–913.
Constantine VII Porphyrogenitus, 913–959, married to Helen, daughter of the usurping Romanus I Lecapenus, 919–944, and associated with the sons of Romanus, Christopher, 921–923,

913. Simeon of Bulgaria appears before Constantinople.
929. 'Abd ar-Rahman III establishes the Western Caliphate at Cordoba.
941. Russian expedition against Constantinople.

Stephen, 944–945, and Constantine, 944–945.

Romanus II, 959–963.

## USURPER

Nicephorus II Phocas, 963–969, married to the Empress Theophano, widow of Romanus II.

John I Tzimisces, 969–976, married to the sister of Romanus II, Theodora.

## MACEDONIAN DYNASTY

Basil II Bulgaroctonos, 976–1025.

Constantine VIII, 976 (1025)–1028.

Romanus III Argyrus, 1028–1034, married to the Empress Zoe, daughter of Constantine VIII, 1028–1050.

Michael IV, the Paphlagonian, 1034–1041, married to the Empress Zoe.

Michael V Kalaphates, 1041–1042, nephew of Michael IV.

Zoe and Theodora, 1042.

Constantine IX Monomachos, 1042–1055.

Theodora, daughter of Constantine VIII, 1055–1056.

## NON-DYNASTIC

Michael VI Stratioticus, 1056–1057.

## DYNASTY OF THE DUKAS AND THE COMNENES

Isaac I Comnenus, 1057–1059.

Constantine X Dukas, 1059–1067.

Romanus IV Diogenes, 1067–1081, married to the widow of Constantine X, Eudocia Macrembolitissa.

A.D.

959. Princess Olga of Russia embraces Christianity.

969. The Fatimid Caliphs in power in Egypt.

936–973. Otto the Great, Emperor of the West.

971. The Emperor John Tzimisces annexes Eastern Bulgaria.

973–983. Otto II.

983–991. Regency of the Byzantine Princess Theophano, wife of Otto II.

983–1002. Otto III.

c. 989. Vladimir of Kiev embraces Christianity.

986–1018. The Eastern Emperor Basil II at war with the Bulgars.

994–1001. The Eastern Emperor, Basil II, at war with the Fatimids.

997. Accession of St. Stephen of Hungary and the conversion of the Magyars.

1046. The annexation of Armenia to the Byzantine Empire.

1048. Appearance of the Seljuk Turks on the eastern frontier of the Empire.

1054. The Schism between the Greek and Roman Churches.

1061–1091. The Norman Conquest of Sicily.

1064. The Seljuk Turks conquer Greater Armenia.

A.D.

Michael VII Parapinakes, also a Dukas, 1071–1078.

1071. Capture of Bari by the Normans and the loss of southern Italy. Battle of Manzikert. The Byzantine army routed by the Seljuks. The Seljuks occupy Jerusalem.

## USURPER

Nicephorus III Botaniates, 1078–1081, married to the widow of Michael VII, Maria of Alania.

1078. The Seljuks at Nicaea.

## THE COMNENE DYNASTY

Alexius I Comnenus, 1081–1118.

1086. Incursions of the Patzinaks.

1095. Pope Urban II and the Council of Clermont proclaim the First Crusade

1099. The Franks establish the Kingdom of Jerusalem.

1115–1153. St. Bernard, Abbot of Clairvaux.

John II, 1118–1143.
Manuel I, 1143–1180.

1122–1126. The Eastern Empire at war with Venice.

1147–1149. The Second Crusade.

1147–1149. The Eastern Empire at war with Roger II of Sicily.

1152–1154. The Eastern Empire at war with Hungary.

1152–1190. The Emperor Frederick I Barbarossa.

1159. Entry of the Emperor Manuel Comnenus into Antioch.

Alexius II, 1180–1183.
Andronicus I, 1182 (1183)–1185.

1180. Foundation of the Serbian monarchy by Stephen Nemanja.

## DYNASTY OF THE ANGELI

Isaac II Angelus, 1185–1195 and 1203–1204.
Alexius III, 1195–1203.
Alexius IV, 1203–1204.

1180–1223. Philip II Augustus of France.

1186. Second Bulgarian Empire founded.

1187. Saladin captures Jerusalem.

1189–1192. The Third Crusade.

1191. Richard I of England occupies Cyprus.

1193–1205. Reign of the Doge Enrico Dandolo.

1197–1250. The Emperor Frederick II Hohenstaufen.

1201–1204. The Fourth Crusade.

## USURPER

Alexius V Dukas Mourtzouphlos, 1204, married to a daughter of Alexius III, Eudocia.

1204. The Sack of Constantinople. Alexius Comnenus founds the state of Trebizond. Theodore Lascaris founds the Greek Empire of Nicaea.

LATIN EMPERORS OF
CONSTANTINOPLE

A.D.

Baldwin of Flanders, 1204–1205.
Henry of Flanders, 1206–1216.
Peter of Courtenay, 1217.
Yolande, 1217–1219.

1219. Creation of a separate Serbian Church.

Robert II of Courtenay, 1221–1228.

1222. First appearance of the Mongols in Europe.

Baldwin II, 1228–1261, assisted by John of Brienne as Regent, 1229–1237; sole emperor, 1240–1261.

1228–1230. The Teutonic Order enters Prussia.

GREEK EMPERORS OF NICAEA

Theodore I Lascaris, 1204–1222, married to Anna, daughter of Alexius III.
John III Dukas Vatatzes, 1222–1254, married to Irene, daughter of Theodore I Lascaris.

1240. Batu the Mongol destroys Kiev.

Theodore II, 1254–1258.

1254. The Mamluk Turkish Sultans established in Egypt.

1258. Destruction of Baghdad by the Mongols and the fall of the Abbasid Caliphate.

John IV, 1258–1261.

1261. End of the Latin Empire at Constantinople.

USURPER

Michael VIII Palaeologus, 1259–1261.

1261–1530. The Abbasid Caliphate in Cairo.

DYNASTY OF THE
PALAEOLOGI

Michael VIII, 1261–1282.
Andronicus II, 1282–1328, associated with his son, Michael IX, 1295–1320.
Andronicus III, 1328–1341.

1270. Death of St. Louis, King of France.
1282. The Sicilian Vespers.
1308. The Ottoman Turks enter Europe.
1329. The Ottoman Turks capture Nicaea.
1331. Coronation of Stephen Dušan as King of Serbia.

John V, 1341–1391.

USURPER

John VI Cantacuzene, 1341–1354.

1357. The Ottoman Turks capture Adrianople.
1360. Formation of the Janissaries from tribute-children.
1373. The Emperor John V becomes the vassal of the Ottoman Sultan Murad.

DYNASTY OF THE
PALAEOLOGI
Andronicus IV, 1376–1379.

John VII, 1390.
Manual II, 1391–1425.

1389. Battle of Kossovo. Fall of the Serbian Empire.

1397. The Ottoman Sultan Bayazid attacks Constantinople.

1398. Timur invades India and sacks Delhi.

1401. Timur sacks Baghdad.

1416. The Ottoman Turks declare war on Venice.

1422. The Ottoman Sultan Murad II besieges Constantinople.

John VIII, 1425–1448.

1430. The Ottoman Turks capture Salonika.

1438. Opening of the Council of Ferrara.

1439. The Council moves to Florence. Completion of Turkish conquest of Serbia.

1440. The Turks besiege Belgrade.

1446. The Turks invade Morea.

Constantine XI Dragases, 1449–1453.

1451. Accession of the Sultan Mehmet II.

1453. The Ottoman Turks capture Constantinople.

1458. The Turks capture Athens.

1463. The Turks capture Bosnia.

1468. The Turks capture Albania.

1517. The Turks conquer Egypt.

1523. The Turks conquer Rhodes.

1571. The Turks conquer Cyprus.

1683. The Turks besiege Vienna.

# INDEX OF NAMES

Abbasid dynasty, 5, 58, 101
Akrites, Basil Dighenes, 129
Alania, Mary of, 110, 116, *figs.* 136, 151
Alexis Apocaucos, 133, 147, 148, 152, *fig.* 197
Alexius I Comnenus, *Emperor*, 111, 121, 137, 138
Alexius II Comnenus, *Emperor*, 123, *fig.* 162
Alexius III Angelus, *Emperor*, 130
'Amr, 5
Anastasia of Russia, 107
Anastasius, *Emperor*, 4, 29, 33, 37, 38, 41, 45
Anastasius II Artemius, *Emperor*, 60
Anastasius Flavius, consular diptych of, 34, *fig.* 42
Andrew I, *King of Hungary*, 107
Andronicus, son of Constantine X, 115
Andronicus I Comnenus, *Emperor*, 130
Andronicus II Palaeologus, *Emperor*, 138, 141
Andronicus III Palaeologus, *Emperor*, 137
Andronicus, son of Manuel II, 149, *fig.* 200
Angeli family, 123, 130
Angelus, Alexius III, *Emperor*, 130
Anna Comnena, 137
Anna Dalassena, wife of John Comnenus, 121
Anna, daughter of Alexius III Angelus, 130
Anna, *Empress*, wife of Andronicus III, 137
Anthemius of Tralles, 31
Antonine family, 53
Apocaucos, *Grand Duke* Alexis, 133, 147, 148, 152, *fig.* 197
Arcadius, *Emperor*, 15–17, 19, 20, *figs.* 14, 16, 17
Areobindus, consular diptych of, 34, 35, *fig.* 43
Argyrus, Romanus III, *Emperor*, 105, 119
Ariadne, *Empress*, 37–38, 42, *figs.* 47, 48
Artavasdes, *Emperor*, 61
Artemius, Anastasius II, *Emperor*, 60
Augustulus, *Emperor* Romulus, 4
Augustus, *Emperor*, 1, 10, 53
Autoreanus, *Patriarch* Michael, 130

Baldwin II, *Emperor*, 134
Barberini diptych, 38–39, 54, *fig.* 49
Bardanes, Philippicus, *Emperor*, 60
Basil, *the Proedros*, 87, 94
Basil I, *Emperor*, 63, 64, 67, 74, *fig.* 83

Basil II Bulgaroctonos, *Emperor*, 94, 97, 98–100, 105, 106, 124, *fig.* 122
  Menologion of, 94–97, 98, 100, *figs.* 120, 121
  Psalter of, 97
Bassus Junius, sarcophagus of, 2
Belisarius, 14
Benjamin of Tudela, 129
Blachena, Maria Ducaena Comnena Palaeologina (Martha the nun), 137
Botaniates, Nicephorus III, *Emperor*, 116–117, 118, 119, *figs.* 150, 151
Bulgaroctonos *see* Basil II
Butromile, Landolph, 120

Cantacuzene, John VI, *Emperor*, *see* John VI
Cerularius, *Patriarch* Michael, 107
Charlemagne, *Emperor*, 58–59, 100
Choniates, Nicetas, 129, 130
Christopher, son of Romanus I Lecapenus, 100
Chrysostom *see* St. John Chrysostom
Clement II, *Pope*, tomb of, 101
Clementinus, consular diptych of, 34, *fig.* 44
Comnena, Anna, 137
Comnene family, 123, 129
Comnenus, Alexius, grandson of Andronicus I Comnenus, 130
Comnenus, Alexius I, *Emperor*, 111, 121, 137, 138
Comnenus, Alexius II, *Emperor*, 123, *fig.* 162
Comnenus I Andronicus, *Emperor*, 130
Comnenus, David, grandson of Andronicus I Comnenus, 130
Comnenus, John, *curopalates*, 121
Comnenus, John II, *Emperor*, 121, *figs.* 161, 162
Comnenus Synadenus, John, 124
Constans, son of Constantine the Great, 7, *fig.* 2
Constantia, *Empress*, 55
Constantine the Great, *Emperor*, 3, 7, 20, 54, 55, 66, 129, 130, *figs.* 1, 2
  with the Virgin and Justinian I, 97, 98, 105, 106, *fig.* 123
Constantine V Copronymus, *Emperor*, 56, 57, 58, 59, 61, *fig.* 75
Constantine VI, *Emperor*, 61
Constantine VII Porphyrogenitus, *Emperor*, 23, 67–70, 73, 87, 88, *figs.* 80, 82
  Book of Ceremonies, 93
  ivory triptych for, 80–82, *fig.* 97

Constantine VIII, *Emperor*, 100, 105
Constantine IX Monomachos, *Emperor*, 105,
    106, 107, 119, *fig.* 130
  Crown of, 107–108, 110, 113, *fig.* 132a, 133
  mosaic of, with Empress Zoe, 104, 107,
    117, 122, *fig.* 130
Constantine X Dukas, *Emperor*, 107, 115
Constantine XI Dragases, *Emperor*, 152
Constantine Porphyrogenitus, son of
    Michael VII Dukas, 110, *fig.* 134
Constantius II, *Emperor*, 7–10, 13, *figs.* 2, 3,
    4, 5, 6
Copronymus *see* Constantine V

Dalassena, Anna, wife of John Comnenus,
    121
Dandolo, Doge Andrea, 112
Diogenes, Romanus IV, *Emperor*, 107
Dioscurides, 35, 83, *fig.* 45
Dukas family, 123
Dukas, Constantine X, *Emperor*, 107, 115
Dukas, John, 134
Dukas, Maria, 121, 138
Dukas, Michael VII, *Emperor*, 110, 115, 116,
    *figs.* 134, 136

Edward the Confessor, tomb of, 101
Eudocia, wife of Constantine X, 115
Eudokia, wife of Romanus II, 82, *fig.* 101
Euripides, 76
Eusebius of Caesarea, 55

Falier, *Doge* Ordelafo, 111
Flavius Anastasius, consular diptych of, 34,
    *fig.* 42

Galla, daughter of Quintus Aurelius Sym-
    machus, 3
Galla Placidia, *Empress*, 3
Gemblacensis, Sigibertus, 68
Germanus, *Patriarch*, 66
Geza I, *King* of Hungary, 110, *fig.* 134
Gregoras, Nicephorus, 138
Gregory II, *Pope*, 58
Grioni, Nicoletta da, 137
Guisa, *Princess*, 120
Gunther, *Bishop*, tomb of, 98, *fig.* 124

Hadrian, *Emperor*, 1, 31
Harbadan, *Khan*, 139
Helena, *Empress*, wife of Manuel II, 149,
    *fig.* 200
Heraclius, *Emperor*, 29, 45, 49, 68, 130, *fig.* 38
Hippocrates, works of, 133, 147, *fig.* 197
Honorius, *Emperor*, 9, 15–16, 17, *fig.* 14
Humbert, *Cardinal*, 107

Ignatius, *Patriarch*, 63
Innocent III, *Pope*, 130
Irene, daughter of Nicephorus Khoumnos,
    120
Irene, *Empress*, wife of John II Comnenus,
    121, *fig.* 161
Irene the Athenian, *Empress*, 56, 61, 64, 107,
    111, *fig.* 137
Isaac I Comnenus, *Emperor*, 121, 138, 139
Isaurian dynasty, 60
Isidore of Miletus, 31

James of Kokkinobaphos, 116, 127, 141,
    *figs.* 149, 168
Joasaph, monk, *see* John VI Cantacuzene
John II Comnenus, *Emperor*, 121, *figs.* 161,
    162
John V Palaeologus, *Emperor*, 152
John VI Cantacuzene, *Emperor* (the monk
    Joasaph), 137, 145, 147, 148, *figs.* 198,
    199
John VIII Palaeologus, *Emperor*, 149, 152,
    *fig.* 200
John *o koulix*, 124
Julian the Apostate, *Emperor*, 13, *fig.* 10
Juliana Anicia, *Princess*, 35, 37, 83, *fig.* 45
Justin I, *Emperor*, 4, 33, 48
Justin II, *Emperor*, 30, 54, 55
  coin of, 48
  consular diptych of, 41, 45, 54, *fig.* 51
  control stamps of, 46
  Cross of, 46, 51, 53, 54, *fig.* 55
Justinian I, *Emperor*, 4, 14, 30–31, 33, 41,
    45, 51, 122, 129, 130, *figs.* 13, 49, 123
  coins of, 48
  consular diptych of, 40, *fig.* 50
  control stamps of, 42
  Dome of, 152
  in Barberini diptych, 38
  restores St. Saviour in Chora, 138
  statue of, 152
  with the Virgin and Constantine I, 97–98,
    105–106, *fig.* 123
Justinian II, *Emperor*, 54, 56, 61, 64, *fig.* 70
  coins of, 65

Kalaphates, Michael V, *Emperor*, 104
Khoumnos, Nicephorus, 120
Khusrau, *King*, 4
Kokkinobaphos, James of, 116, 127, 141,
    *figs.* 149, 168

Lascaris, Theodore, 130
Lecapenus, Romanus I, 64, 68, 87, 100
Leo I, *Emperor*, 14, 29

Leo III, *Emperor*, 6, 56, 58, 61, *fig.* 75
Leo IV, 'the Khazar', *Emperor*, 61
Leo VI, 'the Wise', *Emperor*, 64, 67, 70, 82, 100, *figs.* 77, 79, 81, 111
   Crown of, 87
Leo the Patrician, Bible of, 72–73, *figs.* 86, 87
Leone da Molino, 120
Licinius, *Emperor*, 55
Liutprand of Cremona, *Bishop*, 68, 104

Magna, sister of Emperor Anastasius, 37
Magnus, consular diptych of, 35-37, *fig.* 46
Malalas, John, 4
Manuel I, *Emperor*, 121
Manuel II Palaeologus, *Emperor*, 149, 152, *figs.* 200, 201
Marcian, *Emperor*, 29, 30
Maria, *Empress*, wife of Honorius, 9
Martha the nun (Maria Ducaena Comnena Palaeologina Blachena), 137
Mary (Maria) of Alania, wife of Michael VII Dukas, 110, 116, *figs.* 136, 151
Matthew, copyist, 127
Maurice Tiberius, *Emperor*, 48, *fig.* 61
Mauro of Amalfi, 120
Maximian, *Emperor*, 39
Mehmet II, *Emperor*, 152
Melane the nun (Maria Palaeologina), 138–139
Metaphrastes, Simeon, 124
Methodius, *Patriarch*, 61, 66
Metochites, Theodore, 138, 139, *fig.* 184
Michael III, *Emperor*, 63, 64
Michael IV the Paphlagonian, *Emperor*, 64, 105
Michael V Kalaphates, *Emperor*, 105
Michael VII Dukas, *Emperor*, 110, 115, 116, *figs.* 134, 136
Michael VIII Palaeologus, *Emperor*, 134, 149
Michael Autoreanus, *Patriarch*, 130
Michael Cerularius, *Patriarch*, 107
Michael, *kitonite and eidikos*, 100
Michael 'of the Blachernae', 94
Michael, *Synkellos of the Studion*, 114
Molino, Leone da, 120
Monomachos *see* Constantine IX
Moschus of Syracuse, 77

Nicander of Colophon, 75, *fig.* 89
Nicephorus II Phocas, *Emperor*, 64, 82, 87, 98, 104
Nicephorus III Botaniates, *Emperor*, 116–117, 118, 119, *figs.* 150, 151
Nicephorus Gregoras, 138
Nicephorus Khoumnos, 120

Nicephorus, *Patriarch*, 66
Nicephorus, son of Artavasdes, 61
Nicephorus the Patrician, 106
Nicetas, *Patriarch*, 57

Odovacar the Ostrogoth, 4
Omar, *Caliph*, 5
Oppian, Cynegetica of, 75, 77, 80, *fig.* 90
Orseolo, *Doge*, 111
Osman, *Sultan*, 139
Otto III, *Emperor*, 100

Palaeologina, Euphrosyne Comnena Ducaena, 149
Palaeologina, Maria (Melane the nun), 138–139
Palaeologus, Andronicus II, *Emperor*, 138, 141
Palaeologus, Andronicus III, *Emperor*, 137
Palaeologus, John V, *Emperor*, 152
Palaeologus, John VIII, *Emperor*, 149, 152, *fig.* 200
Palaeologus, John, 145
Palaeologus, Manuel II, *Emperor*, 149, 152, *figs.* 200, 201
Palaeologus, Michael VIII, *Emperor*, 139, 149
Pantaleon, 97
Pantaleon family of Amalfi, 120
Paternus, *Bishop*, 45, *fig.* 57
Pepin the Short, *King*, 59
Peter, *Archon*, 100
Phidias, 129
Philippicus Bardanes, *Emperor*, 60
Phocas, Bardas, 94
Phocas, Nicephorus II, *Emperor*, 64, 82, 87, 98, 104
Placidia, Galla, *Empress*, 3
Plethon, Gemistus, 152
Plotinus, 2
Porphyrius, 24, 35, *figs.* 31–33
Porphyrogenitus *see* Constantine VII
Porphyrogenitus, Constantine, son of Michael VII Dukas, 110
Praetextatus, 4
Probus, 37
Proclus, 15, 16
Psellus, Michael, 105, 107
Ptolemy, astronomical writings of, *fig.* 74
Pulcheria, sister of Theodosius II, 3

Ricimer, 4
Romanus I Lecapenus, *Emperor*, 64, 68, 87, 100
Romanus II, *Emperor*, 82, 87, 93, 94, 100, *fig.* 101
Romanus III Argyrus, *Emperor*, 105, 119

Romanus IV Diogenes, *Emperor*, 107
Romulus Augustulus, *Emperor*, 4
Rufinus, 16

St. Albuin, chasuble of, 100–101
St. Autonomos, 124–125
St. Bacchus, *fig.* 69
St. Demetrius, 145
St. Denys the Areopagite, 152, *fig.* 200
St. Euphemia, *fig.* 195
St. Gaudry, *Bishop*, 100
St. George, 145
St. Germain, shroud of, 101
St. Gregory Nazianzen, Homilies of, 67, 74,
  87, 126, *figs.* 83, 167
St. Helena, statue of, 7, 152
St. James, 85, 131, *figs.* 108, 171
St. Jerome, 4
St. John Chrysostom, 87, 116–117, 137,
  *figs.* 78, 150, 151
St. John the Evangelist, 80, 130, 131, 132,
  *figs.* 100, 173
St. Jude, 131
St. Ladislas, *King of Hungary*, 121
St. Leontius, 125
St. Luke, 85, 107, 130, 131, 133, *figs.* 106,
  107, 166, 171, 174
St. Luke the Stylite, 94
St. Mark, 111, 128, *figs.* 169, 175
St. Matthew, 85, 107, 130, *figs.* 105, 170
St. Michael, *figs.* 41, 76, 118, 150
St. Nicetas, 125
St. Paul, 80, 131, *fig.* 100
St. Peter, 131
St. Serapion, 125
St. Sergius, *fig.* 69
St. Simeon, *Bishop of Jerusalem*, 96, *fig.* 120
St. Simeon the Stylite, 96
St. Stephen, 66
St. Thecla, 125, *fig.* 165
St. Theodore of Alexandria, 125
St. Theodore Stratelates, 137, *fig.* 182
St. Theodore the Tyro, 137
St. Theodosia, 56
St. Ulrich of Augsburg, 101
Samuel, *King of the Bulgars*, 98, 121
Secundinus, 37
Sigibertus Gemblacensis, 68
Simeon Metaphrastes, 124, *fig.* 165
Simeon 'of the Blachernae', 94
Simeon the Syrian, 120
Staurachios, metalcaster, 120
Stephen, keeper of the Treasury of Agia
  Sophia, 83
Stilicho, sarcophagus, 22

Svjatoslav, *Prince of Kiev*, 98
Symmachus, Quintus Aurelius, 3–4

Tarasius, *Patriarch*, 66
Tarchaniotes, Michael Glabas, 137
Thamar, *Queen of Georgia*, 130
Theodora, *Empress*, widow of Theophilus,
  56, 61, 62, 64, 96, 105, *fig.* 131
Theodora, *Empress*, wife of Justinian, 4, 64,
Theodora, *Empress*, sister of the Empress
  Zoe, 105, 107, *figs.* 131, 133
Theodore, Despot of Morea, 149, *fig.* 201
Theodore, son of Manuel II, 149, *fig.* 200
Theodore Metochites, 138, 139, *fig.* 184
Theodoros of Caesarea, 114
Theodosius I, *Emperor*, 15–17, 27, 98, 129,
  130, *figs.* 14, 16, 19
  Column of, 16
  Dish of, 20, 53
  Missorium of, 53
Theodosius II, *Emperor*, 3, 14, 22, 23, 29, *fig.*
  12
  coins of, 48
  consular solidus of, 14
Theodosius III, *Emperor*, 60
Theophanes Continuatus, 57, 68
Theophilus, *Emperor*, 56, 58, 61, 126, 129,
  *fig.* 166
  coins of, 61
Theophilus, monk, 133, *fig.* 174
Thutmosis III, obelisk of, 15
Tiberius II, *Emperor*, 48, 55
  coins of, 54
Tiberius, *Emperor* Maurice, 48, *fig.* 61
Tornikes, Michael, 141
Tzimisces, *Emperor* John I, 64, 98

Umayyad dynasty, 5, 58

Valens, *Emperor*, 31
  aqueduct of, 134
Valentinian I, *Emperor*, 13, 29, *fig.* 11
Valentinian II, *Emperor*, 15–16, *figs.* 14, 16
  statue of, 16, 19, 21, 25, *fig.* 15
Valentinian III, *Emperor*, 35
Vinsauf, Geoffrey de, 129

Xanthicos, Manuel, 115
Xiphilinos, *Patriarch* John, 63, 107

Zeno, *Emperor*, 38
Zoe, *Empress*, 104–105, 107, 151, *figs.* 130,
  131, 132b
  mosaic portrait with Constantine IX, 104,
  106, 107–108, 111, 117, 122, 151, *fig.* 130
Zonaras, 98

# INDEX OF PLACES

Aachen, Cathedral Treasury, 58–60, 100, *fig.* 128
Adrianople, 152
Alexandria, 4–5
Amalfi, 120
Antioch, 4, 7, 13, 98, *fig.* 4
Aphrodisias, 16–19, *figs.* 15, 18, 20, 21
Athens, 98, 129
   National Library, cod. 118 : 130
Athos, Mt., Philotheu, cod. 5 : 131
   Andreaskiti, cod. 753 : 132
   Iviron, cod. 5 : 132
Atrani, Cathedral of, 120
Auxerre, Cathedral of, 100
   Church of St. Eusèbe, 101

Baghdad, 5, 58, 129
Bamberg Cathedral, tomb of Bishop Gunther, 98, *fig.* 124
   tomb of Pope Clement, 101
Barletta, colossus of, 27–29, *fig.* 38
Belgrade, forest of, 31
Berlin, Staatliche Museen, 100, 119, 134, *figs.* 34, 153–154, 177
   Ehemals Staatliche Museen, Dahlem, 135, *figs.* 51, 79, 180
Boiana, 130
Brixen, Cathedral Treasury, 100–101, *fig.* 129
Brussels, Musées, 18, *fig.* 18
Budapest, National Museum, 107, *figs.* 133, 134
Bursa, 152
Byzantium *see* Constantinople

Carthage, 49
Cassino, Monte, 120
Cefalù, 122–123
Chimay, Church of SS. Peter and Paul, 137, *fig.* 183
Chios, Nea Moni on, 106–107, 122, 141
Cologne, Cathedral Treasury, 100, *fig.* 127
Concesti, amphora from, 10, 13, *figs.* 7–9
Constantinople, artists sent from, 106, 122–124, 130
   Augusteion, 7
   Basilica, 7
   Baths of Zeuxippos, 7
   Churches:
      Agia Sophia (Holy Wisdom), 31, 55, 64, 106, 115, 117, 129, 134, 139, 152.—Apse, 62–63, 145, *figs.* 76, 196.—

Imperial Doorway, 64, 65–66, *fig.* 77.—Nave, 66, *fig.* 78.—Outer Hall, 22, *fig.* 27.—Repairs by Michael VIII, 134.—Repairs by Romanus III, 105.—Room over south-west ramp, 5, 57, *fig.* 71.—South Gallery, 104, 121–122, 134, *figs.* 130, 161, 176.—South Vestibule, 97–98, 105, 106, *fig.* 123
      Holy Apostles, 31, 63, 127
      Holy Sepulchre, 29
      Holy Wisdom *see* Agia Sophia
      St. Euphemia, 145, *fig.* 195
      St. George of the Manganes, 106, 119, *fig.* 155
      St. Irene, 31, 57
      St. John of Studius, 95 f., 105
      St. Mary at Blachernae, 94, 105
      St. Mary of the Mongols (Theotokos Mongoulion), 139
      St. Peter and St. Paul, 31
      St. Saviour in Chora (Kariye Djami), 63, 114, 121, 125, 126, 133, 134, 135, 137–143, 145, 151, *figs.* 179, 184, 185, 186, 187, 188, 189, 190, 203
      St. Saviour Pantocrator, 121
      St. Saviour Philanthropus, 120
      St. Sergius and St. Bacchus, 31, 63
      Theotokos Mongoulion, 139
      Theotokos of the Pharos, 62
      Theotokos Pammakaristos, 120–121, 137
      Theotokos Peribleptos, 118–119, 134, *figs.* 153–154
   Column of Marcian, 24
   consular diptychs, 34
   Convents:
      Our Lady of Good Hope, 149, *fig.* 202
      Petrion by the Phanar, 104
      St. George of the Manganes, 106, 119, *fig.* 155
      Theotokos Panghiotissa, 139
   Fenari Isa Djami, 20, *figs.* 23–26
   Forum of Constantine, 7
   Forum Tauri, 16, *fig.* 17
   Gates:
      Ayvan Saray, 23, *fig.* 29
      Chalke, 56, 61
      Golden, 98
      St. Romanus, 152
   Golden Horn, 128, 134

Hippodrome, 7, 15, 24, 30, 56, 129, *figs.*
14, 22
humanists at, 152
images destroyed, 57
Kariye Djami *see* Church of St. Saviour
in Chora
Kontoscalion harbour, 134
Marmara, Sea of, 128, 134
Mesé, 7
Milion, 58
Monasteries:
Chora, of the, 138
St. John of Studius, 26, 49, 54, 57, 114,
117, *figs.* 37, 142, 143, 144, 146
Theotokos Peribleptos, 25
Mosque of Sultan Ahmed, 7
Museum *see* under Istanbul
Palaces:
Blachernae, of the, 94, 121, 133, 134,
152
Great Palace, 29–30, 58, 83, 92, 94, 97,
134, *figs.* 39, 40
Chrysotriclinos, 54, 61–62
Palace of the Magnaura, 94
Philadelphion, 7
Psamatia, 25, 118, *figs.* 34, 153–154
reunion with Rome, 33
sack of (1204), 128–130
Strategion, 7
Syrian artists in, 120
underground cisterns, 31
University, 107
Copenhagen, Royal Library, cod. 6: 85,
*fig.* 109
Corinth, 80
Cortona, Church of S. Francesco, 83, *fig.* 103
Cyprus, 48, 49, 51–53, 80, 132

Damascus, Great Mosque, 5, 58
Daphni, 122, 141
Delphi, 7
Diyarbakr, Syria, 101
Dodona, 7
Dumbarton Oaks *see* Washington
Dusseldorf, 100

Epirus, 130
Esztergom, Cathedral Treasury, 111, *fig.* 139

Faiyum, 149
Fatih, *fig.* 35
Ferrara, Council of, 152
Florence, Church of San Giovanni, 137
Council of, 152
Museo dell' Opera del Duomo, 137

Museo Nazionale, 115, 120, *figs.* 47, 147,
157, 163

Gallipoli, 152
Gargano, San Michele in, 120

Harbaville triptych, 82
Helicon, 7
Herculaneum, 1

Istanbul, Archaeological Museum, 7, 16, 22,
24, 26, 119, 120, *figs.* 15, 17, 20, 21, 23–
33, 35–37, 58, 155
At-Meidan, *figs.* 14, 22
*see* also Constantinople

Jericho, 5, 58
Jerusalem, Dome of the Rock, 5, 58

Karnak, 15
Kasr al-'Amra, 58
Kasr al-Hair, 58
Kastoria, 130
Kertch, 10
Khakuli triptych, 110, *fig.* 136
Kiev, 106, 122, 124
Klimova, 42–45, *fig.* 53
Krefeld, 100

Leningrad, Hermitage Museum, 45, 135,
137, *figs.* 6, 7–9, 53, 56, 57, 62, 63, 64,
66, 182
Limburg, Cathedral Treasury, 88–92, 111,
*figs.* 114–116
Limnae, 124
Lindus, 7
Liverpool, Museum, 34, *fig.* 44
London, British Museum, *figs.* 3, 4, 10–13,
41, 69, 70, 75, 81–82, 131
Add. Ms. 28815 (Gospels), 85, *figs.* 106,
107
Add. Ms. 19352 (Psalter), 114, *figs.* 142,
143, 146
Add. Ms. 11870 (Lives of the Saints), 115,
124, *fig.* 165
Cod. Burney 19 (Gospels), 128, 132, *fig.* 170
Cod. Burney 20 (Gospels), 133, *fig.* 174
London, Victoria and Albert Museum, 59,
118, 119, 137, *figs.* 42, 91–96, 102, 152,
156, 181
Lyon, Musée des Tissus, 59, *fig.* 73

Maastricht, Treasury of the Church of Our
Lady, 92, 110, *fig.* 135
Madrid, Academia de la Historia, 16, 53,
*fig.* 16

Manzikert, 107
Marathonisi, quarries, 118
Meteora, 124
Milan, 4
    Basilica of St. Ambrose, 22
    Museo del Castello Sforzesco, 38, *figs.* 1, 50
Mileševa, 130
Monreale, Church at, 123
Monte Cassino, 120
Monza, Cathedral Treasury, 42, *fig.* 52
Moráča, 130
Moscow, Museum of Fine Art, 131, 142, 144, *figs.* 80, 191, 193, 194
Mount Athos *see* Athos
Mount Privation, 106
Mount Sinai, 47
    cod. 204: 83, *fig.* 104
Mozac, 59–60
Mshatta, 58
Munich, Reiche Kapelle, 112
Mytilene, 106

Nerezi, Church of St. Pantaleimon, 123
New York, Metropolitan Museum of Art, *figs.* 61, 68
    Pierpont Morgan Library, *figs.* 140–141
Nicaea, 116, 130
    Church of the Dormition, 55, 98, 106–107, 128
    Oecumenical Council, 61
Nicomedia, 7, *fig.* 3
Nicosia, Museum of Antiquities, *fig.* 67

Ochrid, Church of St. Clement, 143
Osios Loukas, Phocis, 106
Oxford, Bodleian Library
    Ms. Canon. gr. 110 (Acts and Epistles), 85, *fig.* 108
    Ms. Auct. T. infra 1.10 (New Testament), 125–126, *fig.* 166
Oxford, Lincoln College, Typicon, 149, *fig.* 202

Palermo, Cappella Palatina, 122
Paris, 152
    Abbey of St. Denys, 152
    Alliance Biblique française, Evangeliary, 128
    Bibliothèque Nationale
        Ms. gr. 54 (Gospels), 132, 133, *figs.* 172, 173
        Ms. gr. 64 (Gospels): 115
        Ms. gr. 70 (Gospels), 85, *fig.* 105
        Ms. gr. 71 (Gospels), 115, *fig.* 148

Ms. gr. 74 (Gospels), 114, *fig.* 144
Ms. gr. 117 (Gospels), 133
Ms. gr. 134 (Commentary on Job), 133
Ms. gr. 139 (Psalter), 70–71, *figs.* 84, 85
Ms. gr. 510 (Homilies of St. Gregory Nazianzen), 67–68, *fig.* 83
Ms. gr. 550 (Homilies of St. Gregory Nazianzen), 126, *fig.* 167
Ms. gr. 922 (Parallela Patrum), 115
Ms. gr. 1208 (Homilies on the Virgin), 116, 127, *figs.* 149, 168
Ms. gr. 1242 (Theological works of John VI Cantacuzene), 147–148, *figs.* 198, 199
Ms. gr. 2144 (Hippocrates), 147, *fig.* 197
Ms. gr. Coislin 79 (Homilies of St. John Chrysostom), 116, *figs.* 150, 151
Ms. gr. Coislin 222: 115
Ms. Suppl. gr. 247 (Nicander, Theriaca), 75, *fig.* 89
Ms. Suppl. gr. 309 (Funeral oration), 149, *fig.* 201
Ms. Suppl. gr. 612 (Gospels), 127–128, 133, *fig.* 169
Ms. Suppl. gr. 1262 (Acts of the Apostles), 124, *fig.* 164
Ms. Suppl. gr. 1335 (New Testament, Psalms and Canticles), 133, *fig.* 175
    Cabinet des Médailles, *figs.* 46, 101
    Musée de Cluny, 58, 120, *figs.* 72, 158–160
    Musée du Louvre, 38, *figs.* 5, 49, 98, 200
Peč, 130
Perm, 45
Philippopolis, 152
Phocis, Osios Loukas, 106
Pompeii, 1
Princeton University, Garrett Ms. 2: 132
Prinkipo, Island of, 105
Privation, Mount, 106
Psamatia, Church of the Theotokos Peribleptos, 25, 118, *figs.* 34, 153–154

Ravenna, 4, 22
    Church of San Vitale, 104
    coins from, 14, 49
    Mausoleum of Galla Placidia, 2
    Maximian's Chair, 39
Riha Paten, 26, 46–47, 51, 54, *fig.* 59
Rome, 10, 22, 23, 46, 130, 151
    Ara Pacis, 1
    Arch of Titus, 1, 2
    artists of, 22
    breach with Constantinople, 107
    Campus Martius, 1

catacombs, 2
Church of San Paolo fuori le mura, 120
Church of Santa Maria Maggiore, 2
coins, 14
Column of Marcus Aurelius, 1
Hellenistic revival, 2
House of Livia, 1
iconodule clergy go to, 56
Museo Nazionale, 1
Palazzo Venezia, 80, *fig.* 97
personification of, 37
reunion with Constantinople, 33
sack of, 128–129
St. Peter's Basilica, 2
Trajan's Column, 1

Salerno, 120
Salonika, 14, 47, 116, 123, 124, 130, 131
Church of St. Demetrius, 55, 104
Church of St. George, 5
mint, 14
Sant'Angelo, Monte, 120
Sarigüzel Sarcophagus, 21–22, 23, 30, 54, 83, 142, *figs.* 23–26
Sicily, 122–123
Sidamara, 25
Siegburg, 100
Sinai, Mount, 47
cod. 204: 83, *fig.* 104
Sirmium, 4
Skoplje, Macedonia, *fig.* 192
Sopočani, 130
Stavelot triptych, 113–114, *figs.* 140–141
Studenica, Church of the Virgin, 130
Stuma paten, 26, 46–47, 51, 54, *fig.* 58
Stuttgart, Landesmuseum, 114, *fig.* 145

Tiflis, National Museum, *fig.* 136
Trebizond, 130
Trier, 4
Troyes, Cathedral Treasury, 100, *figs.* 125, 126

Vatican:
Ms. gr. 1291 (Ptolemy), 60, *fig.* 74
Ms. Reg. gr. 1 (Bible), 72, *figs.* 86, 87
Ms. gr. 431 (Joshua Rotulus), 73–75, 77, *fig.* 88
Ms. gr. 1613 (Menologion), 94–97, *figs.* 120-1
Ms. gr. 1162 (Sermons), 116
Ms. Urb. gr. 2 (Gospels), 121, *fig.* 162
Ms. gr. 1208 (Acts and Epistles), 131, 133, *fig.* 171
Ms. Barb. lat. 144: 135
Cross of Justin II, 46, 51, 53, 54, *fig.* 55
miniature mosaic, 137
reliquary of the True Cross, 92–93
Venice, 111, 132, 152
Marciana Library, cod. Lat. I, 101: 87, *fig.* 110
Ms. gr. 17 (Psalter), 97, *fig.* 122
Ms. gr. 479 (Oppian), 75, *fig.* 90
Museo Archeologico, 80, *fig.* 100
Pala d'Oro, 110–112, 113, *fig.* 137–138
St. Mark's Church, 2, 7, 120
Treasury, 80, 87, 92, 108, 111–112, *figs.* 99, 111, 112, 113, 117, 118, 132b, 137, 138
Vera, Macedonia, Monastery, 138
Veroli Casket, 76–80, 137, *figs.* 91–96
Vienna, Kunsthistorisches Museum, *figs.* 2, 48, 65
Oesterreichische Nationalbibliothek, Ms. med. gr. 1 (Dioscurides), 35, *fig.* 45
Vladimir, South Russia, 123–124

Washington, Dumbarton Oaks Collection:
Silenus silver dish, 43, 45, 49, *fig.* 54
Riha paten, 26, 46–47, 51, 54, *fig.* 59
Gold medallion from Cyprus, 48, *fig.* 60
Silver Cross, 94, *fig.* 119
Miniature mosaics, 135, 137, *fig.* 178
Wolfenbüttel, sketchbook, 131

Zurich, Landesmuseum, *fig.* 43